SINCERELY YOURS

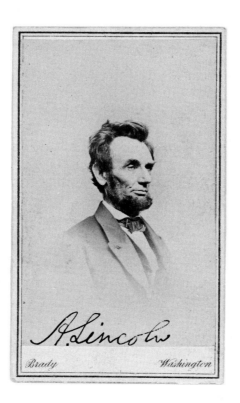

ABRAHAM LINCOLN (1809–1865)

1864. When asked if he had a favorite photograph of himself,
Lincoln pointed to this one from Mathew Brady's studio, saying,
"If I look like any of the likenesses of me that have been taken,
I look most like that one."

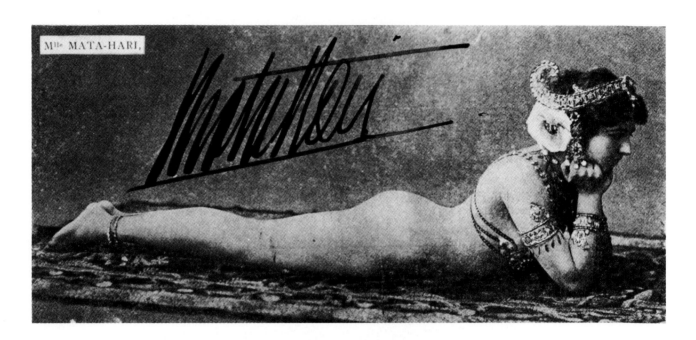

MATA HARI (1876–1917)

Circa 1907. She was born Gertrud Margarete Zelle, but that was hardly
a name for an exotic dancer. The notorious World War I spy,
executed by the French in 1917, must have been better
at concealing secrets than is apparent here.

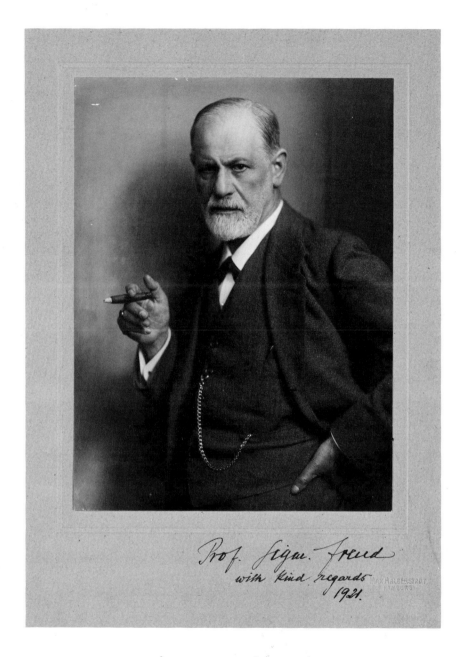

SIGMUND FREUD (1856–1939)

Dated 1921. This famous photograph of the founder of psychoanalysis
was taken by his nephew Max Halberstadt, and it may be
the only existing print made from the original negative.
The inscription is unusual in that it is inscribed
in English and uses the title "Professor."

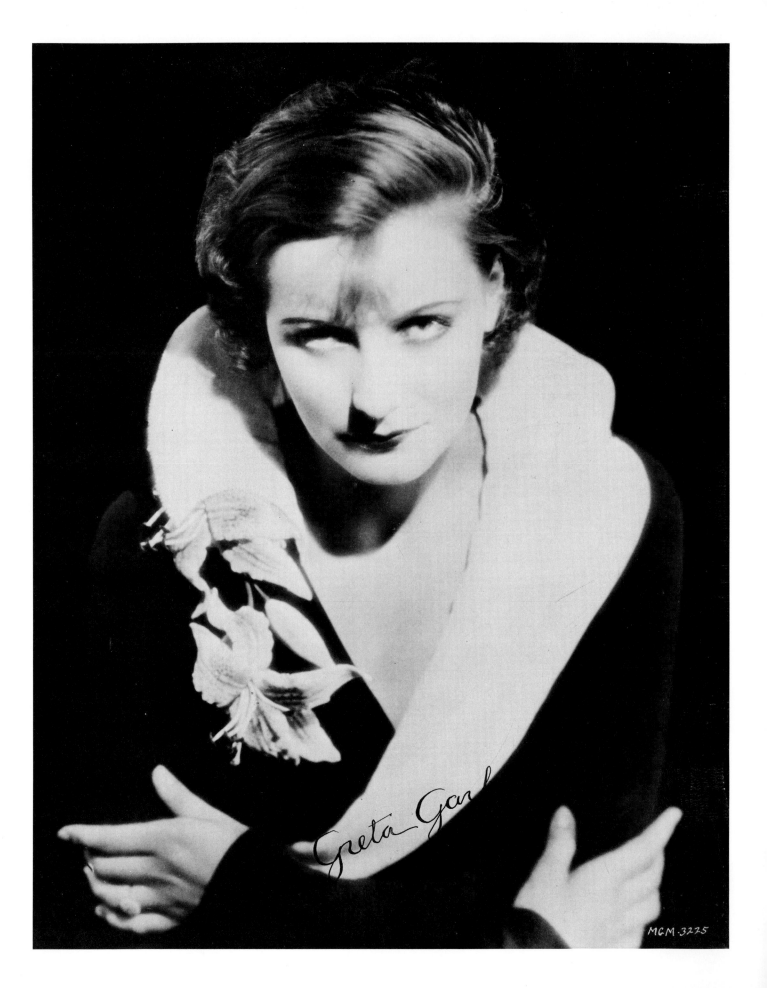

Greta Garbo

MGM-3275

SINCERELY YOURS

The Famous & Infamous As They Wanted to Be Seen,
in Autographed Photographs from
the Collection of

M. WESLEY MARANS

Foreword by Charles Hamilton

A New York Graphic Society Book

LITTLE, BROWN AND COMPANY, BOSTON

GRETA GARBO (1905–)

1926. A rare signed photograph from Garbo's early days in Hollywood,
where her special glamour was quickly recognized.

My thanks to my wife Bea, my daughter Beth, my editor
Betty Childs, and to fellow collectors Barry Hoffman and
George J. Tecci, to Stephen I. Samuels and Sidney L. Kirshner,
to Rodney Armstrong and Donald Kelley of the Boston Athenaeum,
to William M. Bulkeley, J. D. Reed, Ray Cave, Dan H. Fenn, Jr.,
Floyd Yearout, Noel Silverman, Rosalie and Gerald Davidson,
Boris Color Laboratory, and to all the dealers
who helped make the collection possible.

First Edition

Library of Congress Cataloging in Publication Data

Main entry under title:
Sincerely yours.
 (A New York Graphic Society book)
 1. Photography—Portraits. I. Marans, M. Wesley.
II. Series.
TR681.F3S54 1983 779'.23'0922 83–14881
ISBN 0-8212-1552-3

New York Graphic Society Books are published
by Little, Brown and Company, Boston
Published simultaneously in Canada
by Little, Brown & Company (Canada) Limited

Printed in the United States of America

CONTENTS

Foreword, by Charles Hamilton · 1

As They Wanted to Be Seen, by M. Wesley Marans · 4

THE ALBUM

Adventurers, Daredevils & Outlaws · 14

Scientists & Thinkers · 32

Writers · 48

Soldiers & Statesmen · 72

Business Leaders & Social Activists · 104

Artists · 122

Musicians & Dancers · 140

Sportsmen & Sportswomen · 162

Actors & Actresses · 180

Index · 212

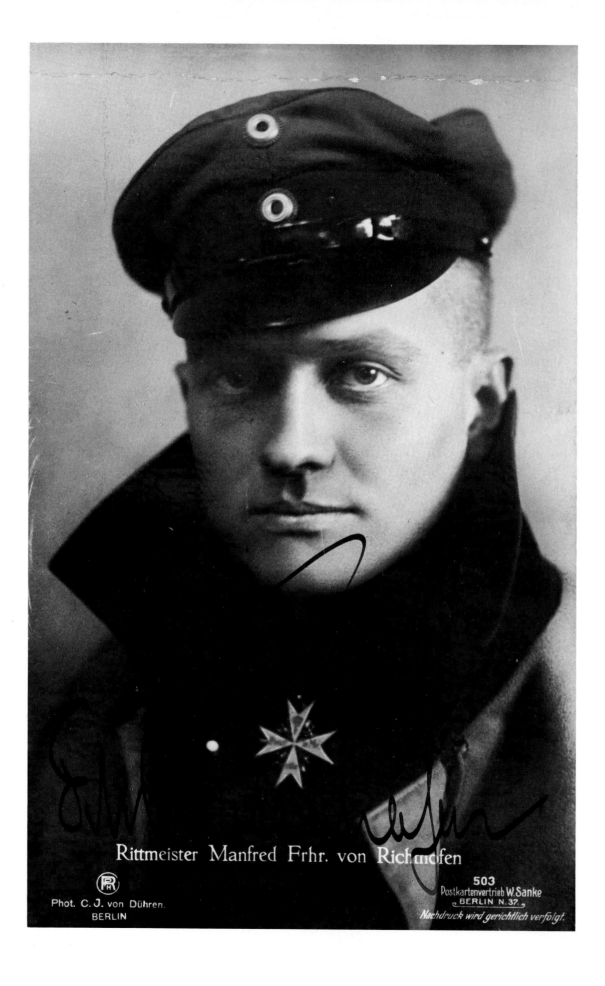

Rittmeister Manfred Frhr. von Richthofen

Phot. C. J. von Dühren.
BERLIN

503
Postkartenvertrieb W. Sanke
BERLIN N. 37.
Nachdruck wird gerichtlich verfolgt.

FOREWORD

by Charles Hamilton

AS YOU TURN the pages of M. Wesley Marans' unique and incredible gallery of signed photographs you will meet many of the world's most interesting personalities. You can examine at leisure their faces and signatures. You can, if you wish, probe the secrets of their minds and discover what made them people of mark.

Long before anyone thought of assembling signed photographs, even before Fox Talbot's invention of paper photographs made it possible, Edgar Allan Poe was an avid collector of engraved portraits and autographs. He wrote an essay on "autography," in which he analyzed, rather brutally, the handwriting of his literary rivals. Poe declared: "Next to the person of a distinguished man we desire to see his portrait; next to his portrait, his autograph." Poe thus charted the course for one of the most exhilarating of all collecting pursuits, one which M. Wesley Marans has brought to a new level, the hobby of collecting signed photographs of celebrities.

Poe's "autography," the science of handwriting analysis, is of recent origin. Yet a century and a half ago the great German poet and philographer Goethe wrote: "There can be no doubt that the handwriting of a person is related to his thought and character, and that we may gain from it a definite impression of his mode of life and conduct."

Most modern graphologists turn crayfish at the suggestion of analyzing character from a mere signature. They require a lengthy letter, a manuscript, a mighty mountain of words before they dare venture upon an opinion. Yet even amateurs like Goethe and Poe were able to draw many valid and even startling conclusions from nothing more than a scrawled name. Signatures often reveal secrets that no psychiatrist would discover.

In this book of camera portraits, many of which Rembrandt would have envied for their awesome candor, we can view the features of some of the greatest men and women of the last century and a half. And these are not fleeting images, such as one might get from a chance personal encounter: they are images limned forever by the camera's eye.

There is a notable difference in the data revealed by photographs and by signatures. The photographer may retouch a photograph to flatter his subject. He can, and often does, iron out wrinkles, subdue or remove wens or warts, or provide a nose job or facelift. A Hollywood camera expert can make a cover girl out of a clock-stopper. But the signature yields to no such blandishments. It comes from deep within the character of the writer. It often strips naked the psyche.

The remarkable changes in photography and handwriting over the past century and a half are manifest in these signed photographs. In the earliest camera portraits the subject was pictured in his Sunday best. He was placed in an ornate chair or propped, rigid and unsmiling, against a headrest, while the photographer counted with what seemed agonizing slowness the sixty to one hundred and twenty seconds required for the image to fix itself on a silver nitrate plate. In no early photograph does the sitter dare to smile. Quite different is modern photography. The artist seeks an informal portrait. He has the equipment to take instantaneous shots and he strives to catch people in revealing poses. In the same way, the florid scripts of our ancestors are replaced by less disciplined hands, often wild, abandoned scrawls. The art of writing is today little more than the ability to make hen scratches with a ball-point pen.

To study the signed portraits in the gallery presented here is almost like testing a mathematical equation. The face makes a statement and the signature usually proves it out. Once in a while there is a startling discrepancy. Thomas A. Edison's thoughtful features, for example, do not entirely jibe with his signature. Its meticulously formed letters and elaborate pen-

BARON MANFRED VON RICHTHOFEN (1892–1918)

Circa 1918. The legendary Red Baron made eighty enemy kills during his career as a German World War I combat pilot before he himself was shot down by a Canadian gunner. The baron was later immortalized as Snoopy's fiendish adversary in Charles Schulz's "Peanuts."

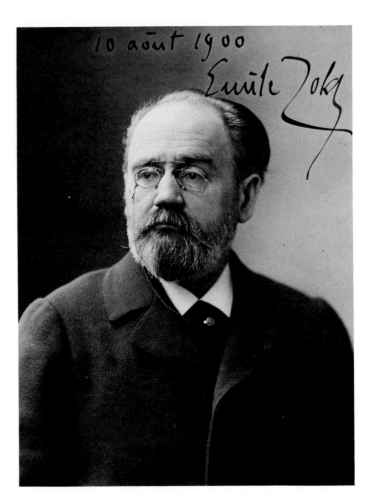

and-ink umbrella suggest the script of an artist rather than an inventor.

Years ago I bought at the same time a signature of Sidney Lanier, the great Southern poet, and a signature of Boston Corbett, the dull-witted, paranoid Union sergeant who shot John Wilkes Booth. With these signatures came two handsome cabinet photographs of the writers. One bore the coarse features of Corbett. The other, the delicate, almost ethereal visage of Lanier. As a joke, I deliberately mismatched the photographs and the signatures, putting the Corbett signature with the Lanier photograph and the Lanier signature with the Corbett photograph. Then I showed the pair to a few friends. The first to view them was a young lady. She said of Corbett: "Is it possible that a man so vulgar looking could have written such beautiful poetry?" And of Lanier: "Incredible, isn't it, that a man whose eyes are so full of dreams could have gunned down a fellow human in cold blood?" Other victims of my joke had exactly the same reaction.

As you adventure into this book you will find it a challenging game to match the faces with the signatures. Look at the signed photograph of Zola, for instance. The features reveal a clenched jaw and prey-seeking eyes behind the professorial pince-nez. Force and power exude from Zola's signature. His *Z* swirls like a cracking whip. Or it may appear to you like a reptile rearing up and about to strike. The end result is the same. It tells you that this man is spoiling for a fight. Examine the dot on the *i* in Emile. No dainty, effeminate dot, this! It looks like a bullet. Can you doubt that here is a great reformer, a man ready to battle for any cause he believes in?

Study the face and signature of Henrik Ibsen. His scowl expresses an Olympian disdain. He seems to be almost a solipsist, a man darkly withdrawn into himself, pugnacious and self-assured. The rigidity and determination of his character is revealed also in his clinical signature, each letter of it regulated to its appointed task, precise but with a touch of artistry.

Observe the little details in each photograph. Take Susan B. Anthony (page 108). The great feminist stands stiffly, primed

EMILE ZOLA (1840–1902)

Dated 1900. French writer and critic, friend and neighbor of Paul Cézanne, fervent champion of Dreyfus (*J'Accuse!*) and of the realistic novel. His *Les Rougon-Macquart* is so realistic it fills twenty volumes.

for a confrontation. Her prim dress has puffed sleeves that make her seem muscular. Her right hand is clenched into a fist. Her dramatic pose, set against a classic background of drapes and pillars, is the identical pose that early photographers chose for fighting statesmen like Daniel Webster and Henry Clay. Susan Anthony's mouth is firmly set and her eyes flash from deep sockets. She is a woman among women, a dauntless Amazon who fights for the rights of her sex. Her signature is simple and clear. She wants everybody to know who she is and what she stands for. And the letters of her name rise in a gentle crescendo, revealing a defiant optimism.

If you're not afraid to get stared down, lock eyeballs with the great Chinese patriot Sun Yat-sen (page 102). His piercing stare will transfix you and follow you around the room. And his disarmingly simple signature, a sharp contrast to the intense look, hints of a calm inner strength.

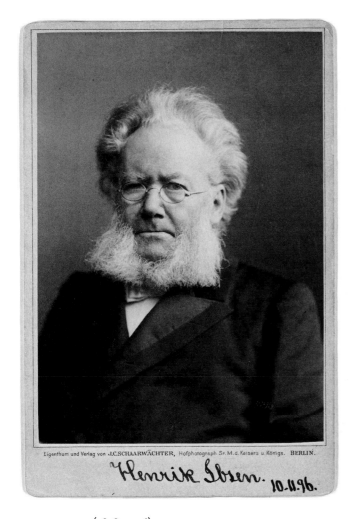

HENRIK IBSEN (1828–1906)

Dated 1896. Norwegian medical student turned poet and playwright. With plays like *A Doll's House* and *Hedda Gabler*, he single-handedly invented modern "psychological" drama.

Examine the features of the famous Red Baron, Manfred von Richthofen, the youthful ace who shot down eighty enemy aircraft before a Canadian warbird drew his number. Richthofen's boyish features suggest the appearance of a Heidelberg student, ready for any sport. In fact, the noted flier was a warrior straight out of the age of chivalry. He even erected gravestones to the men he shot down. Notice his eyes, alert, intense, wary, eager: the eyes of a flawless pilot. But his ruthless signature belies the soft face. It is a profusion of savage angles, like a squad of soldiers with bayonets. Nearly every letter has a sharp point.

Richthofen was slain in battle at twenty-five and his signed photographs are of great rarity. The famed ace once presented a photograph to a nun. As nunnery rules forbade the display of a man's picture in her room, she painted a nun's habit on Richthofen. World War I airmen considered it bad luck to sign one's name just before a mission, but the Red Knight defied the superstition. As he climbed into his red tri-winged Fokker for the last flight on April 21, 1918, a breathless young girl ran up to him and asked him to sign a photograph. Richthofen smiled and, as he wrote his name, spoke his last words: "What's the hurry? Are you afraid I won't come back?"

Peer into the face of the youthful Winston Churchill (page 82). His stare is imperious and cold. The future prime minister is keenly aware of his aristocratic background. His sensitive, lascivious lips form a tight line of determination. The unobtrusive signature is austere. Not a spare stroke. Not an extra flourish. Churchill is a young man who comes right to the point. He even puts a period after his name, as if to say: "There! That's it! My word is final."

As you peruse this unique volume, give a thought to the immense labor and skill it took to compile it. Years of aggressive searching, plus plenty of cajolery and cash, were required to beguile many of these rare signed photographs from their hiding places in attics, old albums – and safe-deposit boxes. But, thanks to the collecting acumen of M. Wesley Marans, the world's most remarkable portrait gallery lies before you.

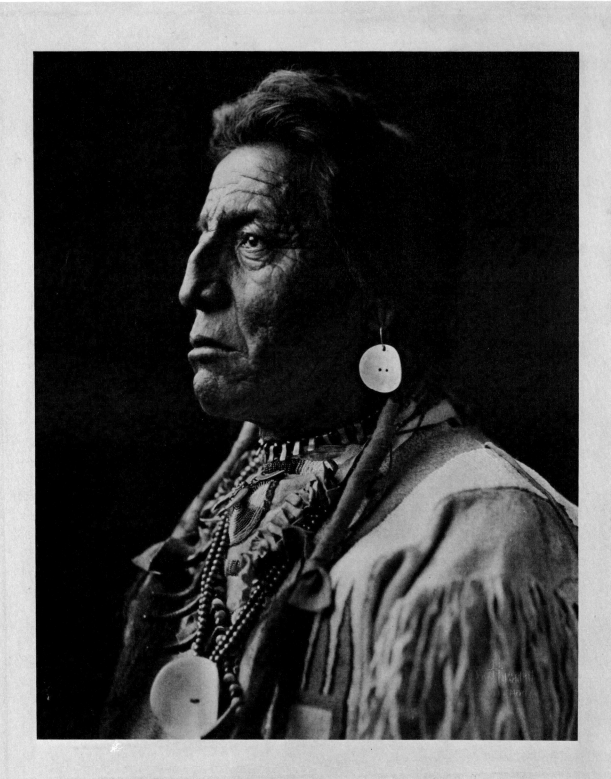

4

AS THEY WANTED TO BE SEEN

by M. Wesley Marans

PRESENCE. That's what it's all about. When I enter the foyer of my home there on the mantel rest several of my favorite signed photographs. They give me a sense of friendly communication with those people and they inspire me. Each is a self-contained bit of history.

I began to collect autographed photos in 1967. One of my best friends, a psychiatrist who treats troubled teenagers, bought at auction a very rare autographed photo of gangster Al Capone. The image, richness, and tone, together with the intriguing signature, had great impact – the photo exuded Capone's presence.

A few weeks later I was walking past Goodspeed's, the renowned dealer in books and autograph material at the top of Boston's Beacon Hill. There in the window were autographed photos of about thirty celebrities. I walked in, ascended to their second floor autograph department, and inquired about them. I was told that they had been collected by a history teacher from western Massachusetts who had written directly to the subjects asking for signed photos. Each was now for sale at three dollars, less if you bought a number of them.

I selected about fifteen that appealed to me and took them home. The more I studied them, the more fascinated I became. Most were made directly from the negative (as opposed to being a photograph of a photograph) and had a wonderful fidelity and vitality. The signatures and inscriptions gave them intimacy and warmth. I began to notice the characteristics of the pen strokes, the color of the ink, the pattern of the letters, the airiness or lack of it in the loops, the way the writing slanted, where on the photo the sitter wrote, as well as what he wrote, and the expression on his face. I asked myself why the sitter liked that particular pose. I found myself trying to visu-

TWO GUNS WHITE CALF (1872–1934)

Circa 1927. The quintessential Noble Red Man, Two Guns posed for the portrait on the Buffalo nickel in 1913. Note his totem signature: two guns and a calf.

alize what these people were doing as they signed. (I still do. That wonderful image of Tolstoy in peasant garb [page 51], for example – was he sitting on a hard bench writing on a bare wooden table in a cabin, as he lived in his later years?)

I returned several times to Goodspeed's in the next few weeks, buying about another twenty signed photos each time, taking them home and studying them. I was hooked.

The combination of the writing and the photograph gave me the sense of meeting each of these people. Many, perhaps most, were probably the subject's favorite photograph of himself, as it was the picture he chose to send to a friend or admirer. This gave the photos an added interest and historical importance, because they tell us how the individual saw himself and how he wanted to be seen by others. It was like a new art form.

I was fortunate that of the world's four largest autograph dealers, three were in the Boston area. Autographed photographs were but a small part of their inventory, the far larger part consisting of letters and documents written or signed by the famous dating back to 1500. I was delighted to find that for a reasonable amount of money I could buy major examples in this art form. It was as if a beginning collector of oil paintings found that Rembrandts were inexpensive and available.

Signed photos were then sold simply as autograph material, with no consideration given to the photographer's reputation. I found myself buying inexpensive photographs by Arnold Genthe, Edward Steichen, Julia Margaret Cameron, Philippe Halsman, George Platt Lynes, Cecil Beaton, Mathew Brady, Yousuf Karsh, Nadar, Camille Silvy, Hurrell, Arnold Newman, and Alfred Eisenstaedt. Almost all were in black and white or sepia, as even today most fine portrait photographers work in black and white, since color distorts and fades over the years. Most were in very good condition. This is characteristic of many signed photos: because they were autographed, the recipient handled them carefully. Some photos over one hundred years old look as fresh as if they had just been picked out of the developer.

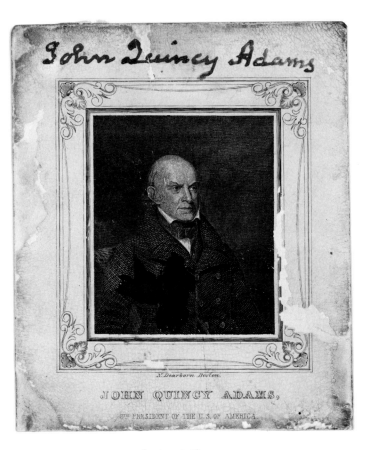

JOHN QUINCY ADAMS (1767–1848)

Circa 1825. The earliest signed image – an engraving – known to me of a United States president.

I bought whatever appealed to me. While there were collectors of signed photos in specialized categories – opera singers, composers, authors, royalty, and so on – hardly anyone was collecting in all fields. But I started to do so; anyone was fair game – with the exception of Nazis. (Germans of that era who turned against Hitler, however, were another matter. The collection includes Erwin Rommel, who paid with his life for his part in the attempted assassination of Hitler in 1944, and General von Choltitz, who defied Hitler's command to burn Paris.)

The collection now consists of over six thousand items from all over the world. Almost all have come from dealers or from auctions. Occasionally I trade and occasionally I find material at photographic shows or flea markets. (My daughter, now thirteen, has been going to flea markets with me since she was four, and this has been an amusing and educational way of spending time with a growing child.) Most of the best-known people from all areas of achievement since the invention of photography in 1839 are represented. For the great majority of those not represented, no autographed photo is known to exist. It would be virtually impossible for anyone today to come close to duplicating this collection, as in many cases the photographs just do not exist.

A major boost to the formation of the collection, improving it in both quality and quantity, occurred in 1971. Parke-Bernet (not yet a branch of Sotheby's) sold at auction the superb collection of autographed photos amassed by the Reverend Cornelius Greenway. Over the years he had written to celebrities all over the world asking each for an autographed photo to put up on his vestry walls. (Notice the numbers of photos in these pages inscribed to him.) He also had managed to acquire many rare and even unique signed photos dating back to the early days of photography. Most of the prices at the auction were low, and I was able to obtain most of the items that I really wanted.

At this point I became aware that I was now also an archivist. I had acquired a unique collection, and I had an obligation to take good care of and to keep safe for posterity what it had been my good fortune to acquire.

A word about prices. The financial value of an autographed photo is determined mainly by demand for the subject and by its rarity. The combined impact of the photo and the signature is very important: How penetrating, dramatic, even amusing, is the photograph? How legible and striking is the signature? An interesting inscription can add great value (see, for example, the illuminating inscriptions on the photos of Pavlov and Einstein on pages 40 and 45). Usually photos are more valuable

signed on the front than on the back. The reputation of the photographer is a factor, and, of course, the condition of the print.

Prices have increased dramatically since I began collecting in 1967, and the spectacular growth of interest in photography since the mid-1970s has fueled the rise. It may be useful to note a few current appraisals: The "Red Baron" – Von Richthofen – extremely rare, and a fresh and beautiful photo (page viii), is valued at $10,000. Signed Lincoln photos are generally about $7,500, but the one here (page i) has far greater value. It is in pristine condition, and is one of only two known autographed prints of this photograph, which Lincoln called his favorite. I intensely pursued the acquisition of either of these prints for eight years.

Some others: Gustave Mahler, $2,500; Annie Oakley, $1,500; Al Capone, $5,000 (pages 149, 29, 30). Signed photos of Sigmund Freud sell for $1,000–$1,500, but the one here (page iii), because it may be the only existing direct print of the most famous photograph of Freud, has a value of $2,500. Winston Churchill signed photos (page 82) are not scarce, but demand keeps their price at about $500. Music is the universal language, and collectors of all countries compete for signed photographs of composers, driving up their prices. If the photo also has musical notes in the hand of the composer (see Rossini, page 146), its value can increase substantially. Movie stars, especially of recent vintage, are fairly common and tend to be less expensive – $10 to $50. There has been a recent sharp rise in prices for silent film stars, and for deceased stars of more recent vintage, like Bogart and Monroe. The always elusive Garbo is still rare, and her photograph on page iv is valued at $2,000.

The practice of autographing photographic portraits came into vogue in the 1860s. Until then, people evidently simply did not think of signing images of themselves. There are no autographed engravings or etchings known of George Washington, Napoleon, or Goethe, for example. Portrait engravings were usually bound into books and thus were not sent to others. A handful of autographed engravings have appeared,

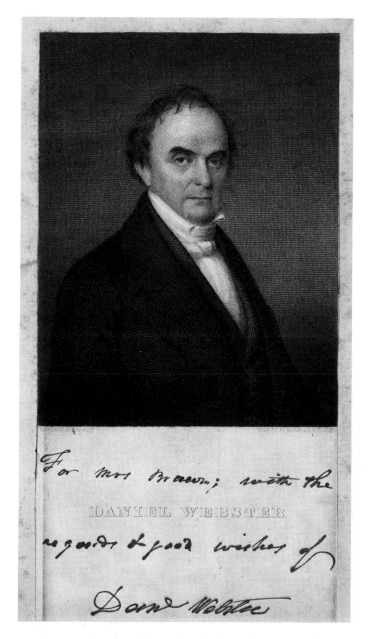

DANIEL WEBSTER (1782–1852)

Circa 1830. This may be the earliest autographed likeness of a celebrity with an inscription. Webster, the greatest orator of his time, was a staunch backer of President John Quincy Adams.

probably signed in the 1830s or 1840s, mainly of United States presidents of that time. Recently I acquired the earliest engraving I have seen with an inscription and sentiment – unfortunately undated – that of a youngish Daniel Webster (who was born in 1782).

The custom of autographing portraits came about with the development of photography. Daguerreotypes, from the process invented in 1839, were made on glass and could not be

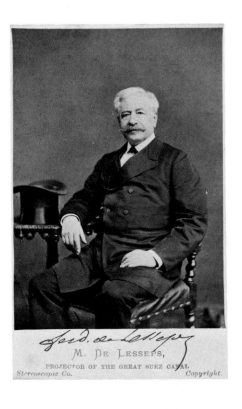

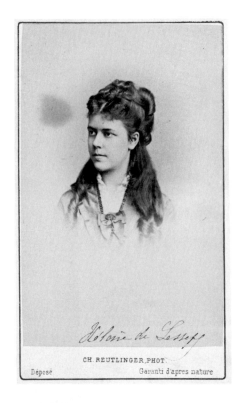

Circa 1870. A pair of cartes de visites of the creator of the Suez Canal and his wife. De Lesseps began to dream of piercing a canal through the Isthmus of Suez while in the French consular service in Alexandria in 1832; under his driving leadership, the first earth was turned in 1859, and the canal linking the Red Sea and Mediterranean was completed a decade later.

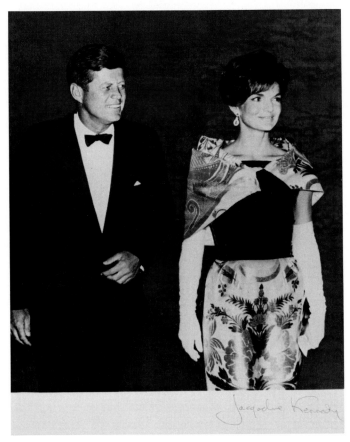

signed; moreover, each picture was unique. At virtually the same time that Daguerre was working on his invention, William Fox Talbot was developing a positive/negative technique, with images on paper that he called calotypes. With the possibility of multiple images, photographic portraits of notables began to appear in the late 1850s, especially after the development of the *carte de visite*, those small paper images, about the size of a visiting card, pasted on a mount. But the availability of the photograph and a paper ground to sign did not immediately start a vogue for autographed portraits. In 1862, huge numbers of *cartes de visite* of Barnum's great attraction, Tom Thumb, with his wife, were distributed, with their facsimile signatures printed on the back. Yet I have never heard of a photograph actually signed by Tom Thumb. Similarly, Charles Dickens, who died in 1870, is relatively common in autographed materials – letters and documents – but scarce in autographed photographs. Presumably he was rarely asked to sign

JOHN FITZGERALD KENNEDY (1917–1963) &
JACQUELINE BOUVIER KENNEDY (1929–)

Circa 1961. Camelot. The First Lady and her husband.

BASIL ZAHAROFF (1850–1936)

Dated 1919. Known as "the mystery man of Europe," this munitions manufacturer was accused of fomenting warfare and being a cause of World War I. He was so fearful for his life that until a very old age he did not allow himself to be photographed; this hitherto unknown photograph may be the only existing one of him at an earlier age.

>

Basil Zaharoff (signature)

Numa Blanc fils Monte-Carlo

1919

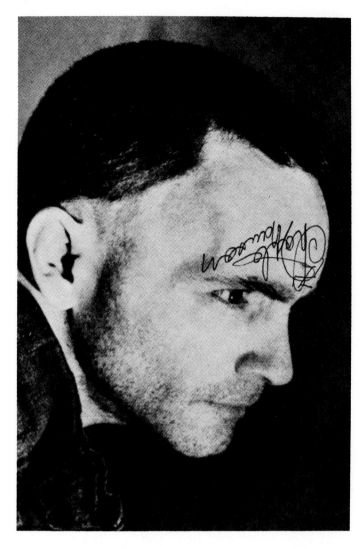

CHARLES MANSON (1934–)

Circa 1975. The photograph was signed while Manson serves a life sentence for the murders of seven people in 1969 by his fanatical followers.

them. The autographing of photos became more common with the increased publicity given to stage stars of the early 1890s, and came into flower with the silent screen. The admirer longed to get closer to his or her idol, and a signed photograph of the idol became prized.

There is very little forgery in autographed photos. Letters or documents provide more lucrative fields for the forger, although the recent case of the purported Hitler diaries demonstrates how the forger can be tripped up by factors like the age of ink, paper, and glue. Most important for handwriting is the experienced eye of the autograph dealer, who can, and will, guarantee the authenticity of signatures. The collector is usually interested in doing some research as well, and since these signatures are of well-known people, comparative mate-

rial is generally available in published sources. But collectors must beware of "secretarial" signatures, and in recent material, of the autopen. Secretarial signatures are more likely on photographs of celebrities like movie stars, who are often inundated with requests. The autopen is a machine that uses an actual pen, moving mechanically from a stylus pattern. Whole letters now can be written in the sender's handwriting. It was first used extensively by John F. Kennedy, a fact not discovered until years later, when it was noticed that some of his signatures turned up in exactly the same form again and again. Signatures are like fingerprints; no two are exactly alike.

I have become fascinated with signatures for the way they shed light on the personalities of these celebrated subjects. The slant, the pen pressure, the size, pattern, and interrelationships of the letters are revealing. It is also interesting to note graphological patterns within a given category. Dancers, for example, whose art evolves in space, tend to use much space in the loops of their *l*'s and *d*'s. Engineers and scientists usually write in a small, meticulous hand. Heavyweight boxers seem to start both their first and last names with a large capital, and then appear to get control of their aggressiveness and make the rest of their names considerably smaller. A bizarre personality like Charles Manson has, not surprisingly, a bizarre handwriting. Now when I know that a particular signed photograph is on its way to me, I visualize what the signature will look like. Many times I am quite correct.

ROY CHAPMAN ANDREWS (1884–1960)

Dated 1930. This American naturalist and explorer was especially famous for his travels in the then uncharted Gobi region of Central Asia, where he found perfectly preserved dinosaur eggs. On other expeditions into Manchuria, Tibet, China, Borneo, and Burma he discovered rich fossil fields and the remains of the *Baluchiterium*, the largest known land mammal. The photograph evokes the romance that a class of high school students must have associated with desert exploration half-a-century ago.

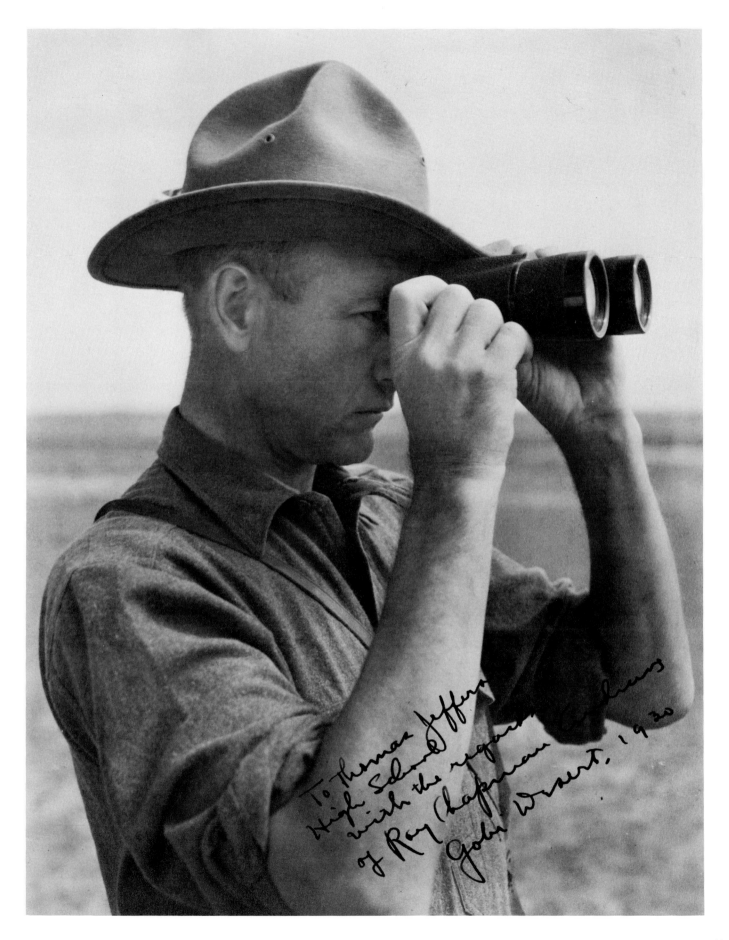

To Thomas Jefferson
High School with the regards of Roy Chapman Andrews
John Wisbert, 1930

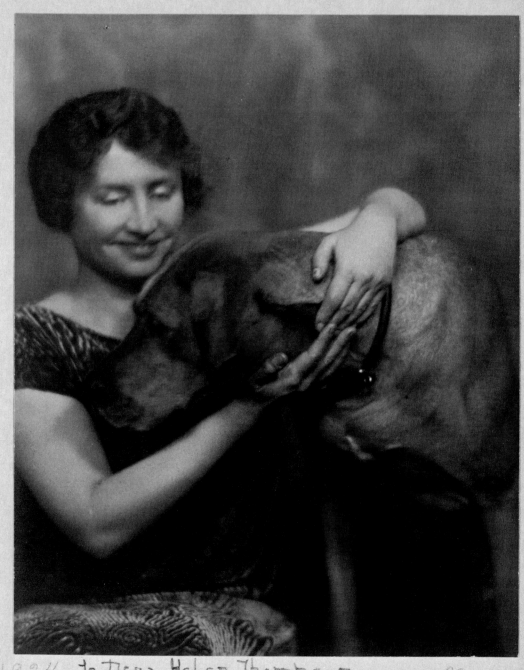

1924 to Dear Helen Thompson
with Love and greetings
From
Helen Keller
May. 1924 and Sieglinde.

HELEN KELLER (1880–1968)

Dated May 1924. This remarkable photograph by Nickolas Muray allows us to feel along with Helen the pulsations in the dog's neck, and enter for a moment her world.

Until 1981 I avoided publicity about my collection. I did not want to stir up competition, and moreover, I did not want to have to remove the collection from my home for security reasons (that, sadly, has now happened). In May 1981, however, I was asked to address an international convention of the Manuscript Society, to be held in Boston, on the emerging collecting field of autographed photographs. The Boston Athenæum held an exhibition of some 125 photographs from my collection at the same time. The exhibition, entitled "This Is My Favorite Photograph of Myself," had an extraordinary reception, going beyond Boston to the national, and even international, press. Then New York Graphic Society Books approached me about a book, with the results you see here.

A book, of course, is not a collection or an exhibition. The selection of the 380 photographs reproduced here is obviously a personal view of the collection as a whole. Although signed photographs of celebrities from the last thirty or forty years are usually more easily come by than those of earlier times, and in fact are well represented in the collection, the older photos are more heavily represented in this book. They tend to have more charm and much more impact, and they hold more interest for me both as portraits and as autographs. Today's autographed photographs are generally glossies – with that aura of public relations – and most are signed with ball-point or felt-tip pen. Neither instrument reveals the pen pressure, firmness of line, or other nuances in the way the older nib or fountain pen did; the earlier signatures usually have greater individuality. As for their appeal as photographs, the softer paper of the older images gives a warmth and subtlety. In the earliest, the slow film used forced the sitter to hold still for long exposures, resulting in poses of contemplation. For the purposes of this book especially, the older photos also often offer a sense of discovery in showing the less familiar face behind a name that reverberates from the past. Thus Nellie Melba appears on page 145, while Maria Callas remains tucked away in my portfolios.

Though I have tried to present meaningful historical groupings of representative figures from the past 130 years, this was not always possible within the limitations of a book. There are some strange companions on these pages, and there are gaps that could have been filled from the collection, but only by sacrificing some equally intriguing photograph or by reducing the scale of the reproductions.

I have found that the collection has greatly stimulated my interest in the individuals pictured, and I have read about them enthusiastically, acquiring an overview that has helped me to see how they fit into the jigsaw puzzle of relationships. The brief captions in the book are meant simply as reminders of the subjects' accomplishments, in some cases also giving peripheral information that may amuse.

As for the dates: "*Circa*" refers to the date of the photograph rather than of the autograph, and is usually derived from an estimate of the subject's age. "*Dated*" refers to an inscribed date, which may, of course, be later than the photograph. Precise dates are given when the year the photograph was made is known from external information.

Most of the photographs are signed on the front, but if the signatures and inscriptions are difficult to read in the reproduction the information is often given in the caption, or in the notes in the back of the book. When the photograph has been signed on the back, the signature and inscription, if any, are reproduced alongside.

A final word: This book is intended primarily to amuse. But as I turn the pages I am warmed and inspired by these reminders of what individuals can accomplish (for good or, in a few cases, for evil). These photographs present an enduring community of determination, of physical and spiritual courage, of intellectual and creative achievements.

Adventurers, Daredevils
& Outlaws

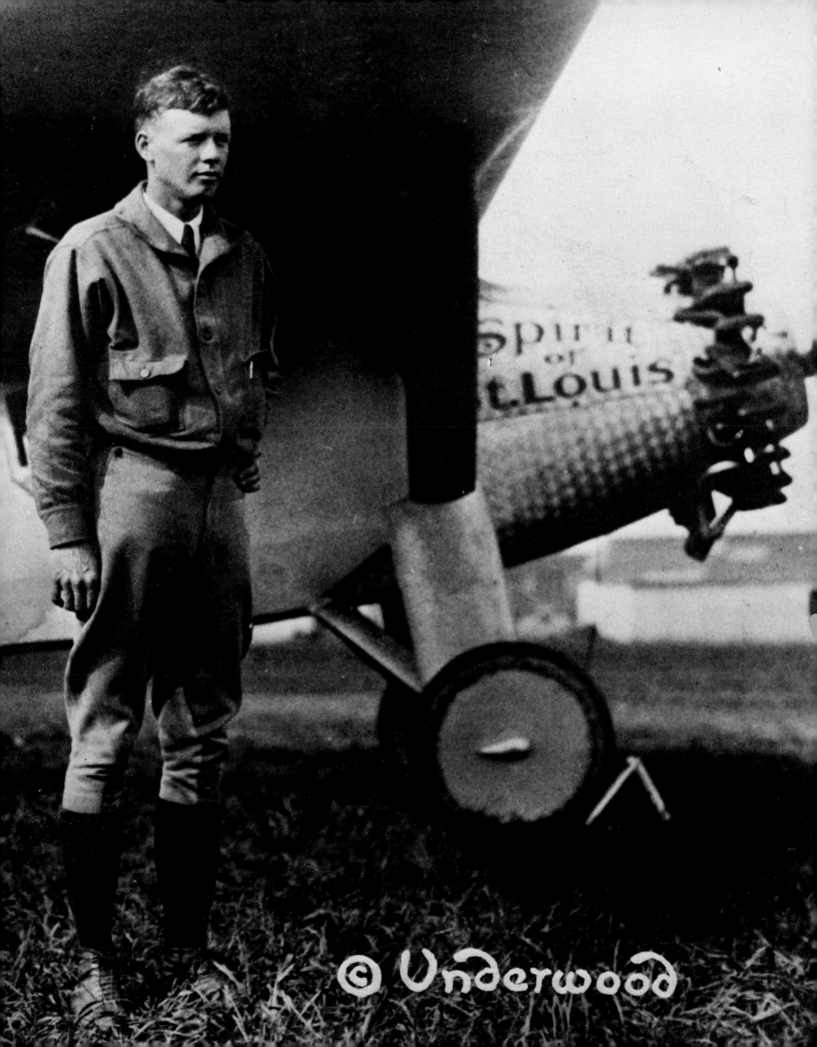

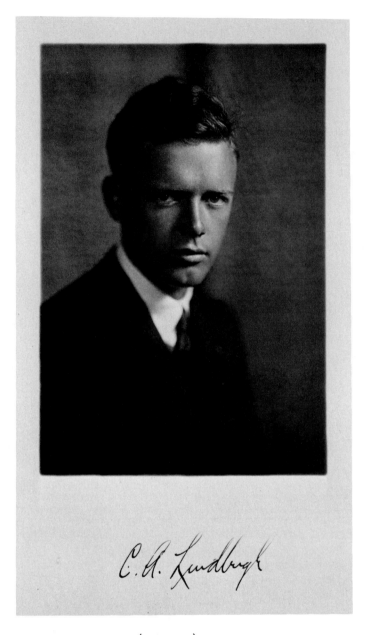

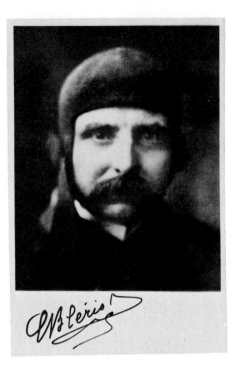

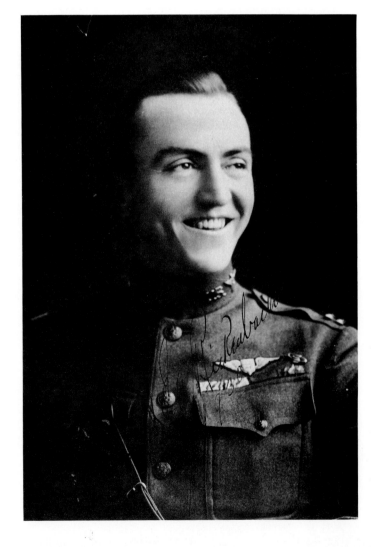

C. A. Lindbergh

CHARLES LINDBERGH (1902–1974)

Circa 1927. After making the first transatlantic flight, "The Last American Hero" surveyed the Pacific for the budding airline TWA, investigated the power of the Luftwaffe in 1936, worked with rocket pioneer Robert Goddard (page 44), flew combat in World War II, and was a Pulitzer Prize–winning author.

EDDIE RICKENBACKER (1890–1973)

Dated 1930 (but the photo is probably circa 1918). Before the war, America's leading World War I ace (twenty-six enemy craft shot down) had been internationally famous as a daredevil speed driver. He later became a very successful businessman, for many years president of Eastern Airlines.

OVERLEAF:

1927. Charles Lindbergh and *The Spirit of St. Louis.*

LOUIS BLÉRIOT (1872–1936)

Circa 1912. On July 25, 1909, Blériot made the first aerial crossing of the English Channel. The intense-looking Frenchman won a large cash prize for this feat of great courage, which made people aware for the first time that the airplane might become a formidable weapon of war.

<

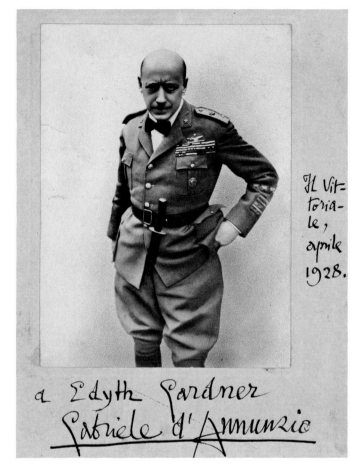

GABRIELE D'ANNUNZIO (1863–1938)

Dated 1928. The Italian poet and dramatist was a daring aviator whose sensational exploits during World War I lost him an eye. Famous as a lover as well as warrior and poet, his inamoratas included Eleanora Duse (page 182). D'Annunzio was an early supporter of Fascism, and was one of the few writers courted by Mussolini (page 90).

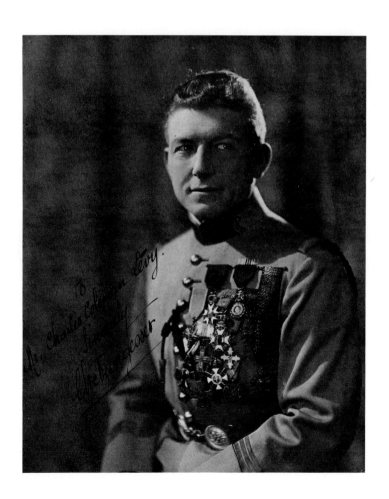

CHARLES NUNGESSER (1892–1927)

Circa 1925. The French World War I ace was credited with bringing down forty-five enemy planes. He was lost at sea in May 1927 while attempting to make the first transatlantic flight, just before Lindbergh's successful crossing, one of nineteen to die in the quest that year alone.

WILBUR WRIGHT (1867–1912)
ORVILLE WRIGHT (1871–1948)

Circa 1910. On December 17, 1903, near Kitty Hawk, North Carolina, they made the first controlled, sustained flights in a power-driven airplane. Record-breaking flights in 1908 by Orville in the United States and by Wilbur in France brought them worldwide fame. Wilbur (above, left) died in 1912 of typhoid fever, but Orville lived to see the extraordinary development of their invention.

COUNT FERDINAND VON ZEPPELIN (1838–1917)

Dated 1910. A German army officer, his great role was as inventor of the first rigid airship in 1900. The type that bore his name went into transatlantic passenger service, but the crash of the Hindenburg in 1937 brought the end of the service and of the zeppelins.

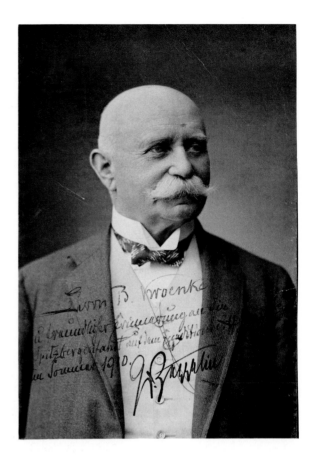

BLANCHE STUART SCOTT (1891–1970)

Circa 1910. On September 2, 1910, after taking a few lessons from Glenn Curtiss, she became the first woman pilot to solo. Scott became a stunt pilot but retired in 1916, frustrated by the lack of opportunities for women in aviation. Too little known, she has finally been honored on a 28-cent airmail stamp.

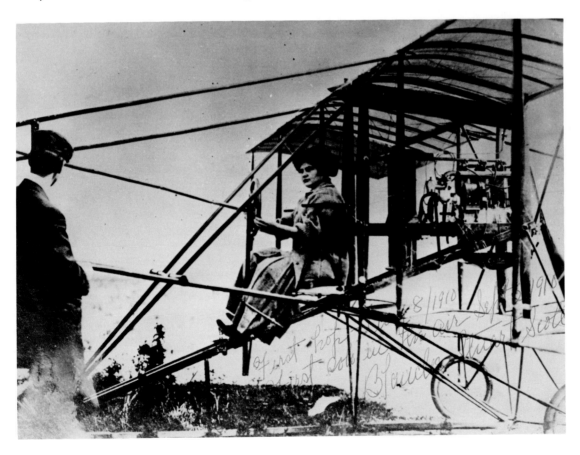

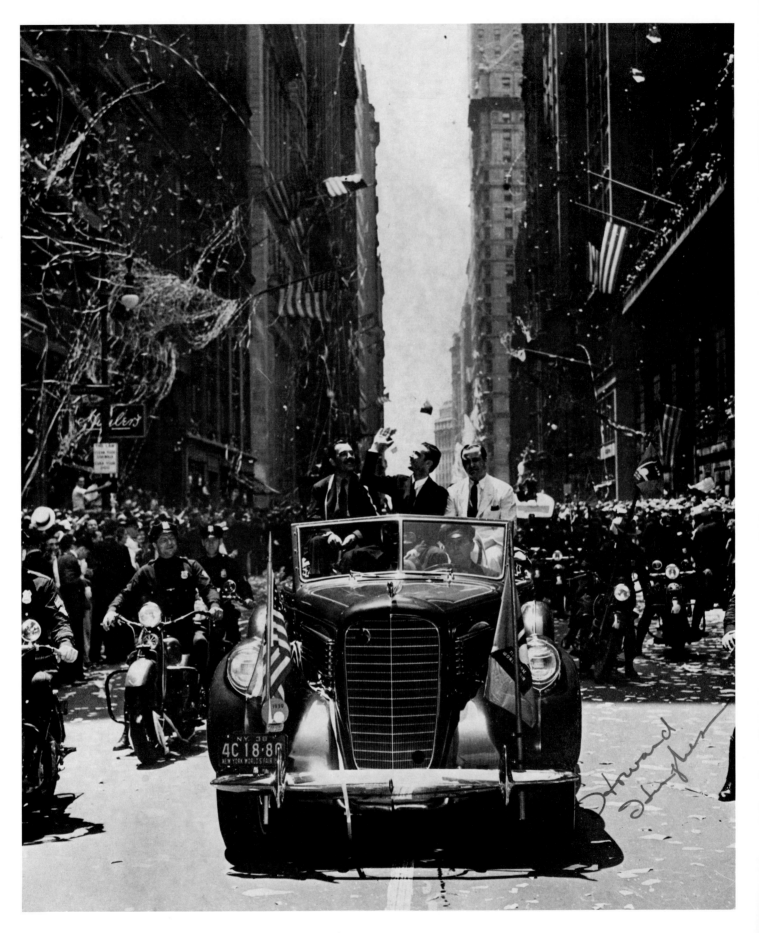

HOWARD HUGHES (1905–1976)

1938. Industrialist, aviator, motion-picture producer, and squire of beautiful women. Sadly, his later years were spent in seclusion. Very rare in an autographed photo, he is pictured here in a ticker-tape parade in New York in 1938 after he had set an around-the-world flight record of 3 days and 19 hours.

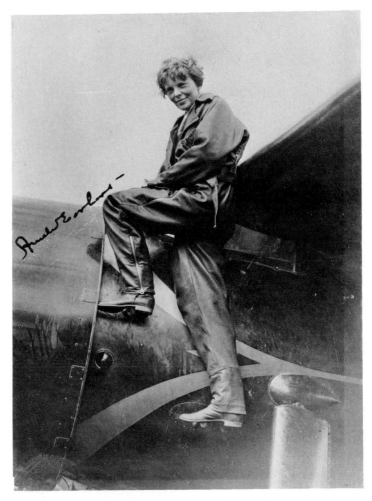

AMELIA EARHART (1898–1937)

Circa 1932. In 1932 she became the first woman to fly the Atlantic alone. Like Lindbergh, to whom she bore a striking resemblance, she captured the public imagination, and her mysterious disappearance over the mid-Pacific on a round-the-world flight in 1937 later caused speculation that she had stumbled on Japanese preparations for war.

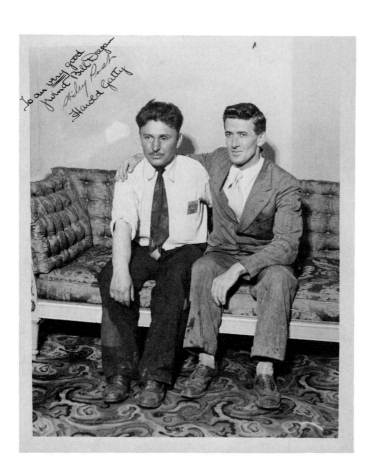

WILEY POST (1900–1935) & HAROLD GATTY (1903–1957)

Circa 1931. In 1933 Post became the first to circle the earth in solo flight. His time, 7 days and 19 hours, trimmed nearly a full day from the record he and Australian navigator Harold Gatty (at right) had set in 1931. Post died in 1935 on a pleasure flight to the Orient, carrying as a passenger his close friend Will Rogers. The grease-stained clothes and general scruffiness in the photo evoke the casual atmosphere of early flying days.

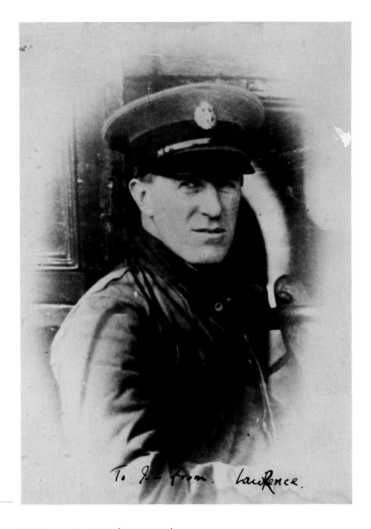

T. E. LAWRENCE (1888–1935)

Circa 1934. The young British archaeologist was assigned to instigate Arab harassment of the Turks during the First World War. Successful beyond his government's wildest dreams or desires, "Lawrence of Arabia" took up the cause of Arab nationhood. Developing an almost pathological aversion to publicity, he later sought anonymity under the name of Ross as a Royal Air Force mechanic, and then as a motorcycle driver named T. E. Shaw. (According to Charles Hamilton, the capital *R* in the signature is in another hand. Probably the recipient of the photo tried to clarify Lawrence's weak *r*.)

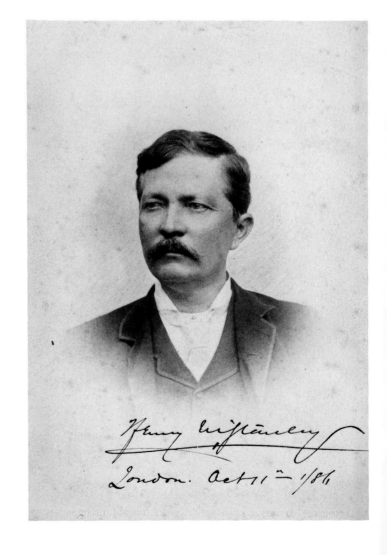

HENRY MORTON STANLEY (1841–1904)

Circa 1880. Sent to Africa on a newspaper stunt to locate someone who was not lost, Henry Stanley found him and spoke the immortal words: "Dr. Livingstone, I presume?" Stanley, English-born, is also notable for having fought on both sides during the American Civil War.

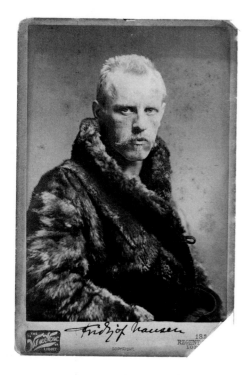

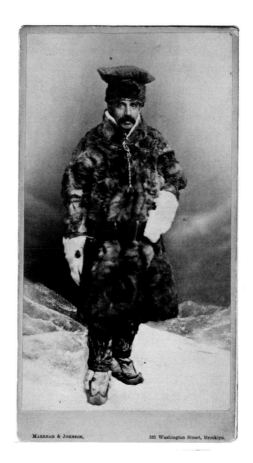

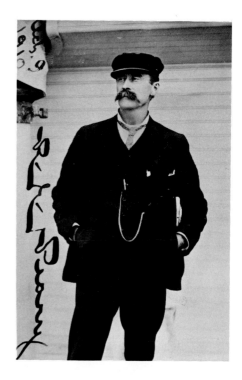

FRIDTJOF NANSEN (1861–1930)

Circa 1895. In 1895 Nansen and a companion reached a point on the Arctic ice within 225 miles of the North Pole. The publicity of this feat was the impetus for the great race to reach the top of the world. Nansen didn't make it, but he did win a Nobel Peace Prize in later life for his humanitarian work.

ROBERT E. PEARY (1856–1920)

Dated 1910. On April 6, 1909, he became the first man to reach the North Pole. On what he thought would be his triumphant return, Peary found that a rival explorer was claiming that he had been to the Pole first. This man was later discredited, and Admiral Peary's achievement officially recognized. His handwriting suggests the individuality and strength of character that took him to the top of the world.

PAUL BELLONI DU CHAILLU (1831–1903)

Dated 1880. Du Chaillu is principally remembered as an African explorer, and for introducing the first gorillas to American zoos. He is shown here equipped for his less-tropical travels in Scandinavia.

YURI GAGARIN (1934–1968)

Circa 1962. In 1961 the young Russian pilot rode a rocket into earth orbit, becoming the first man in space. Seven years later he died in a jet fighter crash.

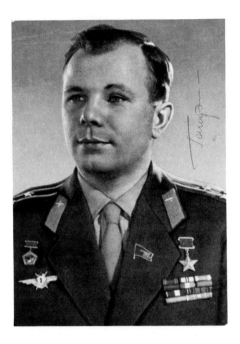

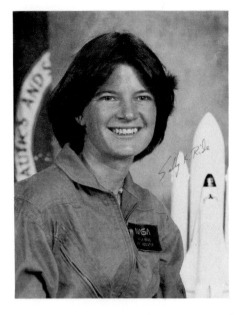

SALLY KRISTEN RIDE (1951–)

1978. The first American woman in space, tennis champion and astrophysicist Sally Ride is pictured here in the first year of her astronaut training. On June 23, 1983, she became the first person to retrieve a signal-receiving satellite from outer space.

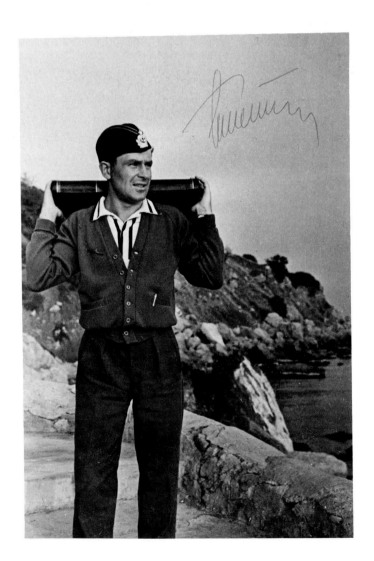

GHERMAN TITOV (1935–)

Circa 1962. Few people remember the second man to orbit the earth – also a Russian. He stayed aloft for a full day and became the first to eat and sleep in space.

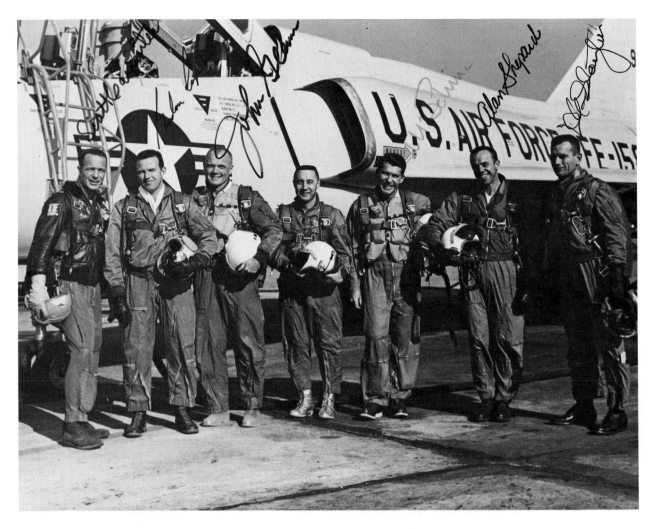

THE MERCURY ASTRONAUTS

Circa 1962. The first American astronaut team; signed by all except an isolated-looking Virgil Grissom, who would die in the 1967 Apollo launch-pad fire at Cape Kennedy. Alan Shepard was the first American to make a flight that escaped the earth's atmosphere, on May 5, 1961, reaching a peak altitude of 115 miles (ten years later he led the Apollo 14 expedition to the moon). John Glenn was the first American to make an earth orbital flight, on February 20, 1962. From the left: Scott Carpenter, Gordon Cooper, John Glenn, Virgil Grissom, Walter Schirra, Alan Shepard, Donald Slayton.

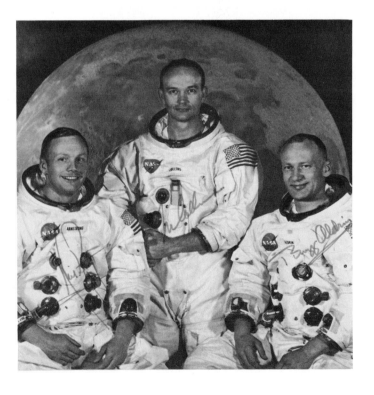

NEIL ARMSTRONG (1930–)
MICHAEL COLLINS (1930–)
EDWIN ALDRIN (1930–)

1969. America jumped ahead in the space race when Neil Armstrong took "one small step for a man" onto the lunar surface in 1969. Aldrin joined him to collect moon rocks while Collins tended the mother ship orbiting overhead.

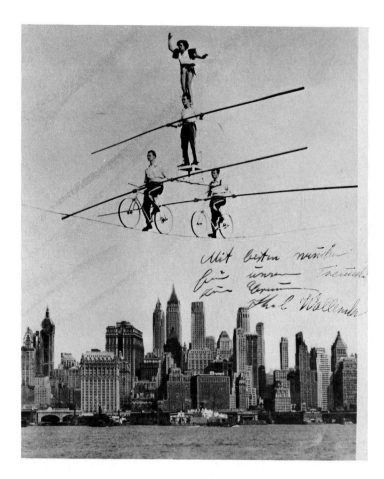

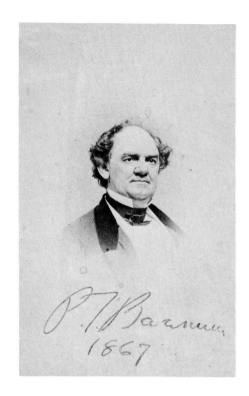

THE FLYING WALLENDAS

Circa 1945. The most spine-chilling act in circus annals, they received a showstopping ovation of fifteen minutes at their debut with Barnum and Bailey in 1928. Pictured here are Herman, Joe, Karl, and Helen. Karl, the leader, continued to perform until his death in 1978 in a fall while performing.

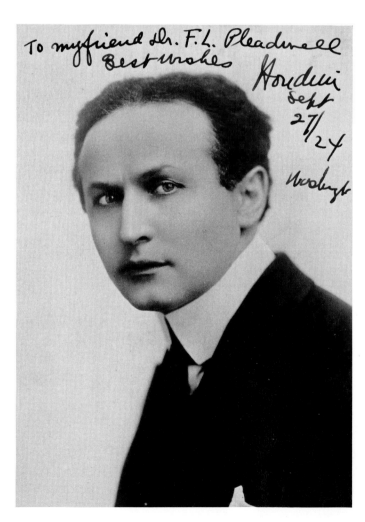

HARRY HOUDINI (1874–1926)

Dated September 27, 1924. The magician and escape artist who captured the world's imagination. Amid great publicity he extricated himself from ropes, straitjackets, and various locked containers. Born Ehrich Weiss in Wisconsin, he took his name from the French magician Jean Houdin. To Houdini magic was an art, and it is not surprising that he was active in exposing fraudulent mind readers and spiritualists.

PHINEAS T. BARNUM (1810–1891)

Dated 1867. A genius as a showman, he presented celebrities from Jenny Lind to Tom Thumb to the elephant Jumbo. He opened his circus, "The Greatest Show on Earth," in 1871, and joined with the competition to form Barnum and Bailey Circus in 1881.

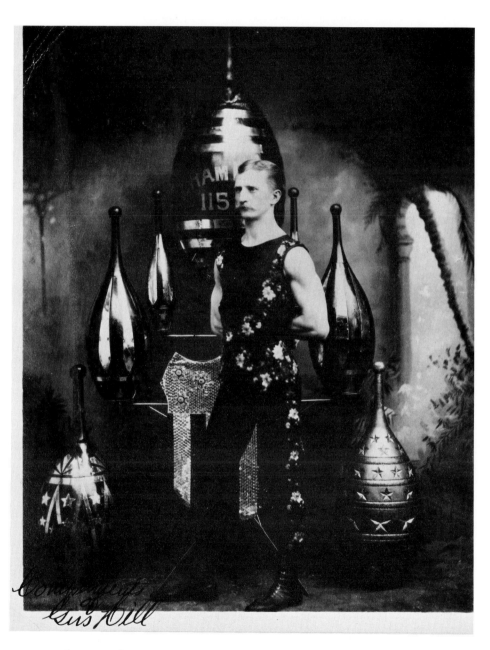

GUS HILL (1859–1937)

Circa 1890. The greatest vaudeville juggler of his time. He worked in his later years to revive vaudeville, and continued to practice "club-swinging" until the age of seventy-three.

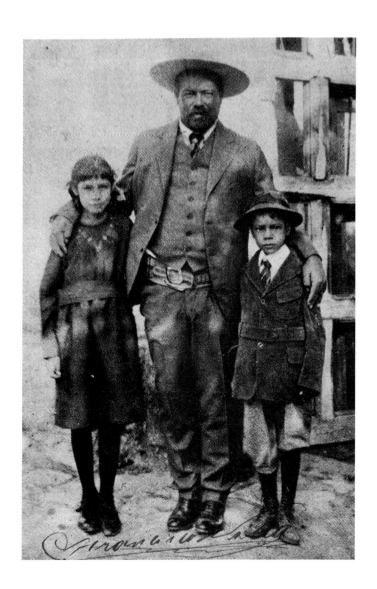

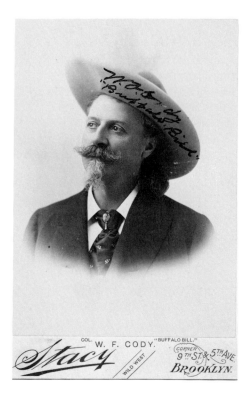

PANCHO VILLA (1877–1923)

Circa 1915. Signed "Francisco" (his first name). Daring, impetuosity, and horsemanship made this Mexican bandit and revolutionary leader the idol of the masses, who regarded him as a sort of Robin Hood. Assassinated at the age of forty-six, he is extremely rare in an autographed photo.

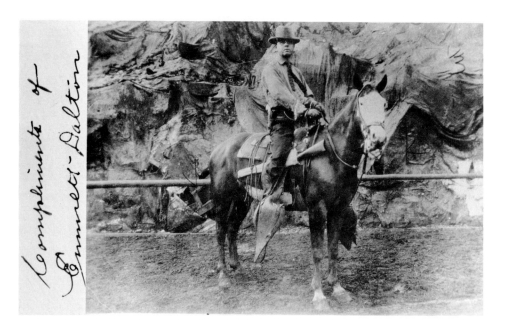

EMMETT DALTON (1871–1937)

Circa 1915. Bank robber. Train robber. The only survivor of the famous Dalton gang shootout at Coffeyville, Kansas, in 1892, he was sentenced to jail. Pardoned in 1907, he completely reformed and became a leading businessman in Los Angeles.

WILLIAM F. CODY (1846–1917)

Circa 1900. Civil War scout, and later Indian scout, he killed over 4,000 buffalo in 1867–68. Ned Buntline dubbed him "Buffalo Bill" and made him a popular hero. The highly successful Buffalo Bill's Wild West Show, which Cody organized in 1883, played to audiences in the East and in Europe, and featured Cody, Annie Oakley, and – briefly – Sitting Bull.
<

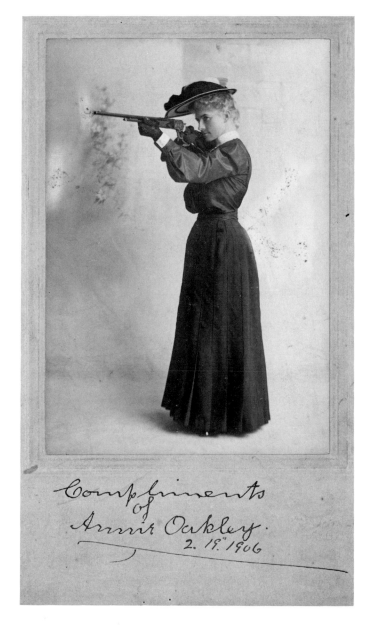

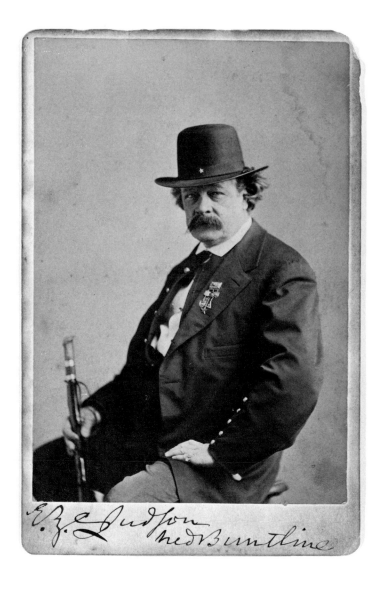

ANNIE OAKLEY (1860–1926)

Dated February 2, 1906. The feats of this pint-sized (4′11″) marksman were truly incredible. An international sensation traveling with Buffalo Bill's Wild West Show, she could split a playing card held on edge at thirty paces. She also shot cigarettes from her husband's mouth, and did so at royal insistence from the mouth of Crown Prince Wilhelm of Germany (page 83).

NED BUNTLINE (1823–1886)

Circa 1870. Adventurer extraordinary, known as "The Great Rascal." King of the dime novelists – he wrote over four hundred of them – he was also soldier, sportsman, roué, and inventor of the gun known as the Buntline Special.

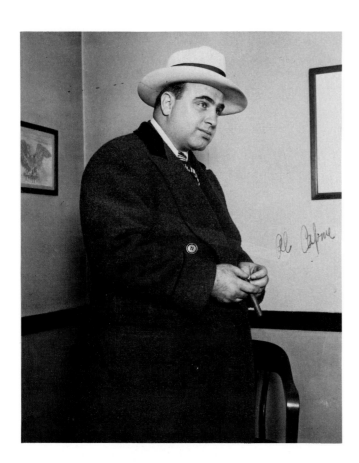

AL CAPONE (1899–1947)

Circa 1930. Kingpin of the mob, symbol of Chicago gangland in the Prohibition era; the Feds finally caught up with him and imprisoned him – for tax evasion.

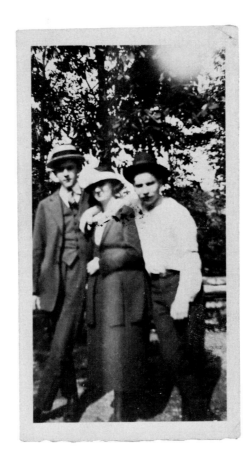

*1933
me – bonnie
and her brother
Jim – clyde*

BONNIE PARKER (1911–1934) &
CLYDE BARROW (1909–1934)

Dated 1933. This photo of the bank robbers (with Bonnie's brother Jim in the white shirt) was found in the trunk of their car after they were slain in a police ambush. The gory scene was the finale of Arthur Penn's memorable film, *Bonnie and Clyde*.

ALBERT ANASTASIA (1903–1957)

Circa 1935. The "reputed underworld leader" is all dolled up for
the camera. As a result of disagreements with his business associates,
his life ended suddenly and violently in a barber's chair.

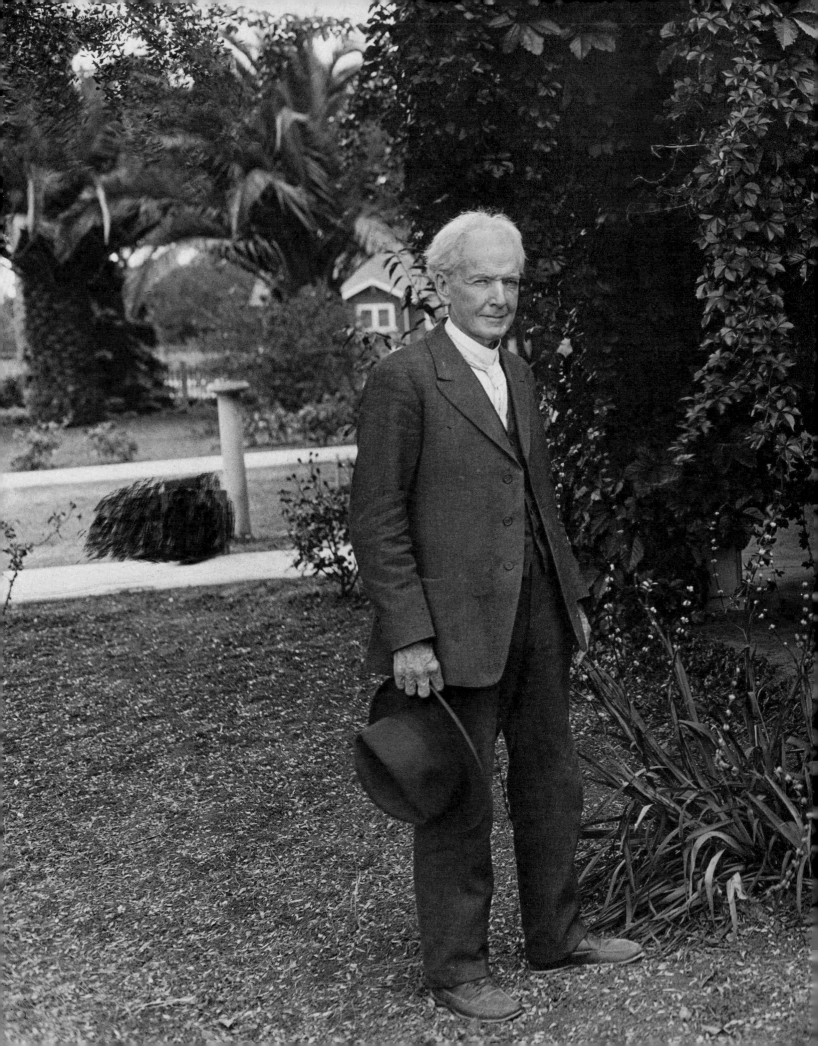

Scientists & Thinkers

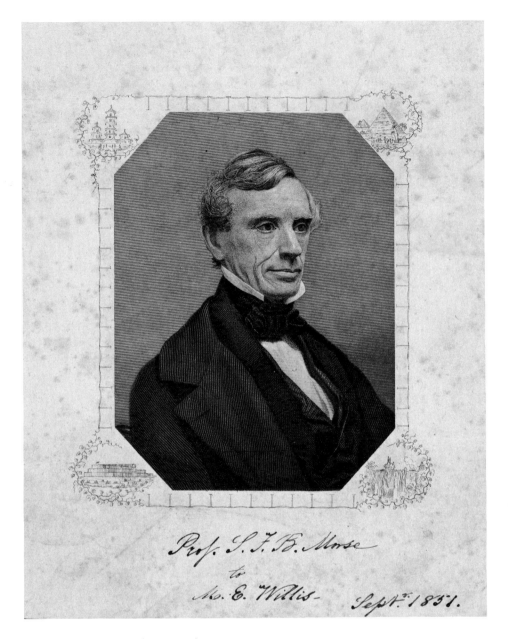

Prof. S. F. B. Morse to M. E. Willis — Sept.r 1851.

SAMUEL F. B. MORSE (1791–1872)

Dated 1851. He developed the telegraph and tapped out the first message, "What hath God wrought!" In a remarkable parlay of talents, Morse was also a very fine painter (one of his works recently sold for $3,200,000). Photography attracted him: within weeks of the arrival in America of Daguerre's instructions on his process, Morse sat his wife and daughter down in the sun to take their pictures. It was Morse who taught the process to Mathew Brady.

OVERLEAF:

Luther Burbank (see page 47).

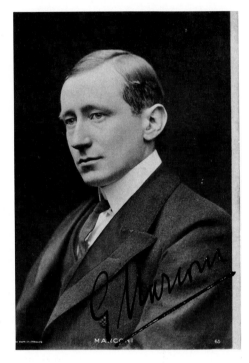

GUGLIELMO MARCONI (1874–1937)

Circa 1905. At first, businessmen and government leaders couldn't be bothered with this Italian scientist's demonstration that electrical signals could be sent through the air. But in 1901 his "wireless telegraph" created a world sensation by transmitting a message across the Atlantic Ocean.

THOMAS WATSON (1854–1934)

Dated February 1, 1927. "Mr. Watson, come here; I want you," were the first words heard on the telephone, spoken by Bell to Watson, his young assistant, on March 10, 1876. Watson went on to become a wealthy shipbuilder.

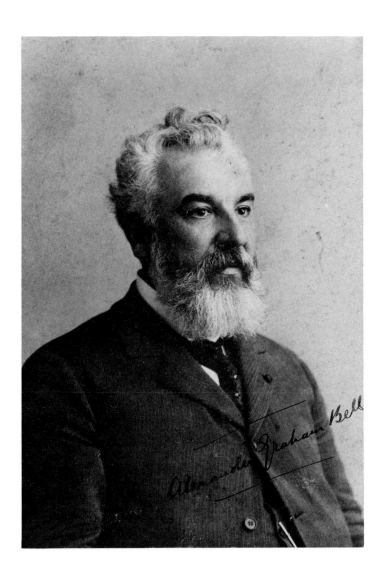

ALEXANDER GRAHAM BELL (1847–1922)

Circa 1905. Pa Bell. An authority on speech correction who made important contributions to the education of the deaf, he invented the telephone in his spare time.

THOMAS EDISON (1847–1931)

Circa 1910. The genius of technology, inventor of the light bulb and phonograph, pioneer in motion pictures. Note his famous "umbrella" signature.

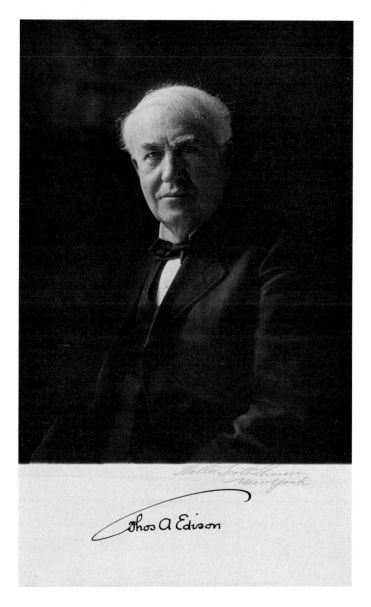

LOUIS PASTEUR (1822–1895)

Circa 1886. In the 1850s he rescued the beer and wine industries of France from bacterial contaminants with a process called pasteurization; the application of the process to milk prevented many diseases. Pasteur is also remembered for the first rabies vaccine, which ended the worldwide fear of mad dogs, but perhaps his most significant achievement was to prove that all living things, even tiny bacteria, have parents.

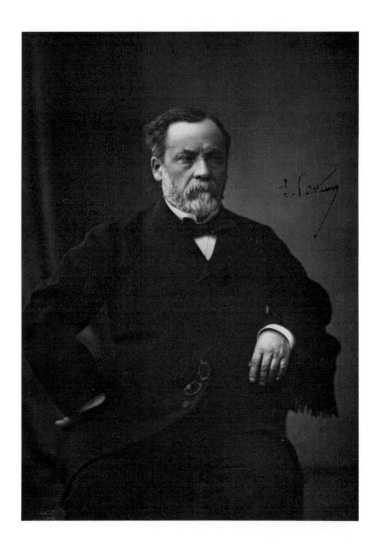

PAUL EHRLICH (1854–1915)

Circa 1911. The German medical scientist who discovered the first cure for syphilis (an achievement that made a surprising subject for a Hollywood movie, *Dr. Ehrlich's Magic Bullet*, with Edward G. Robinson). A beautifully lit portrait, signed boldly on a light area of the coat.

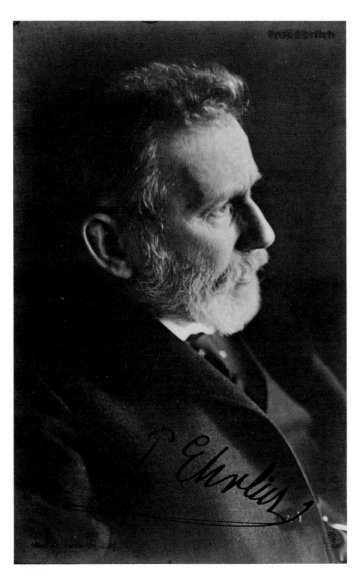

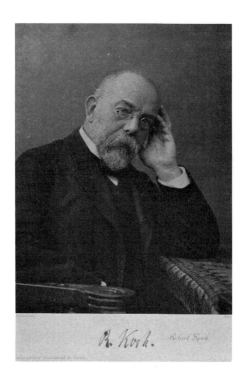

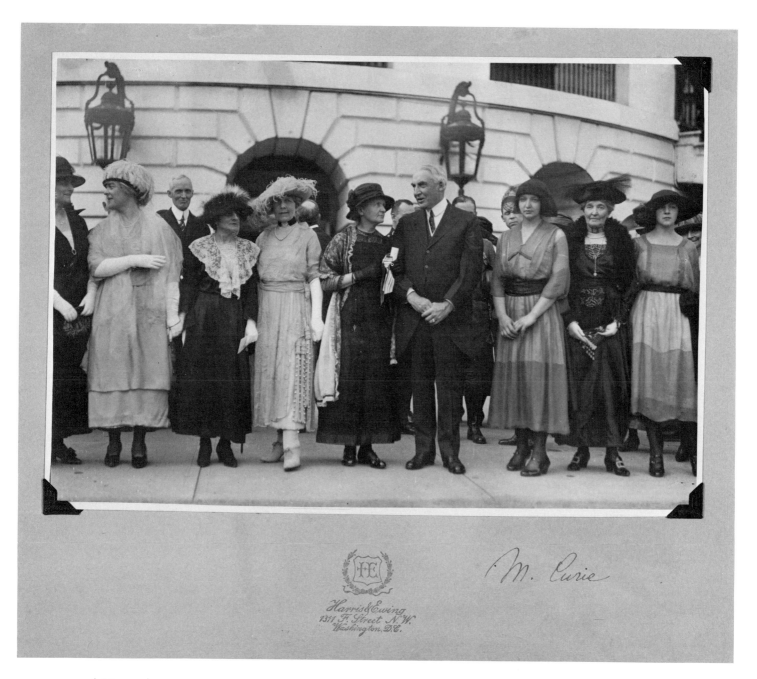

Harris&Ewing
1311 F Street N.W.
Washington, D.C.

M. Curie

MARIE CURIE (1867–1934)

1921. The discoverer of radium, Nobel Prize winner in both physics and chemistry, one of the most admired women of her time. She is seen here with U.S. President Warren G. Harding; the occasion is the presentation of a gift from American women of one gram of radium for the Curie Institute.

ROBERT KOCH (1843–1910)

Circa 1905. A German physician and pioneer in the science of bacteriology, Koch was the first to track down the microorganisms responsible for tuberculosis, anthrax, dysentery, and cholera. Certainly a worthy recipient of the Nobel Prize for medicine (1905).

<

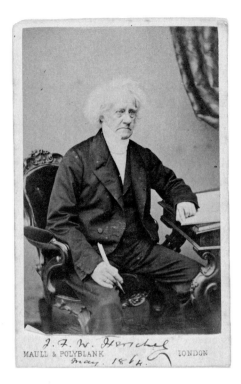

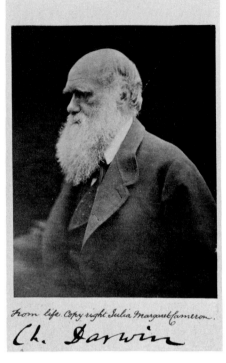

JOHN HERSCHEL (1792–1871)

Dated May, 1864. Son of the English astronomer William Herschel, who discovered the planet Uranus, John Herschel was a renowned astronomer and physicist. Following in his father's footsteps, he moved to South Africa to map the southern skies, and later made important contributions to the development of photography.

ROBERT BUNSEN (1811–1899)

Circa 1865. Famous for the Bunsen burner used in scientific laboratories, the accomplished German chemist also discovered an antidote to arsenic poisoning.

CHARLES DARWIN (1809–1882)

Circa 1872. The great naturalist by a great photographer, Julia Margaret Cameron. Early in his life Darwin studied medicine and prepared for the ministry – two fields he would later turn upside-down with his evolutionary theories. The entire first edition of *On the Origin of Species by Means of Natural Selection* (1859) is said to have sold out in one day.

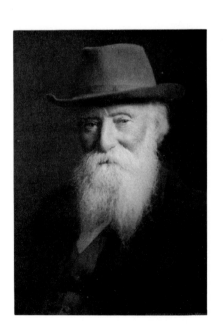

JOHN BURROUGHS (1837–1921)

Circa 1909. Known as the "Sage of Slabsides," after his cabin in the Hudson River valley, Burroughs was a philosopher-naturalist who lived and wrote after the manner of Thoreau, and camped with the likes of Walt Whitman, Edison, Ford, and Theodore Roosevelt.

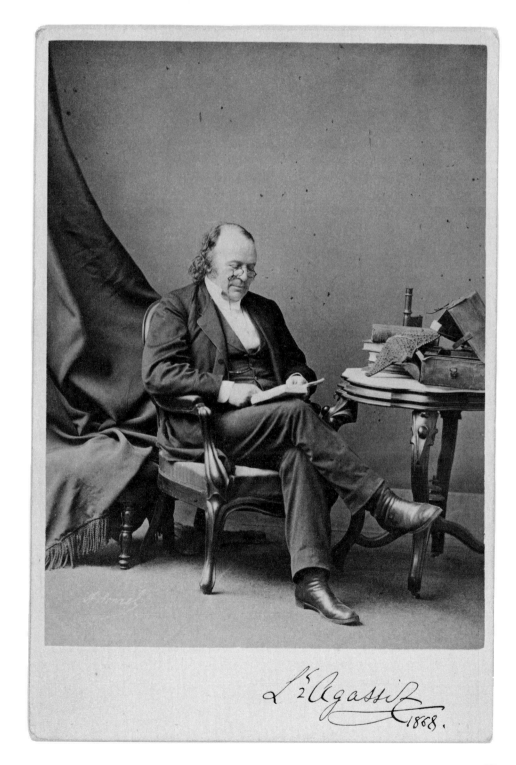

LOUIS AGASSIZ (1807–1873)

Dated 1868. In 1840 he came to the remarkable conclusion that great sheets of ice once covered most of Europe and North America. Agassiz was one of the most innovative scientists of his day, yet he was unsympathetic to the revolutionary ideas of his colleague Charles Darwin. His most important contribution may have been as an educator: a professor at Harvard, he stimulated interest in natural history and introduced vivid teaching methods that had a lasting effect on American education.

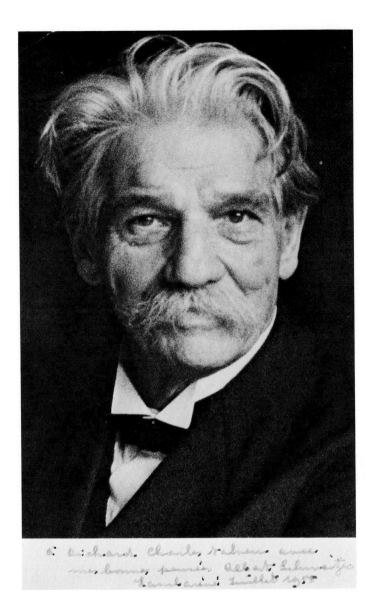

ALBERT SCHWEITZER (1875–1965)

Dated July 1955. Schweitzer was already a world figure in theology and music when, at the age of thirty, he resigned his university appointments to become a mission doctor in Africa. He was awarded the 1952 Nobel Peace Prize for his efforts in behalf of "the Brotherhood of Nations."

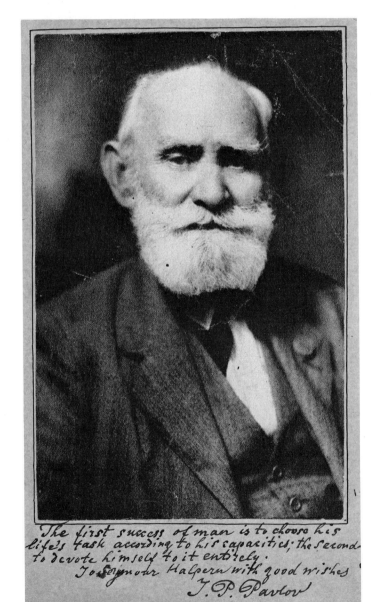

IVAN PAVLOV (1849–1936)

Circa 1925. The Russian physiologist is best known for the hungry dog he trained to salivate at the sound of a bell, introducing the concept of the conditioned reflex. The inscription reads: "The first success of man is to choose his life's task according to his capacities; the second – to devote himself to it entirely."

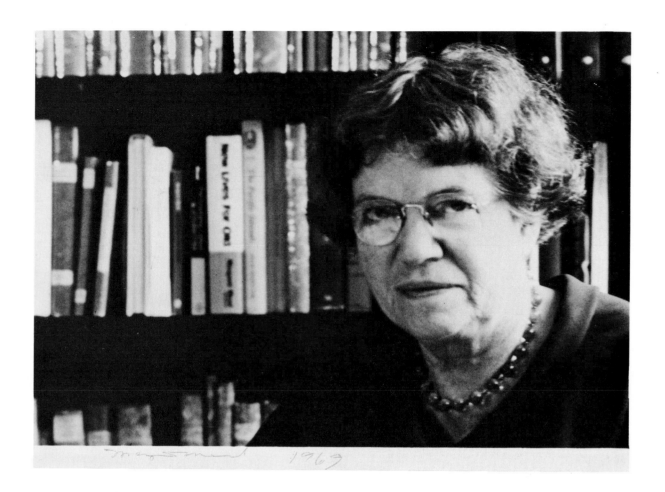

MARGARET MEAD (1901–1978)

Dated 1969. The controversial anthropologist made her reputation – and was able to sell a large number of books – on the subject of sexual mores in the South Pacific.

HAVELOCK ELLIS (1859–1939)

Dated December 1935. His seven-volume *Studies in the Psychology of Sex*, published at the turn of the century, was the first thoroughly scientific work on sexual behavior. The courts, however, disagreed, calling its scientific basis "a pretense, adopted for the purpose of selling a filthy publication."

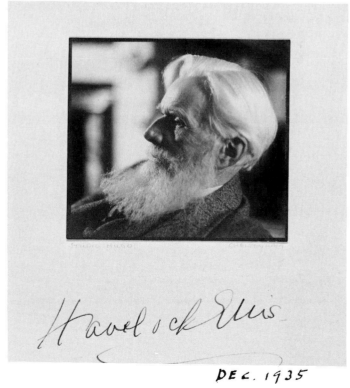

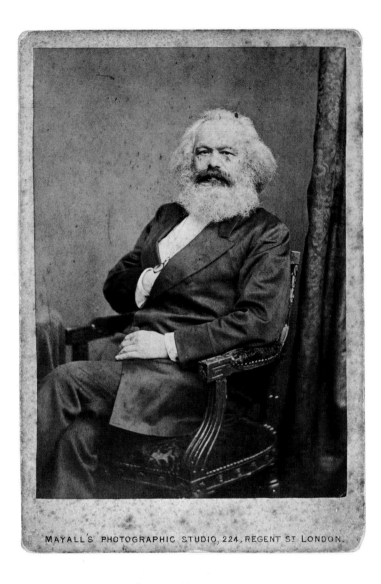

MAYALL'S PHOTOGRAPHIC STUDIO, 224, REGENT ST LONDON.

Madame James M. Williamson

with the wishes for a happy new year

Karl Marx

Ventnor 7 January 1883

KARL MARX (1818–1883)

Circa 1878. The German social and political philosopher whose writings form the theoretical basis of Communism. He attacked the injustices of the early industrial society, frequently urging aggressive policies. Exiled from most continental centers, he settled permanently in London in 1849. Marx long lived in poverty so bitter that it caused the death of several of his children. This photo by Mayall was inscribed just two months before his death to the wife of his physician on the Isle of Wight. (Signed on verso.)

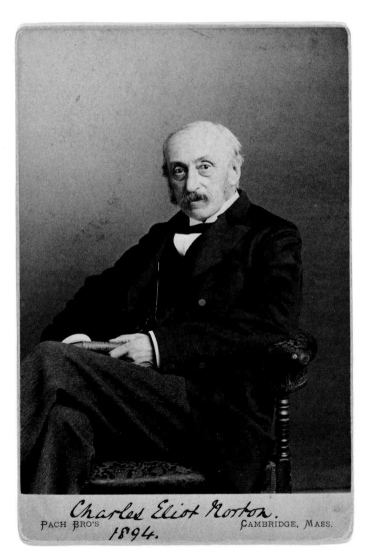

PACH BRO'S CAMBRIDGE, MASS.

Charles Eliot Norton.
1894.

CHARLES ELIOT NORTON (1827–1908)

Dated 1894. This versatile man of letters from Boston taught art history at Harvard, translated the works of Dante, and founded the political periodical *The Nation*.

RACHEL CARSON (1907–1964)

Circa 1963. In 1962 her book *Silent Spring* was a lone and powerful voice warning against the dangers of environmental pollution.

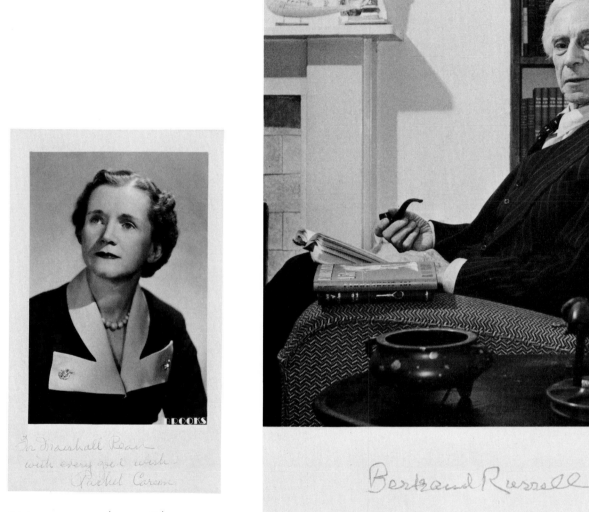

Bertrand Russell

BERTRAND RUSSELL (1872–1970)

Circa 1950. The most famous atheist of his day, he was also one of its most outstanding philosophers. His greatest influence was in mathematical logic, which he virtually abandoned at the time of the First World War to take up (and get jailed for) the causes of pacifism and social reform.

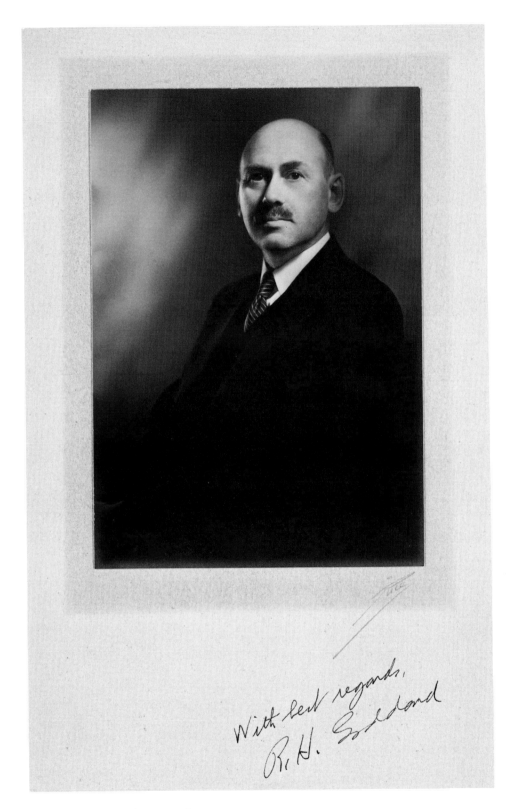

With best regards,
R. H. Goddard

ROBERT GODDARD (1882–1945)

Circa 1930. In 1926 he launched the world's first liquid fuel rocket – the forerunner of the great space vehicles of today. "Moonie" Goddard's predictions of travel beyond the earth met with high public amusement.

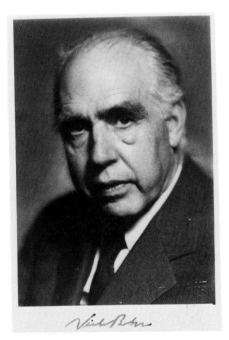

NEILS BOHR (1885–1962)

Circa 1950. One of the pioneer explorers of the subatomic world of the quantum, the Danish physicist had a running debate with Einstein on the meaning of these discoveries for our understanding of the universe and our place in it.

ALBERT EINSTEIN (1879–1955)

Dated 1933. The foremost theoretical scientist of this century. Einstein was deprived of his German citizenship not long after writing a scathing denunciation of the Nazi mentality in 1933. He inscribed this photograph expressing his ardent anti-fascist sentiments that same year.

>

The man who enjoys marching in line and file to the strains
of music falls below my contempt; he received his great brain by
mistake — the spinal chord would have been amply sufficient.
Albert Einstein. 1933.

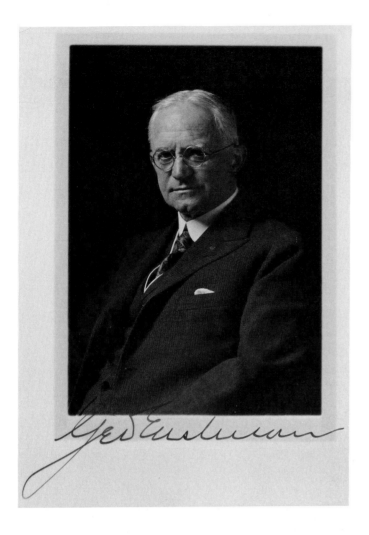

Circa 1915. "You press the button; we do the rest" was the slogan for his 1888 model Kodak camera. After the owner had shot the factory-installed film, he simply mailed in the entire camera and received his developed pictures (and his reloaded camera) by return mail. It was a social revolution as well as a scientific one.

EDWIN LAND (1909–)

Circa 1955. In 1948 the brilliant inventor demonstrated the Polaroid instant picture – a black-and-white photograph that miraculously developed itself. Fourteen years later he accomplished the same feat for color film. Needless to say, this is a Polaroid photograph.

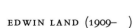

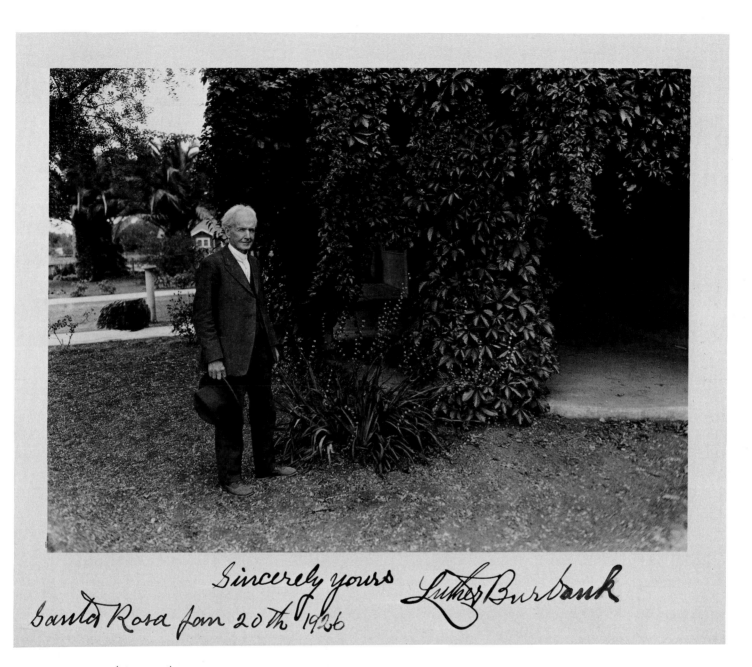

Sincerely yours *Luther Burbank*

Santa Rosa Jan 20th 1926

LUTHER BURBANK (1849–1926)

Dated January 20, 1926. "The farmer's Edison" is shown here in his lifelong laboratory – the garden. His remarkable experiments made plant breeding a modern science, and gave us the Burbank potato, the Shasta daisy, and over eight hundred other varieties of plants.

Writers

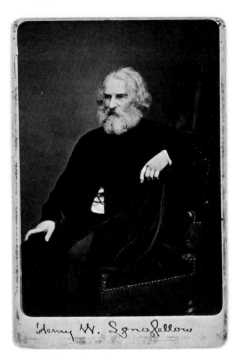

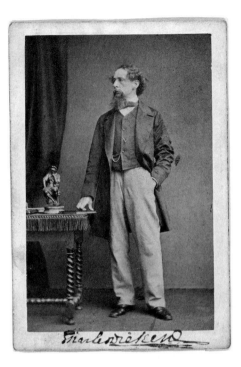

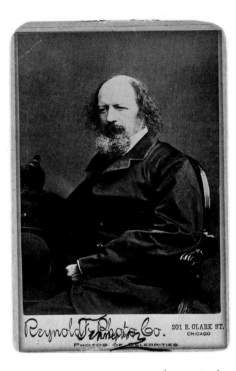

HENRY WADSWORTH LONGFELLOW
(1807–1882)

Circa 1874. Well-loved New England poet, the American counterpart to Tennyson; his best-known poem is "The Village Blacksmith," wherein the smithy stands under a spreading chestnut-tree.

CHARLES DICKENS (1812–1870)

Circa 1868. The brilliant chronicler of social ills, and creator of Scrooge, Oliver Twist, Nicholas Nickleby, and Little Nell, he used to say that his characters appeared to him as he wrote, holding lengthy conversations among themselves.

ALFRED, LORD TENNYSON (1809–1892)

1892. Melancholy poet laureate of Great Britain from 1850 until his death, he is remembered particularly for the stirring "Charge of the Light Brigade."

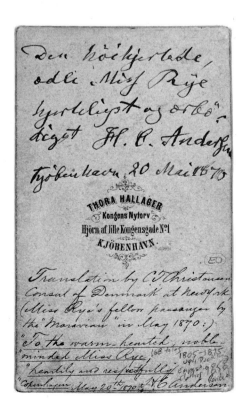

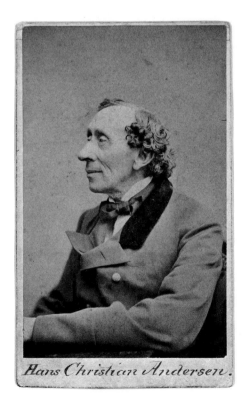

HANS CHRISTIAN ANDERSEN
(1805–1875)

Dated May 20, 1870. Unlike his hopelessly Grimm competitors, Andersen always gave his fairy tales a gentle moral: "The Emperor's Clothes" and "The Ugly Duckling" taught the follies of vanity and intolerance. (Signed on verso.)

COUNT LEV NIKOLAYEVICH TOLSTOY (1828–1910)

Dated December 12, 1905. The towering Russian novelist, like his character Levin in *Anna Karenina*, spent much of his long life worrying about such things as morality, Christianity, and the nature and consequences of love. He managed to support a brood of ten children and a large country estate with the royalties from his immensely popular novels, but in his later years Tolstoy (here in peasant garb) took to the Spartan life and celibacy he describes in his essays.

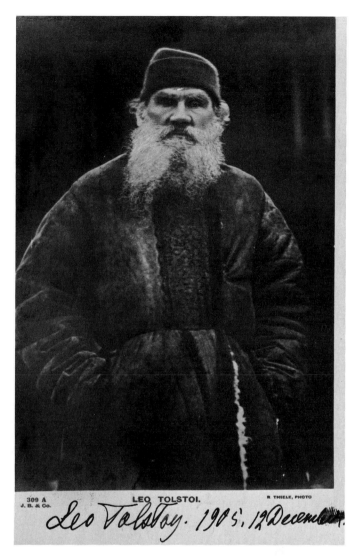

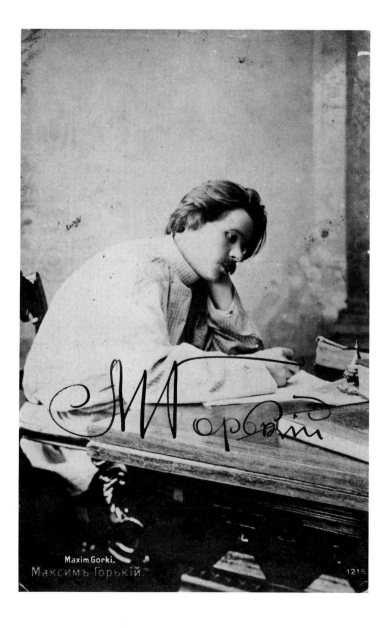

MAKSIM GORKI (1868–1936)

Cira 1906. The grim writer Aleksei Maksimovich Peshkov chose a pen name that means "the bitter one" – not surprising, since he was orphaned and sent to work as a dishwasher on a Volga steamer at the age of nine. As the first Russian writer to emerge from the lower classes, he was a sometime favorite of the Bolsheviks; but not of Stalinists, who ordered him killed in 1936. Detail of signature, overleaf.

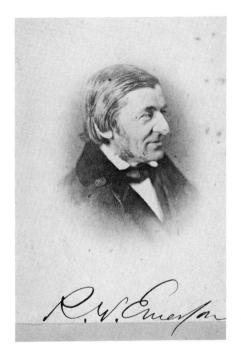

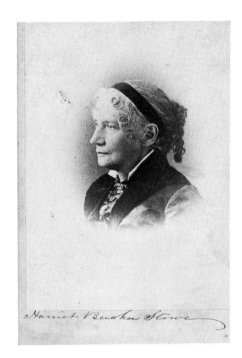

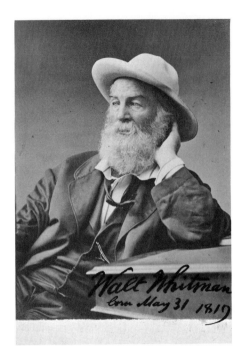

RALPH WALDO EMERSON (1803–1882)

Circa 1860. "The Sage of Concord"; American poet, essayist, and philosopher, who somehow remained an optimist despite the frequent company of Thoreau, Melville, and Hawthorne.

HARRIET BEECHER STOWE (1811–1896)

Circa 1876. Daughter of a clergyman, sister of a clergyman (page 52), wife of a clergyman, all abolitionists. Author of *Uncle Tom's Cabin*, the story of a faithful black slave and his villainous overseer, Simon Legree – the book credited with helping to precipitate the Civil War. She claimed that God wrote it, and she merely took dictation.

WALT WHITMAN (1819–1892)

1872. The enigmatic, egocentric, and sexual libertarian poet who astonished the literary world in 1855 with *Leaves of Grass*. The secretary of interior condemned it as "immoral," but Emerson said, "I greet you at the beginning of a great career." Whitman was one of the most photographed men of the nineteenth century, recognizing the publicity value of the medium.

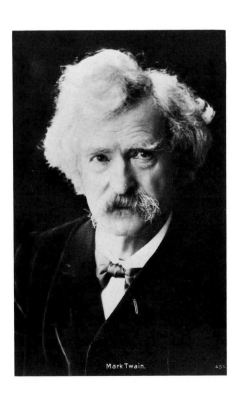

CARL SANDBURG (1878–1967)

Circa 1930. After leaving school at age thirteen, Sandburg toured the West as a hobo, fought in the Spanish-American War, and then settled down as a poet, biographer, and journalist. The first part of his famous biography of Abraham Lincoln appeared in 1926, and the second won him the Pulitzer Prize in 1939.

>

MARK TWAIN (1835–1910)

Circa 1900. Samuel Langhorne Clemens, the sometime riverboat pilot and sometime Wild West reporter, took as his pen name the Mississippi riverboat term for "deep water." Critics have been plumbing the depths of his *Tom Sawyer* and *Huckleberry Finn* ever since.

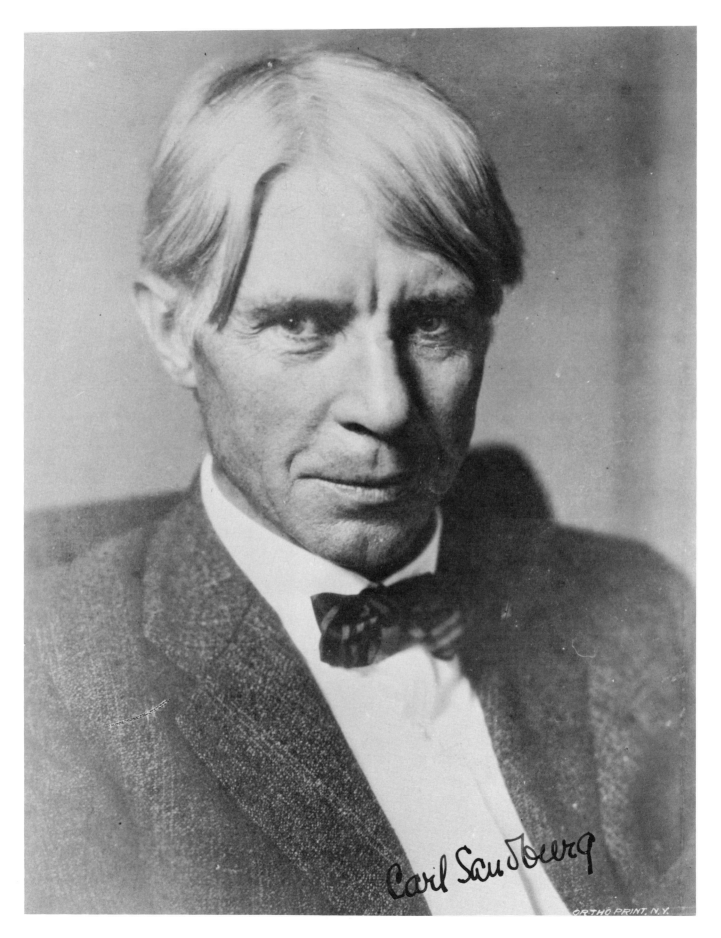

Carl Sandburg

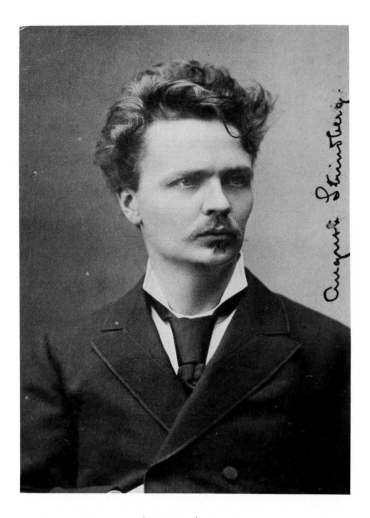

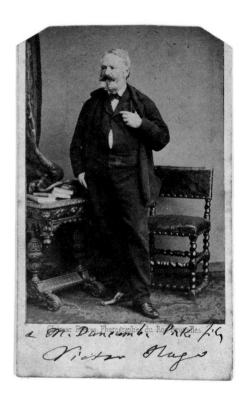

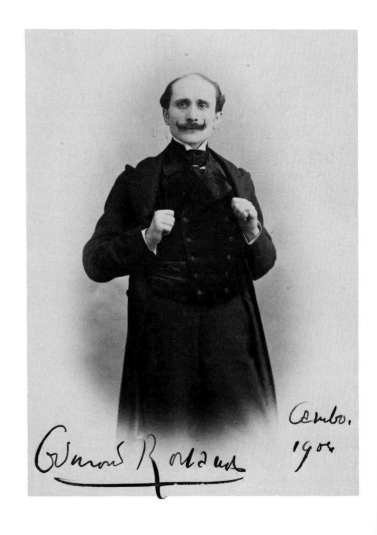

AUGUST STRINDBERG (1849–1912)

Circa 1890. The Shakespeare of Sweden – experimental playwright, novelist, and poet, who, like Zola, was both realistic (once jailed for blasphemy) and prolific (55 volumes). His three marriages to "emancipated" women apparently provided considerable inspiration to his obsessive theme of the battle – frequently to death – of the sexes. When the British theatrical manager Robert Lorraine read *The Father* to his wife, she interrupted by falling to her knees and swearing their children were all his.

EDMOND ROSTAND (1868–1918)

Dated 1906. He wove historical dramas around historical fact, never more successfully than in the enormously popular *Cyrano de Bergerac*, based on the figure of a seventeenth-century duelist and writer; *L'Aiglon*, one of Bernhardt's most famous vehicles, is the story of Napoleon's son.

VICTOR HUGO (1802–1885)

Circa 1870. Revered French poet, novelist, and romantic; author of *Les Misérables* and *The Hunchback of Notre Dame*, from which sprang a succession of grotesque Hollywood Quasimodos.

<

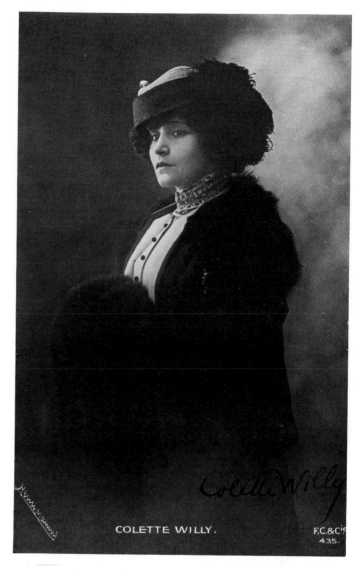

COLETTE WILLY.

F.C.&Cie 435.

COLETTE (1873–1954)

Circa 1905. Her full name was Sidonie Gabrielle Claudine Colette. Sometime music-hall dancer, sometime novelist. Best remembered for *Gigi*, the story of a young Parisian courtesan too naive to be taken advantage of. Willy was her husband's pen name, which she shared until 1916.

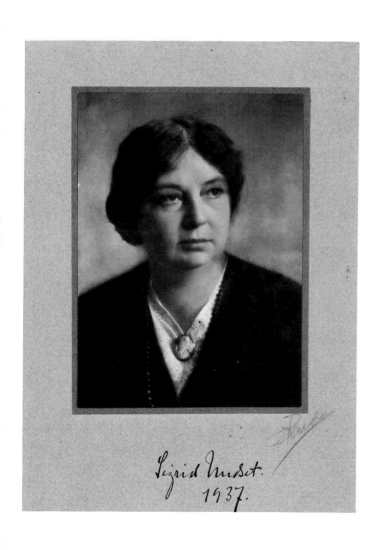

Sigrid Undset.
1937.

SIGRID UNDSET (1882–1949)

Dated 1937. Norwegian novelist, Nobel Prize winner, author of many historical novels (*Kristin Lavransdatter*). An enthusiastic Medievalist, she lived in a thousand-year-old Norse castle, and often dressed as a Rhinemaiden.

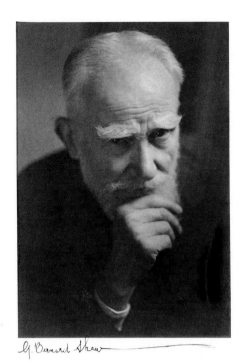

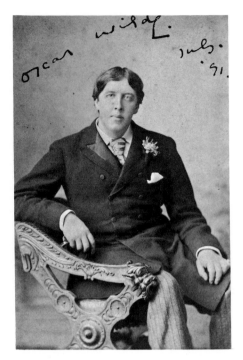

Dated July 31, 1925. The Irish novelist whose works – *Dubliners*, *A Portrait of the Artist as a Young Man* – are rooted in Ireland, though he spent most of his life in self-exile. His revolutionary innovations in the novel – interior monologues, unique language – have made an indelible impression on English literature.

>

OSCAR WILDE (1854–1900)

Dated July 1891. Born in Ireland as Oscar Fingal O'Flahertie Wills Wilde; British poet, novelist, and playwright; his *The Importance of Being Earnest* is one of the masterpieces of English drama. When asked upon arrival in New York if he had anything to declare, Wilde replied, "I have nothing to declare except my genius."

GEORGE BERNARD SHAW (1856–1950)

Circa 1925. "G.B.S." was a music critic and writer of socialist novels before his plays caught on with theater audiences. His most famous, *Pygmalion*, caused quite a scandal in its day (1913), but by the time of *My Fair Lady* it had become a familiar British institution.

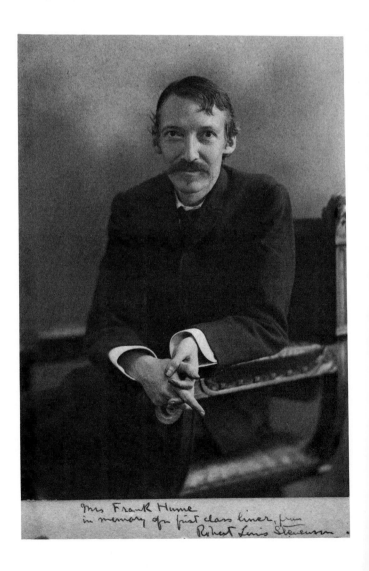

ROBERT LOUIS STEVENSON (1850–1894)

Circa 1890. Like his fictional Dr. Jekyll, Stevenson had two sides: the sickly, tubercular law student, and the flamboyant adventurer who traveled from his native Scotland to America (he lived in New York State briefly, where he wrote *Treasure Island*) and Africa, and ended his days on the South Sea Island of Samoa. The photo, which Stevenson gave to a fellow passenger on an ocean liner, "lays open a vital and engaging face . . . and intelligence, so rarely caught on film, dances in warm eyes." (J. D. Reed, *Time*)

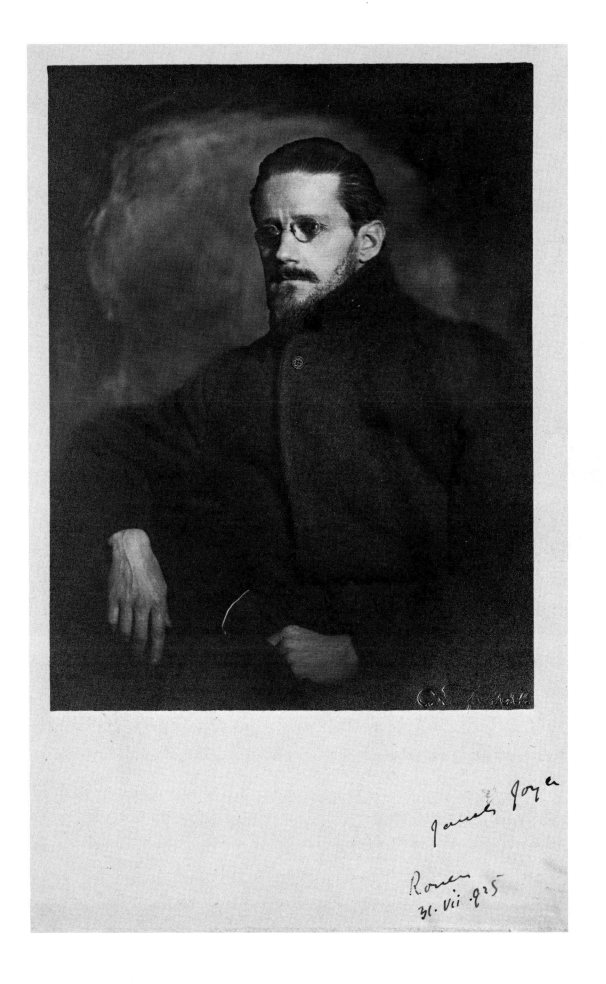

James Joyce

Rouen
31. vii. 925

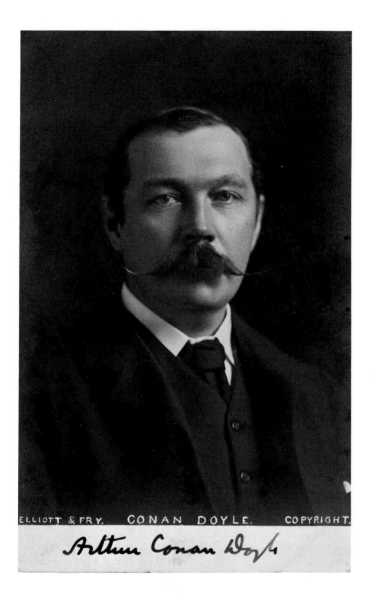

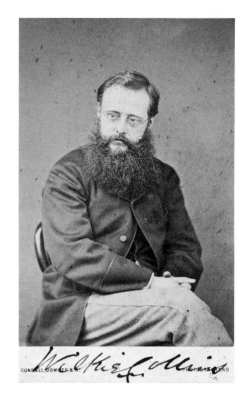

SIR ARTHUR CONAN DOYLE (1859–1930)

Circa 1900. British physician, best known for his creation (in 1889) of the indefatigable Sherlock Holmes. Doyle tried to kill his hero off some thirteen years later, only to incur the wrath of Holmes's many admirers – including several members of Parliament. Holmes returned in 1903, and has been around ever since in a variety of literary and cinematic incarnations.

EDGAR WALLACE (1875–1932)

Circa 1915. The British writer of thrillers was enormously popular and prolific – 175 books, 15 plays, and the screenplay (as co-author) for the Fay Wray *King Kong*. He lived the good life of country houses and racing stables until bankrupted by an all-too-effective promotion scheme – an offer of £500 to anyone who solved the mystery of *The Four Just Men*.

WILKIE COLLINS (1824–1889)

Circa 1870. Collins is generally credited with the invention of the English mystery story. *The Moonstone* (1868) includes that staple of the genre in its early years, the villain from the mysterious East, and the first (?) detective hero in English fiction, Sergeant Cuff. But let us not forget that another policeman, Mr. Bucket in Dickens's *Bleak House*, was detecting sixteen years earlier!

<

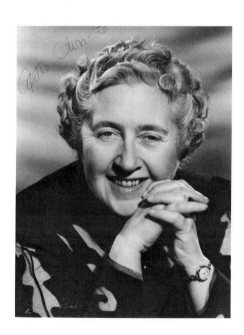

DAME AGATHA CHRISTIE (1891–1976)

Circa 1940. Doyenne of the English detective novel. Hers were usually set in country houses populated by eccentric aristocrats, and most often solved by Hercule Poirot. The Belgian detective with the overabundance of the little grey cells made his first appearance in 1927 (*The Mysterious Affair at Styles*); his death in 1975 (*Curtain*) required a front-page obituary in *The New York Times*.

GEORGES SIMENON (1903–)

Dated 1969. Prolific and remarkable writer of detective stories, born (like Christie's Hercule Poirot) in Belgium, but claimed by France. Unlike Poirot, "Sim's" Inspector Maigret (who first appeared in *Les Fiançailles de M. Hire* in 1933) does his best thinking not in country houses, but in the grittier setting of the Boulevard Richard-Lenoir.

DAME NGAIO MARSH (1899–1982)

Circa 1970. English writer of mystery novels; born in New Zealand (Ngaio, pronounced Ny-o, means "flowering tree" in Maori); creator of the urbane Roderick Alleyn and his liberated wife, Troy. Marsh's early training was as a producer, hence the convincing theatrical settings of many of her mysteries, including her last, *Light Thickens*.

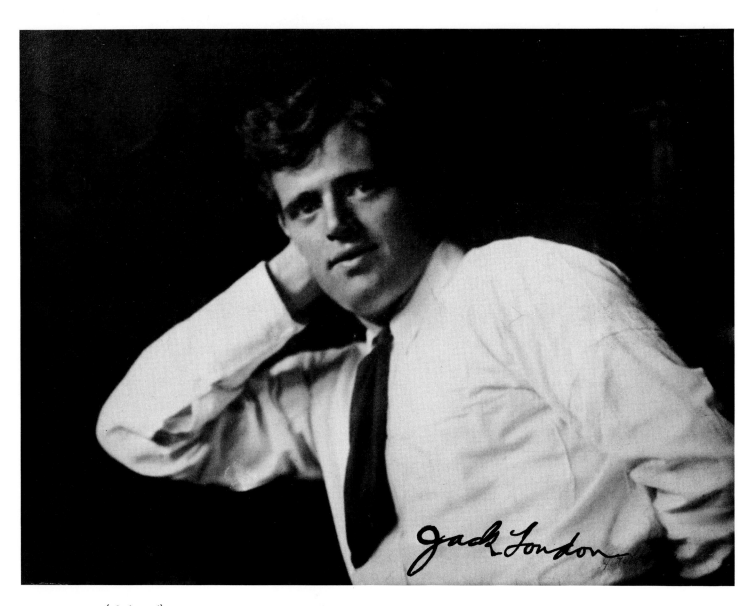

JACK LONDON (1876–1916)

Circa 1915. An illegitimate child born in Gold Rush San Francisco, London had an adventurous adolescence as a seaman and then as a Klondike gold prospector. *The Call of the Wild*, published in 1903, was one of the first in a string of successful novels that made London, in his day, the highest-paid writer in America. The photograph is by Arnold Genthe.

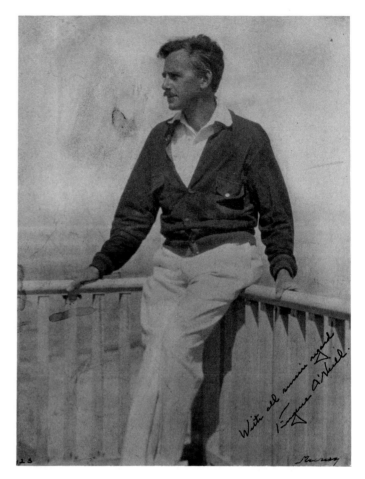

EUGENE O'NEILL (1888–1953)

Dated 1923. American playwright, considered by many to be the greatest of the twentieth century. The publication of *Long Day's Journey into Night* after O'Neill's death revealed the unhappy details of his childhood: his mother was a morphine addict, his actor father (page 188) ill-equipped to cope, and Eugene himself suffered from tuberculosis. The photograph is by Nickolas Muray.

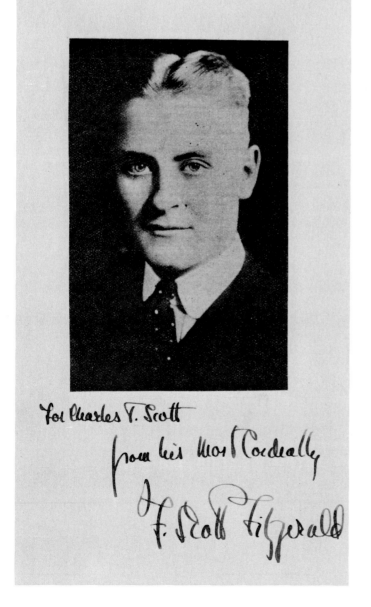

F. SCOTT FITZGERALD (1896–1940)

Circa 1925. Another American superlative. The novelist was born far from Paris, in St. Paul, Minnesota. In between writing *The Beautiful and Damned* and *The Great Gatsby*, during a memorable spell of artistic and recreational pilgrimage to the French capital with his Zelda, he acted as amateur literary agent and recommended "a young man named Ernest Hemmingway [sic]" to the attention of his luminous editor, Maxwell Perkins.

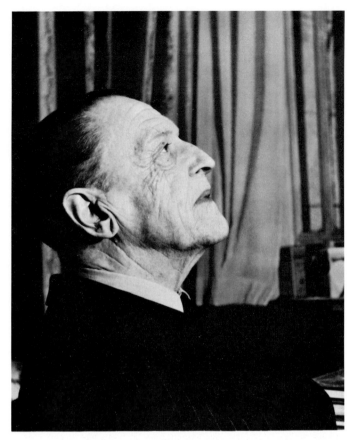

W. Somerset Maugham [signature]

W. SOMERSET MAUGHAM (1874–1965)

Circa 1940. Orphaned at age ten, Maugham was a medical student (interning in a London slum) and a British secret agent during World War I before settling down to write novels, short stories, and plays, including *Of Human Bondage* and *The Razor's Edge*.

DAME EDITH SITWELL (1887–1964)

Circa 1930. The Sitwells were a formidable English literary family, and Edith wrote and published experimental poetry that slowly won her a wide and appreciative audience. In later years, she joined the Catholic Church and took to wearing medieval dress, which suited her Plantagenet profile.

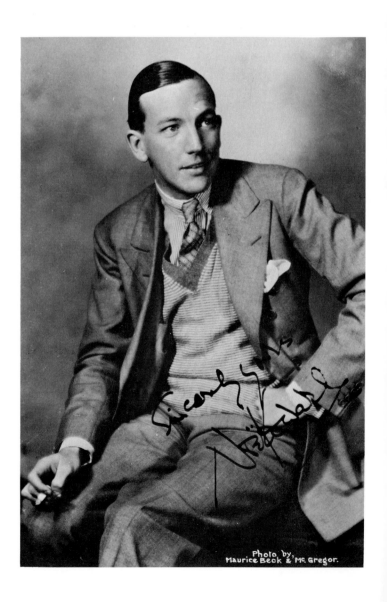

Photo by, Maurice Beck & Mc Gregor.

NOËL COWARD (1899–1973)

Circa 1925. English playwright, composer, director, and actor, who began the last-named career at age twelve. His numerous plays – including Broadway perennials *Present Laughter* and *Private Lives* – usually dealt brightly with the romantic problems of the spoiled and eccentric, people not unlike Coward himself. He ended up Sir Noël, and he didn't care for the man at upper left.

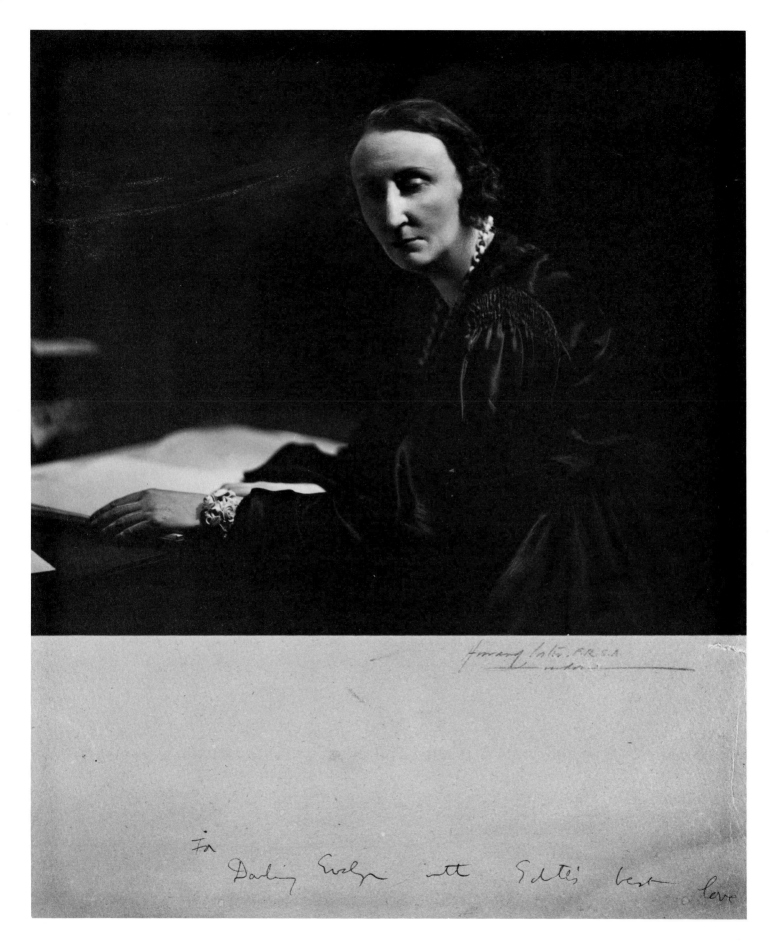

For Darling Evelyn with Edith's best love

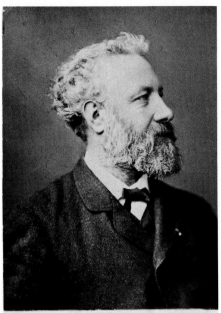

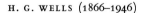

JULES VERNE (1828–1905)

Dated August 16, 1900. The French novelist Verne (*Around the World in Eighty Days*) not only predicted a moon flight (along with submarines, radar, dirigibles, and a host of other technological prophecies), but picked for its launch a spot twenty miles from Cape Canaveral.

H. G. WELLS (1866–1946)

Dated May, 1926. Herbert George to his friends; the George Bernard Shaw of the science-fiction set. His novels *The Time Machine* and *The War of the Worlds* have spooked many a reader – and radio listener – but his screenplay for *Things to Come* is even more chilling, predicting World War II, chemical weapons, and mass manipulation via television.

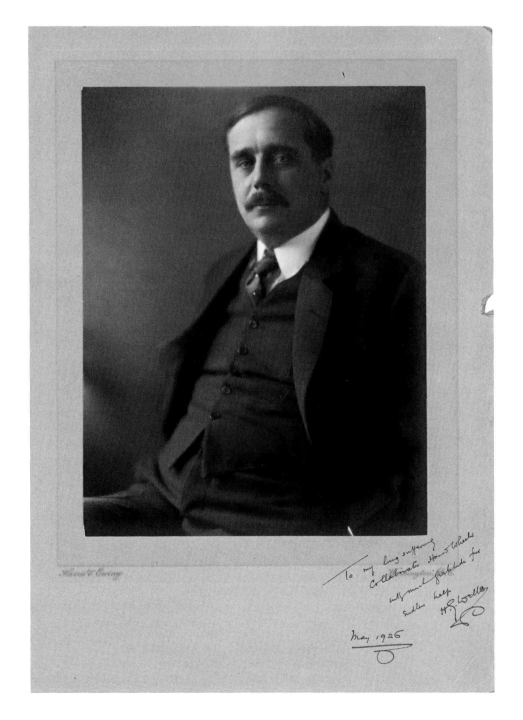

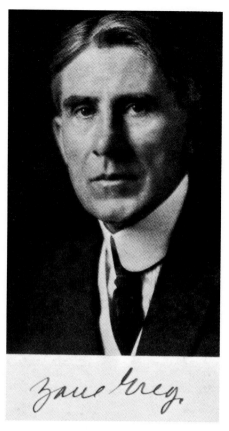

ZANE GREY (1875–1939)

Circa 1920. Born in Ohio, Grey was a New York dentist when he realized that writing of the Old West was his true vocation. Among his many colorful novels are *Riders of the Purple Sage*, *The Last of the Plainsmen*, and *West of the Pecos*.

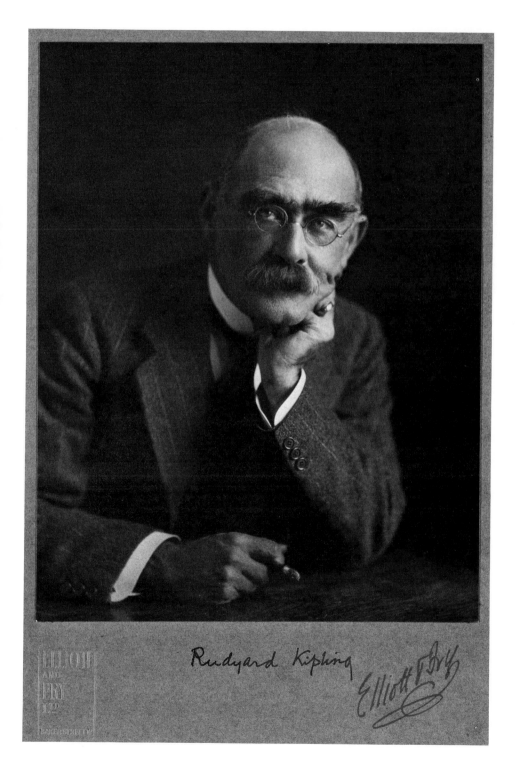

RUDYARD KIPLING (1865–1936)

Circa 1925. Kipling was England's answer to Jack London: a flamboyant, well-traveled, and enormously popular literary figure. His poems and novels set in his native India, including "Gunga Din" and *The Jungle Book*, were particular favorites.

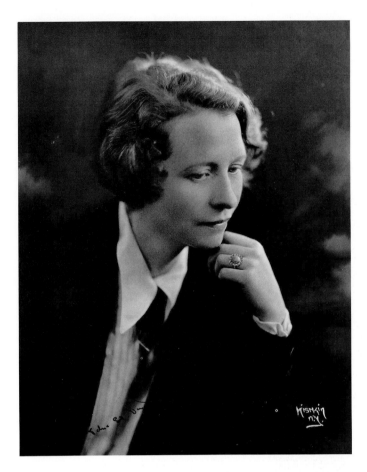

EDNA ST. VINCENT MILLAY (1892–1950)

Circa 1928. Celebrated American poet of the 1920s, remembered as much for her freewheeling life-style – burning candles at both ends in Greenwich Village – as for her lyrical poems written in traditional forms.

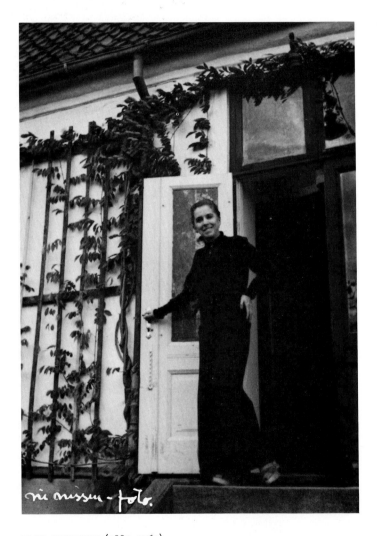

ISAK DINESEN (1885–1962)

Dated 1957. Pen name of Baroness Karen Blixen, Danish writer (*Seven Gothic Tales*). Her most famous work, *Out of Africa*, recounts her experiences on a coffee plantation in British East Africa (now Kenya). This photo of a handsome young woman was signed decades after it was taken; by then a gaunt, gothic visage with glittering, mascaraed eyes was familiar to the public.

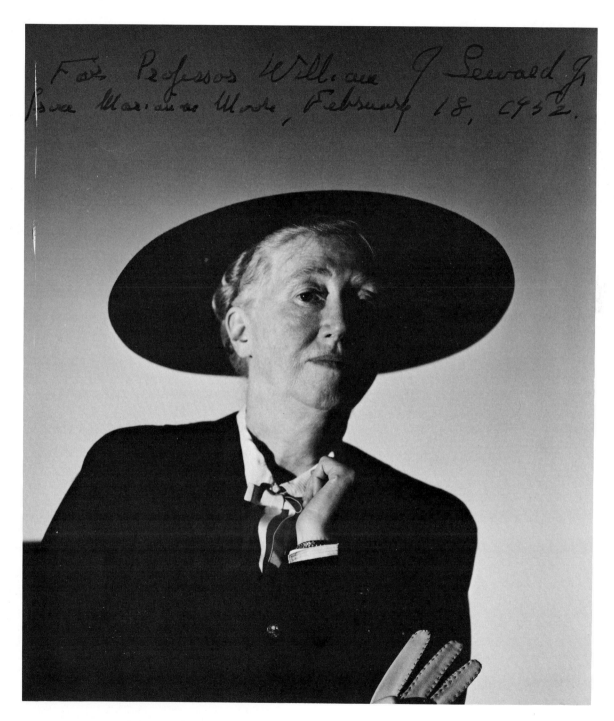

MARIANNE MOORE (1887–1972)

Dated February 18, 1952. American poet, editor of *Dial* from
1925 to 1929. The Ford Motor Company once asked Moore to
name their latest car model, but they found her suggestions too
poetic, and used a name the committee liked better – Edsel. The
striking photo is by George Platt Lynes.

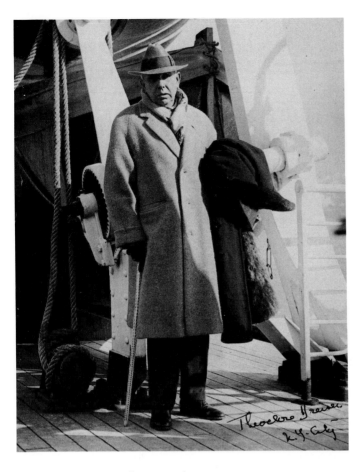

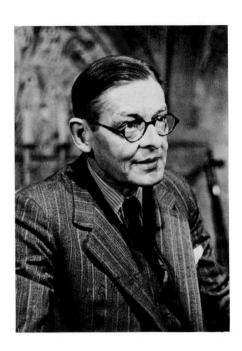

THEODORE DREISER (1871–1945)

Circa 1935. American novelist. This sour, if atmospheric, shipboard portrait recalls stories of Dreiser's unhappy life: raised in abject poverty, he considered suicide when his first novel, *Sister Carrie*, was condemned as immoral and withdrawn from sale.

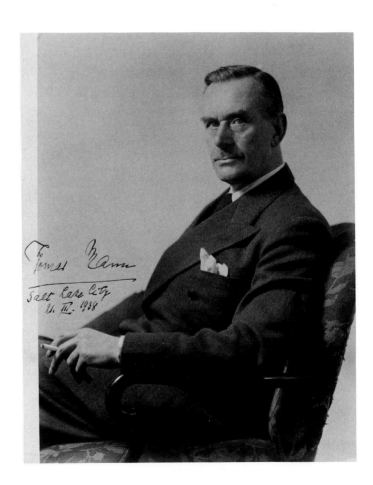

THOMAS MANN (1875–1955)

Dated March 21, 1938. German Nobel Prize–winning novelist and essayist; admired for his treatment of myth, spiritualism, and the artistic temperament in such works as *The Magic Mountain* and *Death in Venice*. Mann believed the artist to be above the sordid concerns of politics and was slow in taking a stand against the Nazis, but during the war years, spent in the United States, he made broadcasts to his homeland on B.B.C. radio, urging the German people to break with the Nazis.

T. S. ELIOT (1888–1965)

Circa 1950. Born in St. Louis and educated at Harvard, Eliot settled in London in 1914 and once described himself as "an Anglo-Catholic in religion, a classicist in literature, and a royalist in politics." Eliot's *The Waste Land* had the same startling effect on English poetry as Joyce's *Ulysses* had on English fiction (both were published in 1922). One of his lighter works, *Old Possum's Book of Practical Cats*, is the basis for the London and Broadway musical *Cats*.

<

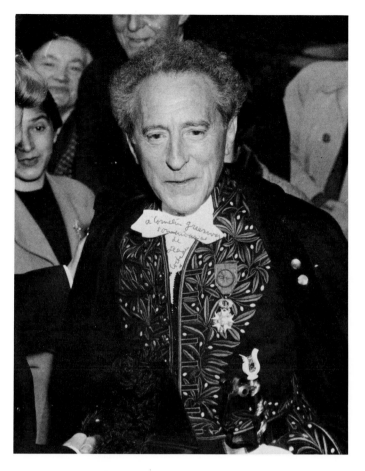

JEAN COCTEAU (1889–1963)

Circa 1960. French Renaissance man, who has left his mark on almost every modern art form, including poetry, fiction, ballet, drama, film, even drawing. His most famous work is *Les Enfants Terribles* (1930), filmed in 1950 by Cocteau. He is shown here in uniform as a member of the Académie française; the election of this *surréaliste terrible* to that august body was highly controversial.

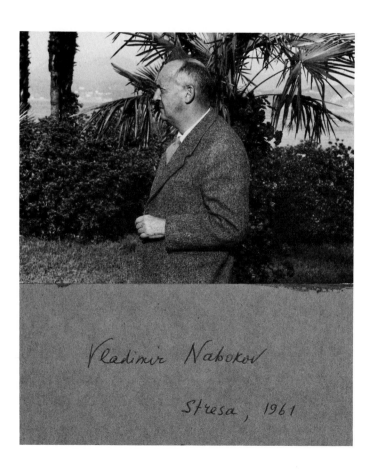

VLADIMIR NABOKOV (1899–1977)

Dated 1961. Novelist, critic, and lepidopterist, born in Russia of a noble family. The brilliant *Lolita*, which describes an affair between a middle-aged man and a twelve-year-old "nymphet," was written in English, and published in Paris in 1955 after four American publishers rejected the manuscript.

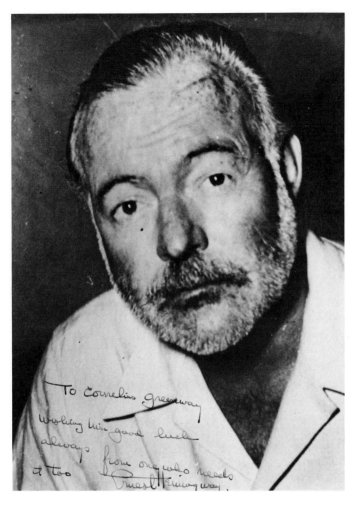

ERNEST HEMINGWAY (1899–1961)

Circa 1960. Papa to his friends. With the possible exception of Twain, he is the most widely read American writer. The Original Real Man. War Correspondent. Bullfights. African safaris. Four wives. *The Sun Also Rises. The Old Man and the Sea.* Nobel Prize. A somewhat wistful inscription reads: "To Cornelius Greenway, wishing him good luck always from one who needs it too."

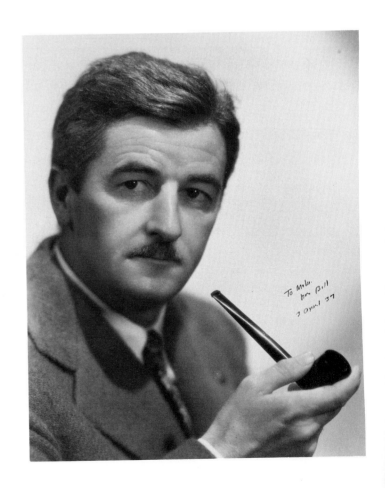

WILLIAM FAULKNER (1897–1962)

Dated April 3, 1937. American writer, whose novels – *The Sound and the Fury, Absalom, Absalom!* – distilled the South in ways that Margaret Mitchell could not have imagined. When asked what tools he needed to write, Faulkner replied, "Paper, tobacco, food, and a little whisky." The photograph is inscribed to Meta Carpenter, the great love of his life.

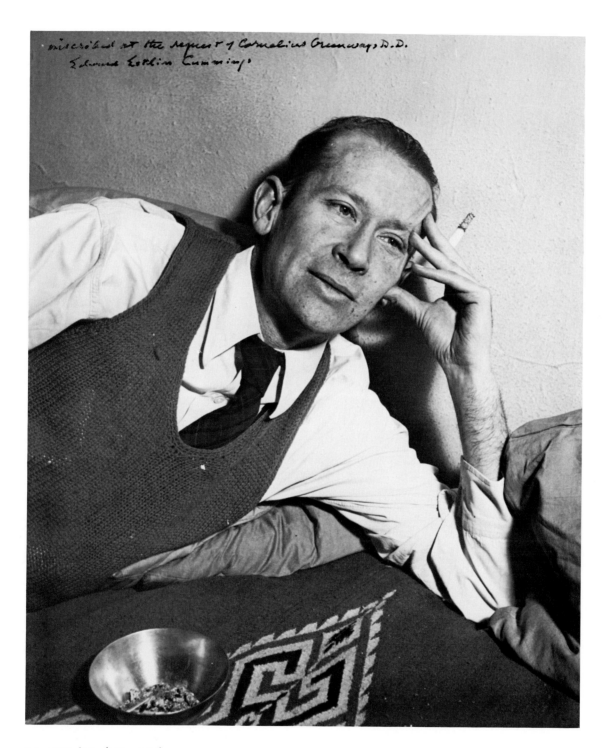

e. e. cummings (1894–1962)

circa 1935. american poet, born in cambridge, noted for his
eccentric typography, among other things; author of *50 poems*,
1×1, i, six nonlectures, The Enormous Room. the e.e. stands for
edward estlin.

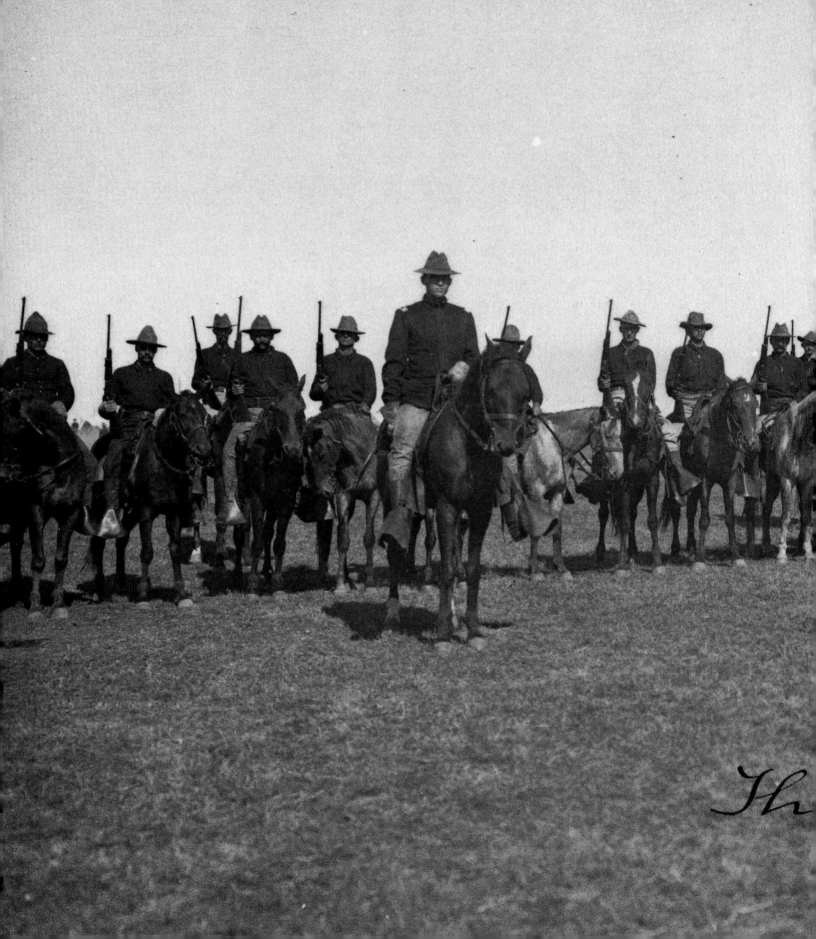

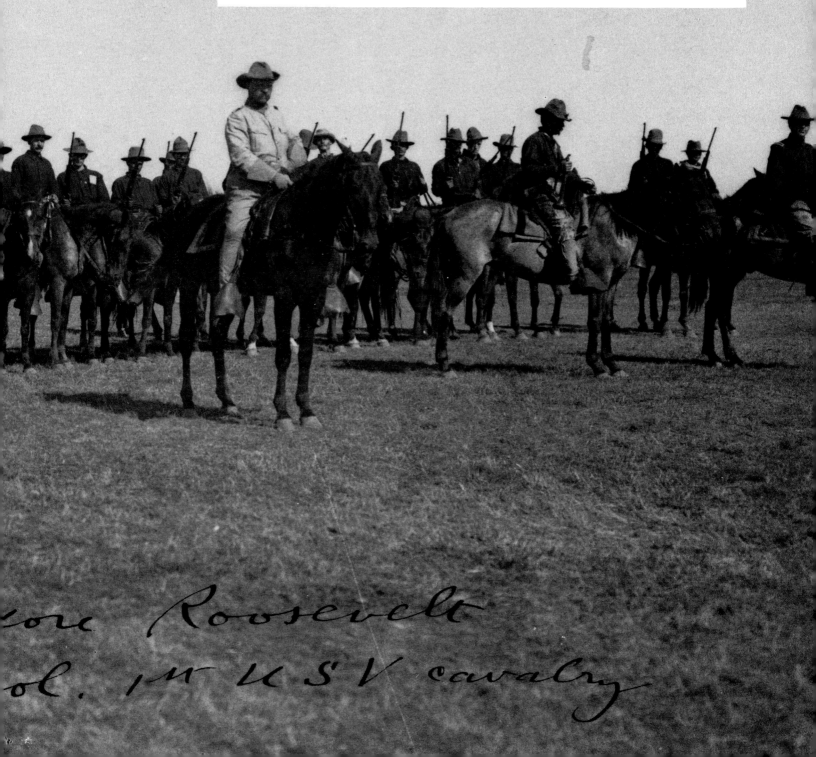

Soldiers & Statesmen

...ore Roosevelt
...ol. 1ˢᵗ U.S.V. cavalry

OVERLEAF:

Circa 1898. Colonel Theodore Roosevelt at the head of the "Rough Riders" during the Spanish-American war.

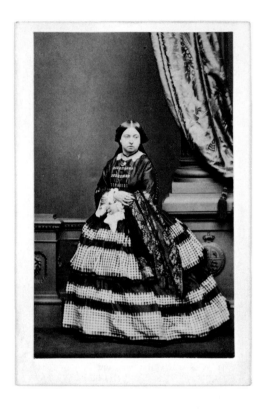

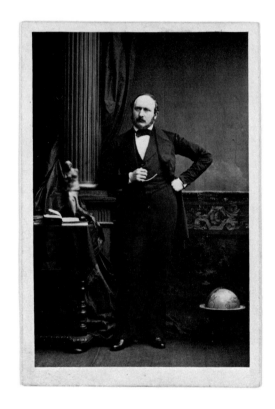

QUEEN VICTORIA (1819–1901) &
PRINCE ALBERT (1819–1861)

Dated 1861. A pair of matched *cartes de visite*: the queen by Mayall, and her consort by the master Silvy, both taken and signed (on verso) the year of Albert's death. This was the great age of the *carte de visite*, and Silvy made them of virtually every member of Victoria's court except the queen herself.

74

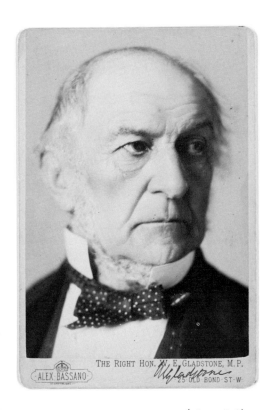

WILLIAM EWART GLADSTONE (1809–1898)

Dated October 27, 1896. Alexander Bassano has captured the deeply religious and high moral tone of the British Liberal leader, who was four times Victoria's prime minister, but was passionately disliked by her. In the perverse way of Fame, he is commonly remembered in tandem with his chief rival, Disraeli, and for his earnest attempts to rehabilitate prostitutes.

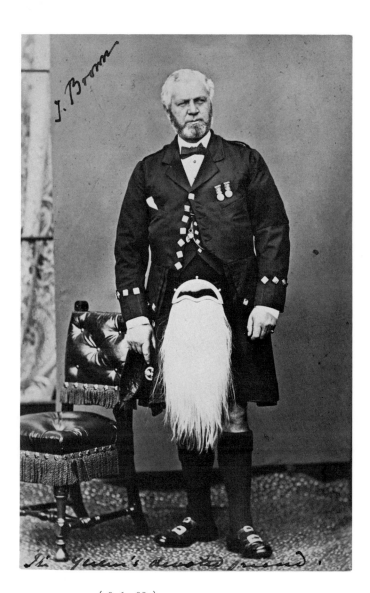

JOHN BROWN (1826–1883)

Circa 1875. First ghillie, then equerry to Queen Victoria. In her inconsolable grief following her husband's death, Victoria made this low-born Scotsman her closest confidant, causing raised eyebrows in her court and open speculation among royalty-watchers even now. So might the inscription: "The queen's devoted friend."

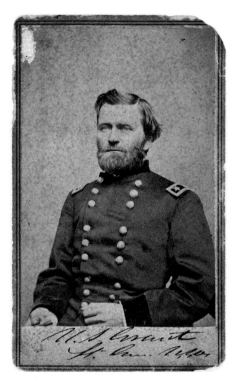

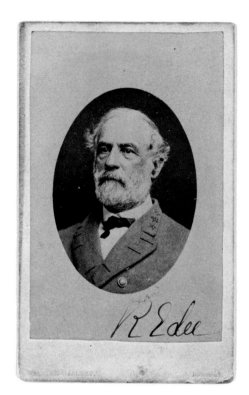

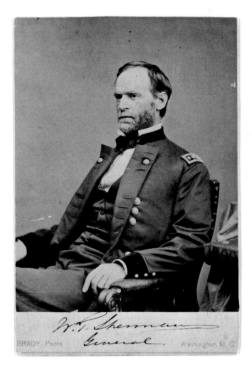

ULYSSES S. GRANT (1822–1885)

Circa 1862. A thirty-nine-year-old alcoholic clerk in a leather store in 1861, Grant joined the Union army and rose steadily by virtue of his knack for winning battles. By 1864 he was commander in chief and a year later Lee was handing over his sword.

ROBERT E. LEE (1807–1870)

Circa 1862. Imagine a soldier of such ability that both sides in a conflict offer him command; such was Lee's situation at the outbreak of the Civil War. He felt honor bound to side with his native South.

WILLIAM TECUMSEH SHERMAN (1820–1891)

1865. "War is hell," the hard-fighting Union general said, and by 1864, the Confederacy knew it firsthand. In twenty-four days of devastation he marched his army from Atlanta to the sea, bringing the war to the home and hearth of the South.

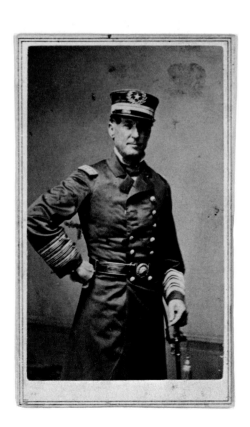

DAVID FARRAGUT (1801–1870)

Circa 1865. The Civil War admiral wears what is perhaps the most glamorous naval uniform ever. He captured Fort Morgan, running the gauntlet of torpedoes with his exhortation, "Damn the torpedoes – full speed ahead!"

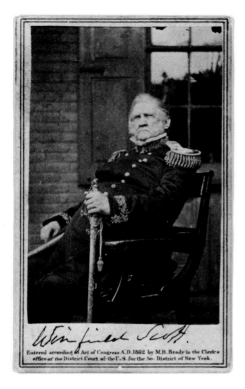

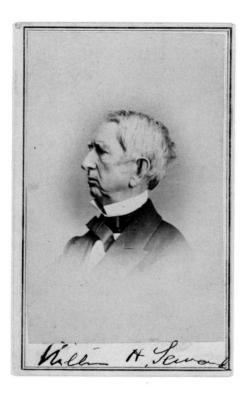

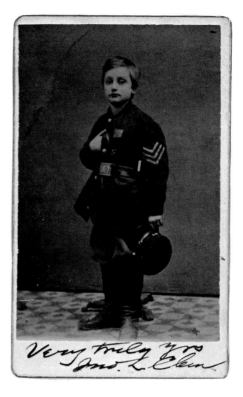

WINFIELD SCOTT (1786–1866)

1862. The preeminent military figure in America for nearly half a century, he began his military career in the War of 1812, was the hero of the Mexican War, and served in the early part of the Civil War. The photo is by Mathew Brady.

WILLIAM SEWARD (1801–1872)

Circa 1867. Lincoln's, then Johnson's, very competent secretary of state. In 1867 he negotiated the purchase of Alaska from Russia for $7,200,000 – a stroke of business then known as "Seward's Folly."

JOHNNY CLEM (1851–1937)

Circa 1863. "The Drummer Boy of Chicamauga." During one of the great battles of the Civil War, drummer-boy Johnny Clem helped turn the tide for the Yankees by picking up a rifle and felling a Confederate colonel leading a charge. He was made sergeant at age twelve, and retired from the army a major general.

GEORGE ARMSTRONG CUSTER (1839–1876)

Dated February 27, 1865. The youngest general in the Union army, his record was one of the most spectacular of the Civil War. He possessed lust for battle, a massive ego, and driving ambition. He was also impetuous, but he was successful until that afternoon of June 25, 1876, when he and his entire force of 266 officers and men were massacred at Little Big Horn, Montana, by over 2,000 Sioux, led by Sitting Bull.

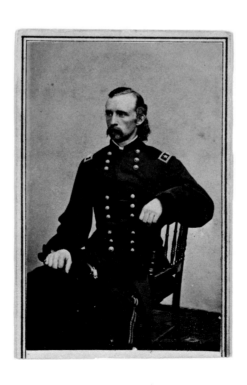

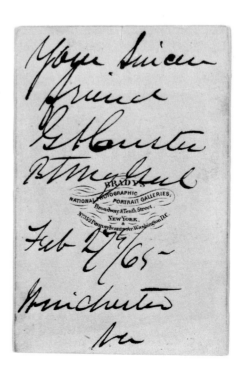

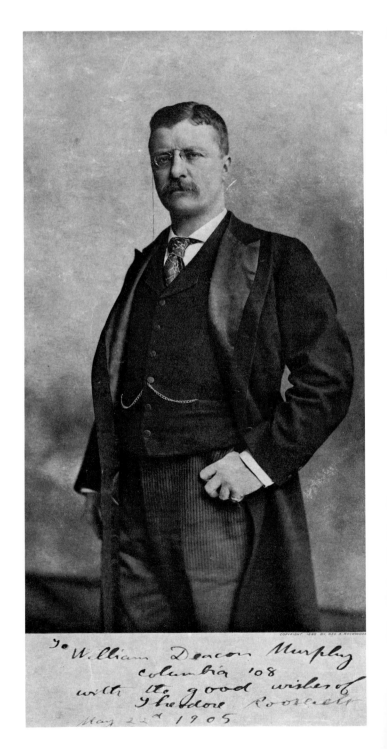

Dated 1902. The bartered bride. Vanderbilt Heiress Weds Peer of the Realm. An outstanding deal, evidently satisfactory to all but the principals. (In this photograph by Lafayette the duchess is robed for the coronation of Edward VII.)

>

ALICE LEE ROOSEVELT (LONGWORTH) (1884–1980)

Dated 1902. Headstrong and rebellious, the daughter of President Theodore Roosevelt had an acerbic wit that could be counted on to provide good newspaper copy all during her long life. The noted photographer Frances B. Johnston took this photograph of an eighteen-year-old Alice during her father's first term in office.

THEODORE ROOSEVELT (1858–1919)

Dated May 22, 1905. The twenty-sixth president of the United States said of his daughter, "I can manage Alice, or I can manage the nation. I can't do both." He certainly did the latter, showing remarkable foresight in understanding the need for political adjustment to a new economic age. One of the most colorful men ever to hold the presidency, he was widely admired for his boundless gusto and great integrity.

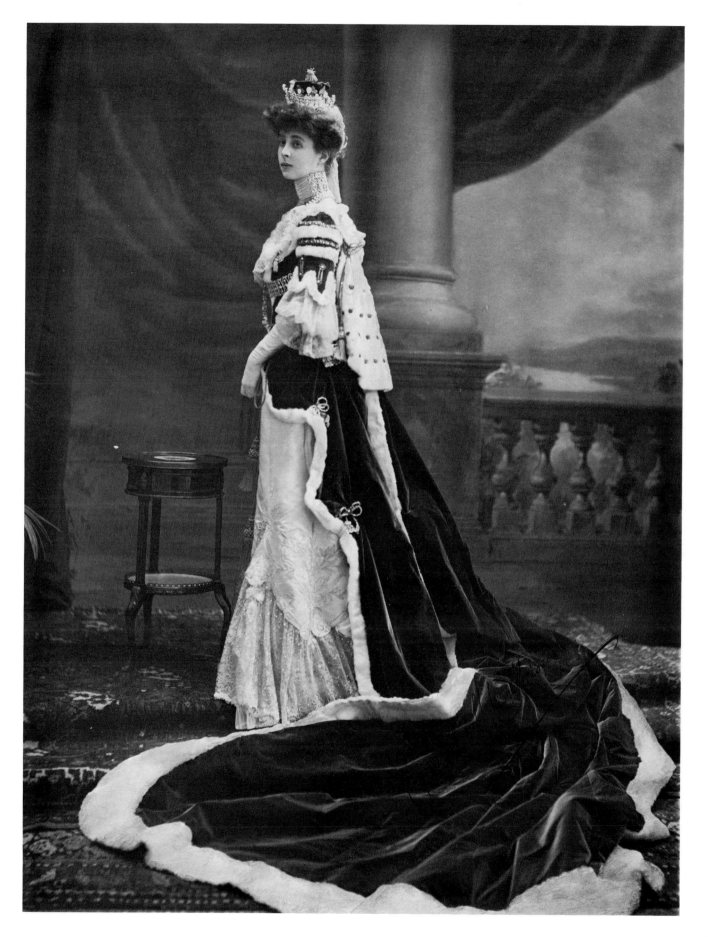

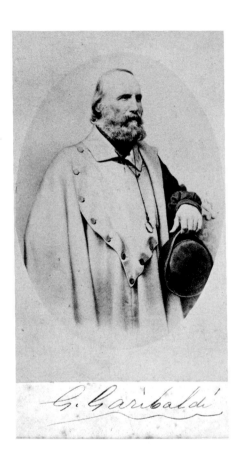

G. Garibaldi

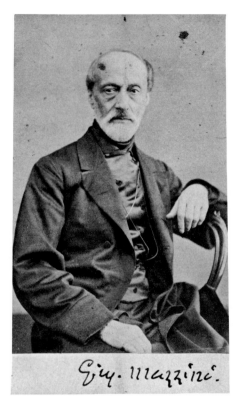

Giy. Mazzini.

GIUSEPPE GARIBALDI (1807–1882)

Circa 1870. Popular hero of Italians the world over, he was a tireless soldier and key figure in the struggle for Italian unification. He once served a brief exile as a candle-maker on Staten Island before returning to conquer Sicily and Naples for the first king of Italy, Victor Emmanuel.

GIUSEPPE MAZZINI (1805–1872)

Circa 1865. A firm supporter of Garibaldi, Mazzini nevertheless was a die-hard republican who could not stomach monarchy. He went underground and founded the secret revolutionary movement Young Italy.

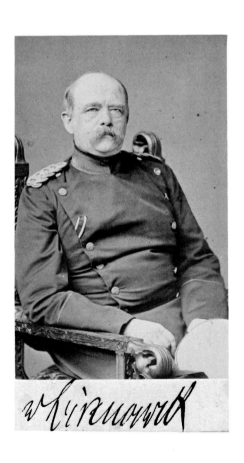

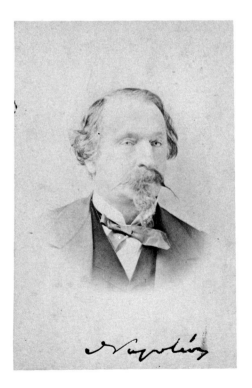

OTTO VON BISMARCK (1815–1898)

Circa 1870. The "Iron Chancellor" was the genius behind the consolidation of the German state and empire during the last century.

NAPOLEON III (1808–1873)

1870. Though hardly cast in the mold of his mighty uncle, Bonaparte, he was shrewd enough to capitalize on the Napoleonic image and to govern France capably, albeit dictatorially. His downfall came when he encountered the far more canny Bismarck and the Franco-Prussian War ensued. Extremely rare in an autographed photo, he signed this one while a prisoner of the Germans in 1870.

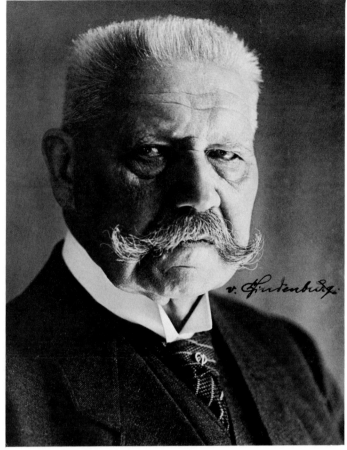

PAUL VON HINDENBURG (1847–1934)

1925. The aging field marshal emerged from retirement to command German troops in the First World War, and to lead several postwar governments. In 1933, nearly senile, he gave in to pressure and appointed Adolf Hitler chancellor.

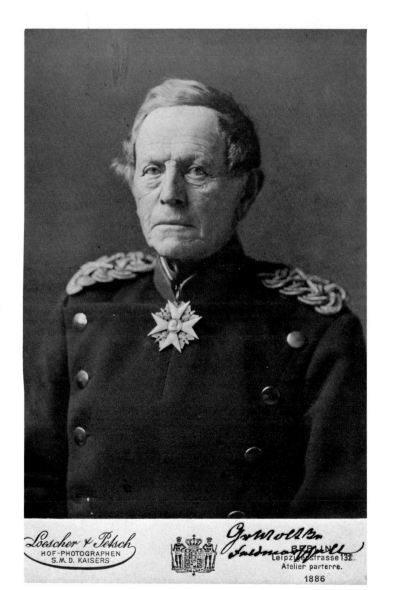

COUNT HELMUTH VON MOLTKE (1800–1891)

1886. He was created field marshal in recognition of the superb tactics that led to complete victory over the French, and the humiliation of Napoleon III, in the Franco-Prussian War of 1870–1871.

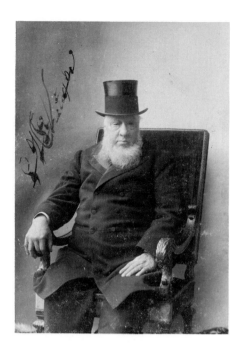

STEPHANUS PAULUS KRUGER
(1825–1904)

Circa 1900. A founder of the independent
state of Transvaal, "Oom Paul" Kruger
was the leader of the South African Dutch
settlers in their unsuccessful war with
England. His cause ultimately prevailed in
an independent South Africa, and the
Krugerrand gold coin commemorates him.

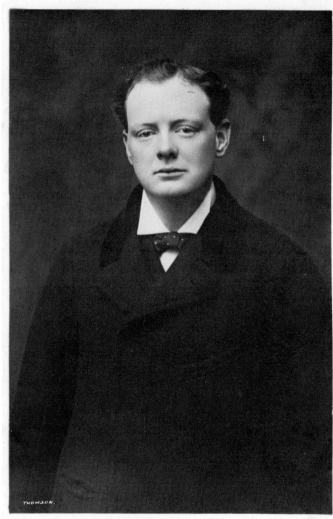

96 A WINSTON SPENCER CHURCHILL, ESQ. M.P. ROTARY PHOTO, E.C.

WINSTON CHURCHILL (1874–1965)

Dated 1905. When this photograph was
made Churchill was famous as a
correspondent in the recent Boer War
and a promising young member of
Parliament. (He was also a rejected suitor;
see page 187.) His political fortunes met
many reversals before he emerged as
leader of Great Britain during the darkest
days of World War II.

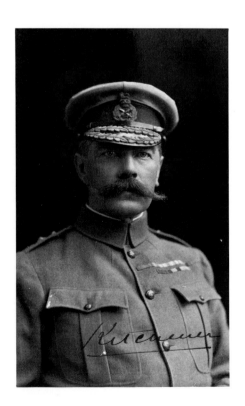

HORATIO HERBERT KITCHENER
(1850–1916)

Circa 1900. Idolized by the British public
for his victories in the Sudan in 1898, he
ruthlessly crushed the struggle for
independence by Dutch settlers in South
Africa in the Boer War. His soldier's luck
ran out, however, when his ship struck a
German mine during World War I.

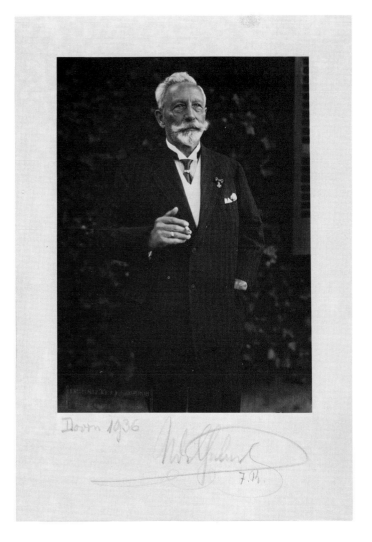

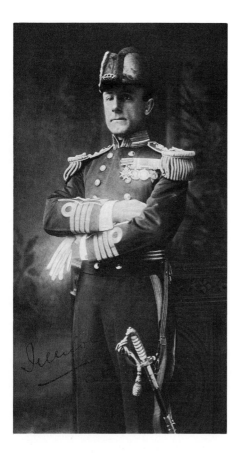

JOHN RUSHWORTH JELLICOE
(1859–1935)

Circa 1910. The British admiral confidently
sailed his superior fleet against the
Germans at the Battle of Jutland in 1916,
and just managed to claim victory.

WILHELM II (1859–1941)

Dated 1936. "Kaiser Bill," a grandson of
England's Queen Victoria (page 74), was
emperor of Germany when the First
World War broke out in 1914. Indeed,
historians consider that his bombast and
bullying can be counted among the
causes of the disastrous conflict.

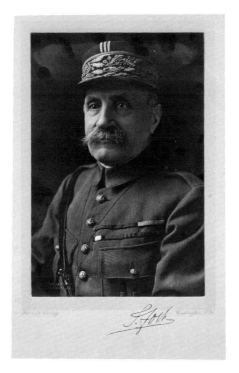

FERDINAND FOCH (1851–1929)

Circa 1915. When the German army broke
the French and English lines in the fourth
year of World War I, General Foch was
named supreme commander of the Allied
armies and given responsibility for the
counteroffensive. Seven months later it
was the Germans who were surrendering.

83

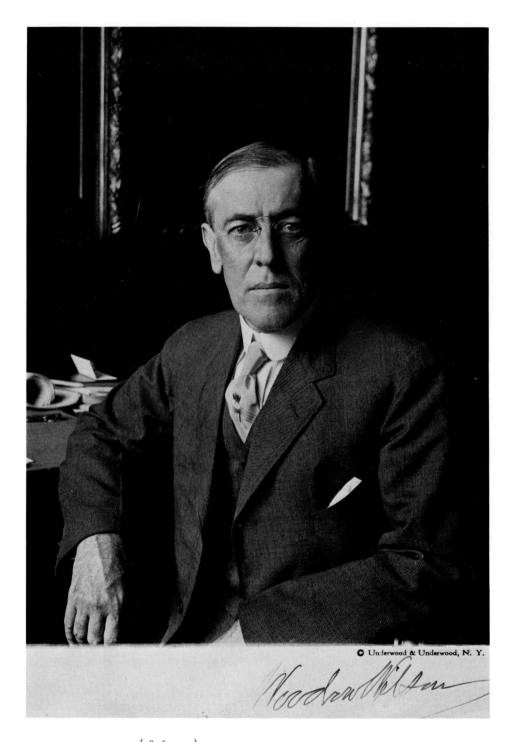

© Underwood & Underwood, N. Y.

WOODROW WILSON (1856–1924)

Circa 1915. The former president of Princeton University, he became the twenty-eighth president of the United States. His administration saw the passage of a variety of political reforms, the enactment of prohibition, and women's suffrage – and, despite his efforts to maintain neutrality, the entry of the United States into World War I. At the close of the war he failed in his ambition to involve the U.S. in his plan for world government: the League of Nations.

JEANNETTE RANKIN (1880–1973)

Dated April 6, 1917. The first woman to serve in the U.S. Congress, she was one of the few to vote against the declaration of war on Germany in 1917, and wrote this inscription at the time: "I want to stand by my country but I cannot vote for War. I vote *no*." In 1941, after Pearl Harbor, she cast the sole vote against the declaration of war on the Axis powers.

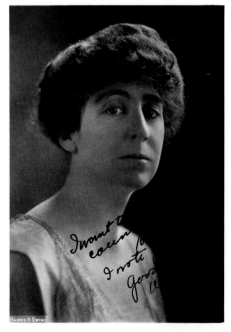

COUNT FELIX VON LUCKNER
(1886–1966)

Dated October 25, 1927. His bold U-boat raids on Allied shipping during the First World War won him the nickname "the Sea Devil." Here, in a more domestic moment, he is seen with his young bride.

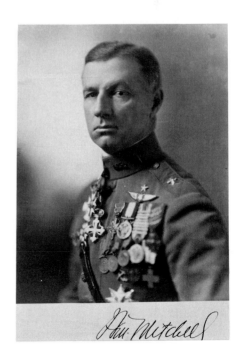

WILLIAM (BILLY) MITCHELL
(1879–1936)

Circa 1924. The American army officer was the first to demonstrate, in a controlled test, that armed airplanes could sink a warship. Unfortunately, the lesson was lost on his superiors, who arranged to have him court-martialed.

EAMON DE VALERA (1882–1975)

Circa 1930. Imprisoned for his part in the 1916 Easter Rebellion, the Irish patriot escaped execution because he was a U.S. citizen. Later released in a general amnesty, he played a leading part, as head of the Sinn Fein party, in establishing an independent Ireland, which he ultimately served as president.

DAVID LLOYD GEORGE (1863–1945)

Circa 1915. The wily Welshman was prime minister of Britain during much of the First World War. In Irish politics he pursued a repressive policy, but finally relented and gave the Irish a measure of independence.
>

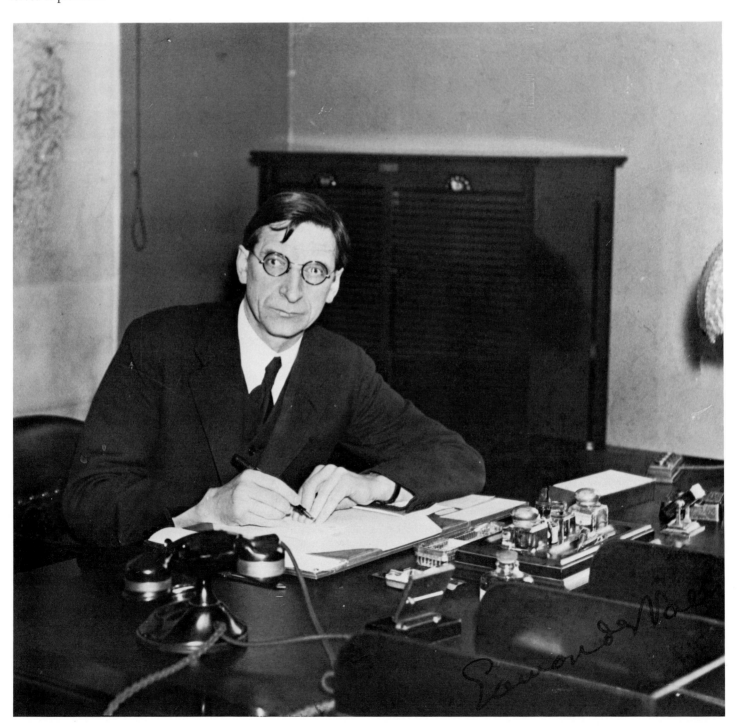

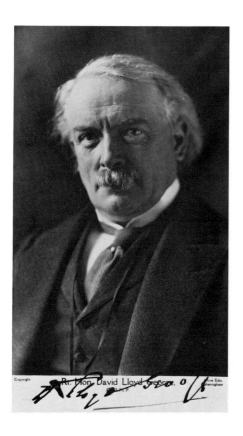

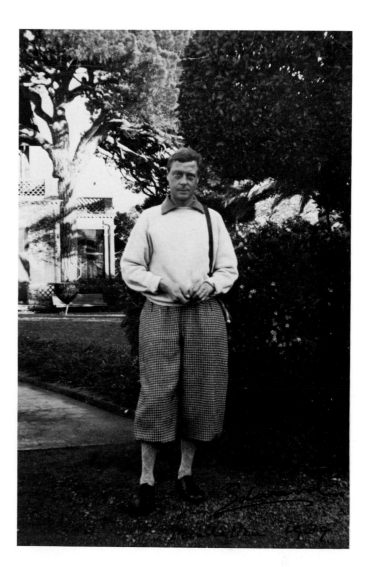

EDWARD, DUKE OF WINDSOR (1894–1972)

Dated 1939. The amorous Edward VIII, seen here three years after his abdication, was a national problem not only because of his divorced fiancée, but because it was widely felt that he had German sympathies. This photograph was taken in France, where he was assigned to liaison work, but still looking for a real job of work (see page 94).

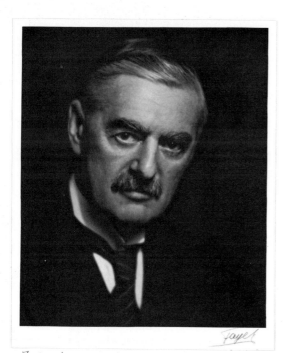

NEVILLE CHAMBERLAIN (1869–1940)

Dated January 1940. The British prime minister will be forever associated with "Munich" and the policy of appeasement. He returned from his meeting with Hitler declaring he brought "peace in our time"; events soon led the world, and Chamberlain, to know otherwise.

FRANKLIN ROOSEVELT (1882–1945)

Circa 1933. Elected an unprecedented four terms, the thirty-second president of the United States led the country through the worst crises of this century – the Great Depression and the Second World War. He died a month short of the Allied victory in Germany.

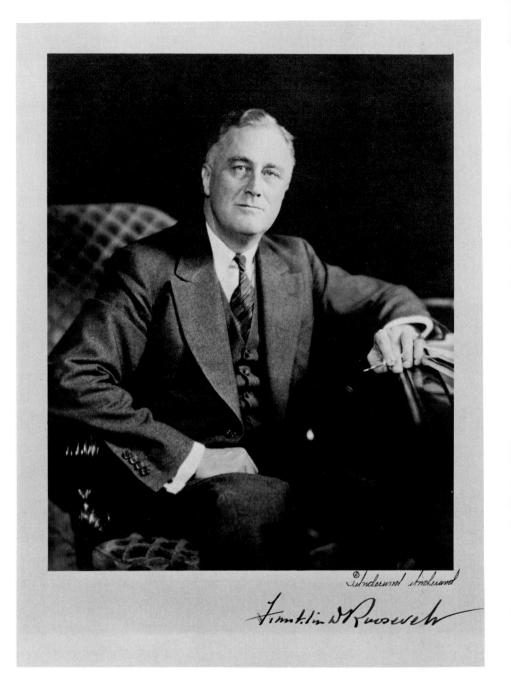

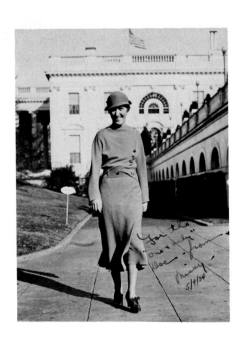

ELIZABETH LEHAND

Dated May 9, 1934. Not quite so famous as Fala, "Missy" LeHand was a household name when she served as Roosevelt's secretary. (The date was added in another hand.)

ELEANOR ROOSEVELT (1884–1962)

1940. The wife of Franklin Roosevelt (also his distant cousin) was an influential public figure in her own right with a daily newspaper column, a national radio show, and a powerful voice in liberal politics. Probably the most revered woman of her time, she was at first ridiculed by a society that wasn't quite ready for her.

>

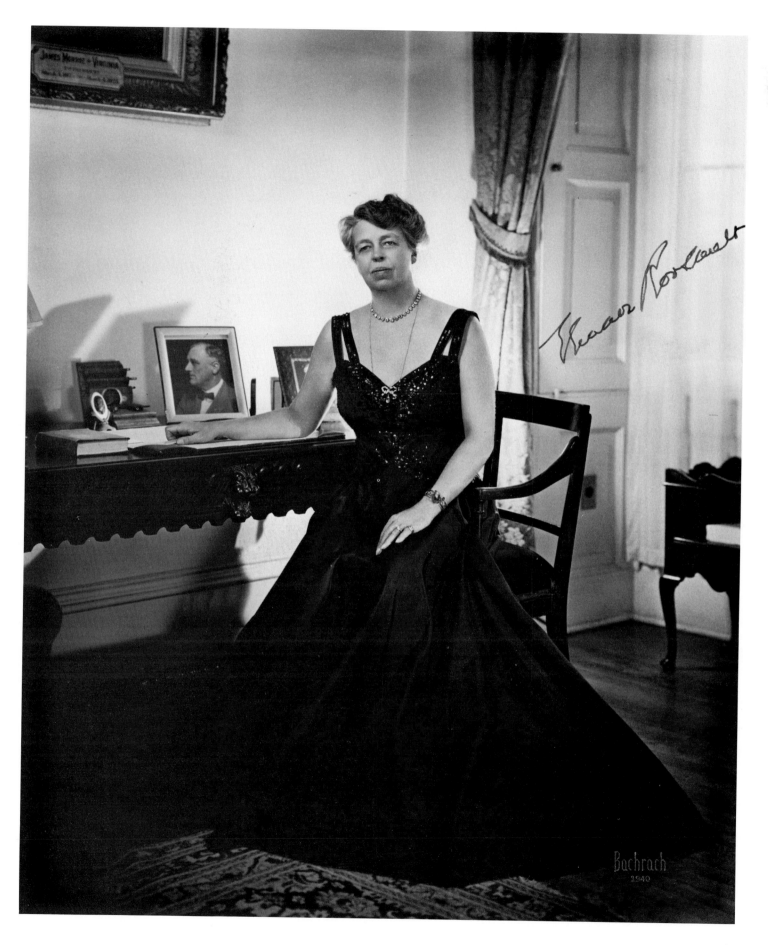

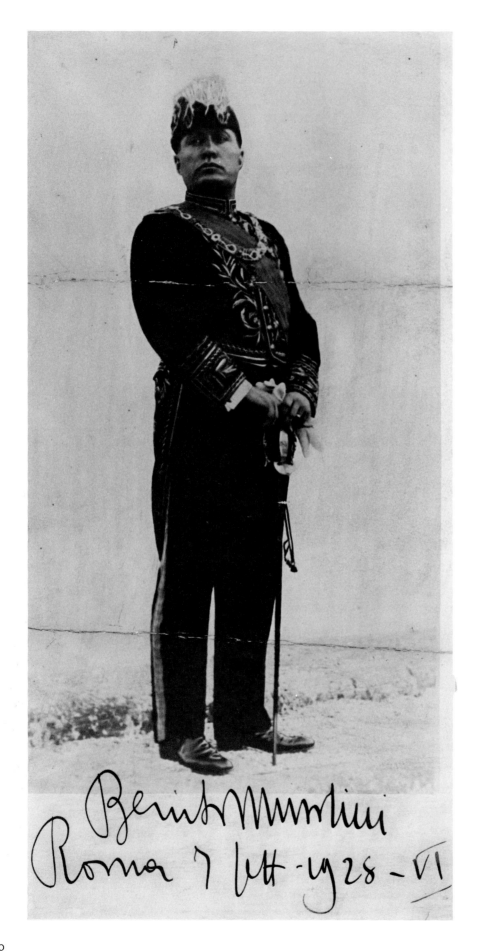

BENITO MUSSOLINI (1883–1945)

Dated 1928. The bombastic Italian dictator styled himself in the mold of the Roman caesars and had ambitions to match. He joined with Hitler as junior partner in a pact to carve up Europe and Africa, and met with the same bloody end as some of his ancient predecessors. (This autographed photograph was hanging in the office of the Italian commandant and was confiscated when the British took Tobruk in 1941.)

HIDEKI TOJO (1884–1948)

Circa 1945. The Japanese admiral who approved the attack on Pearl Harbor. He attempted suicide in September 1945, but was arrested by the Allies, tried as a war criminal, convicted, and executed.

<

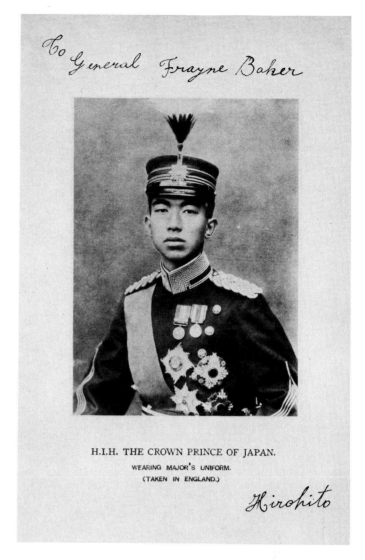

To General Frayne Baher

H.I.H. THE CROWN PRINCE OF JAPAN.
WEARING MAJOR'S UNIFORM.
(TAKEN IN ENGLAND.)

Hirohito

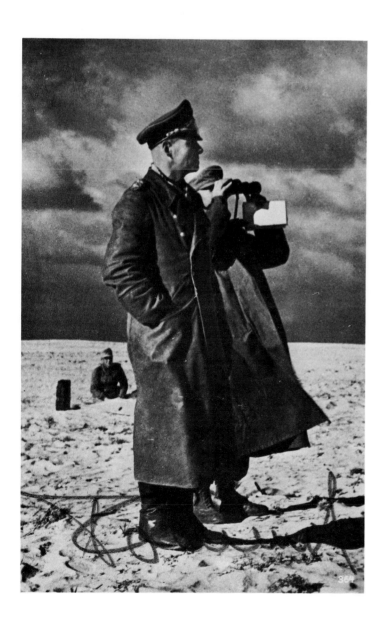

PRINCE HIROHITO (1901–)

1921. The mild-mannered Hirohito inscribed this portrait to the British general who helped him on his world tour of 1921, before he became emperor of Japan. Even as "Son of Heaven" he had no control over the generals who plunged his country into World War II; he did, however, help persuade them to surrender when their cause was lost.

ERWIN ROMMEL (1891–1944)

Circa 1943. "The Desert Fox," the brilliant commander of the Afrika Korps, victor at Tobruk. A key figure in the attempted assassination of Hitler in July 1944, he was forced to take his own life. Rommel signed in pencil because in the desert winds ink evaporated too quickly.

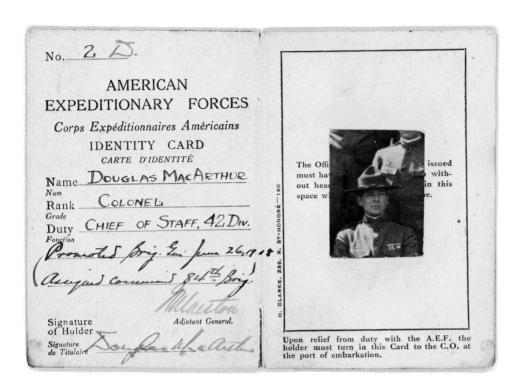

DOUGLAS MACARTHUR (1880–1964)

Circa 1917. This is MacArthur's actual identification card, which he carried in the front lines in World War I as colonel, and shortly thereafter as brigadier general. The superb strategist of the Pacific in World War II was appointed supreme commander of the Allied occupation forces in Japan, inaugurating a new constitution with liberal features, land redistribution, and demilitarization. (The card came from the estate of MacArthur's first wife.)

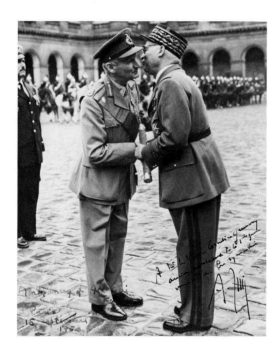

BERNARD LAW MONTGOMERY (1887–1976) & ALPHONSE JUIN (1888–1967)

September 15, 1958. First Viscount Montgomery of Alamein, Monty became the idol of the British public by turning the tide of battle in the desert, winning victory over Rommel (page 91) at El Alamein in 1942. Here he receives a decoration from Marshal Juin, who commanded the French forces in the Italian campaign.

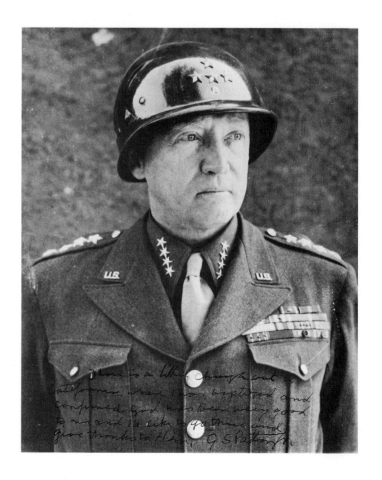

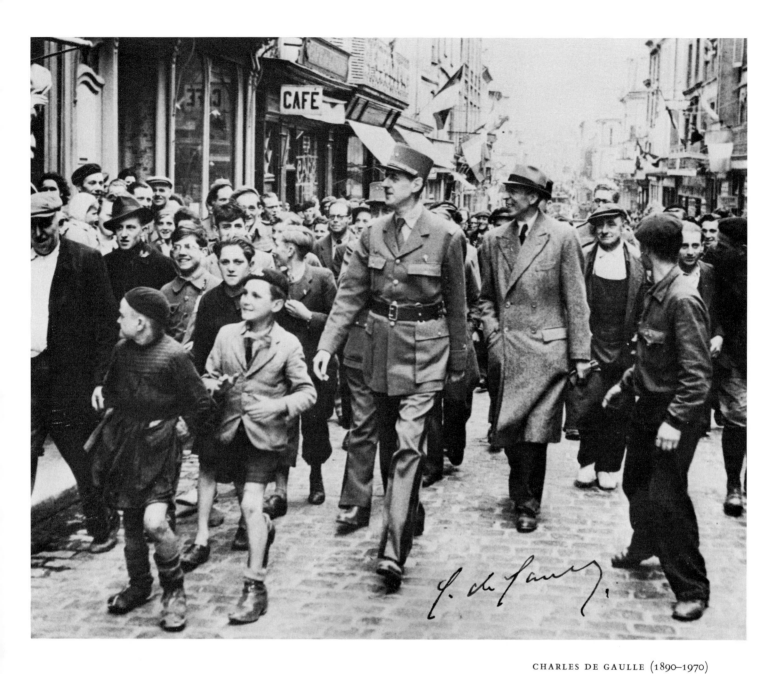

CHARLES DE GAULLE (1890–1970)

1944. The leader of the exiled Free French is shown here entering Paris just after liberation in 1944. The imperious general went on to serve as president of France throughout the 1960s.

GEORGE PATTON (1885–1945)

Circa 1945. The very successful, if controversial, World War II tank commander. Reputedly arrogant and hard-boiled, he shows another side in the inscription (to a minister): "There's a little church out in California where I was baptized and confirmed. God has been very good to me and I'd like to go there and give thanks to him."

<

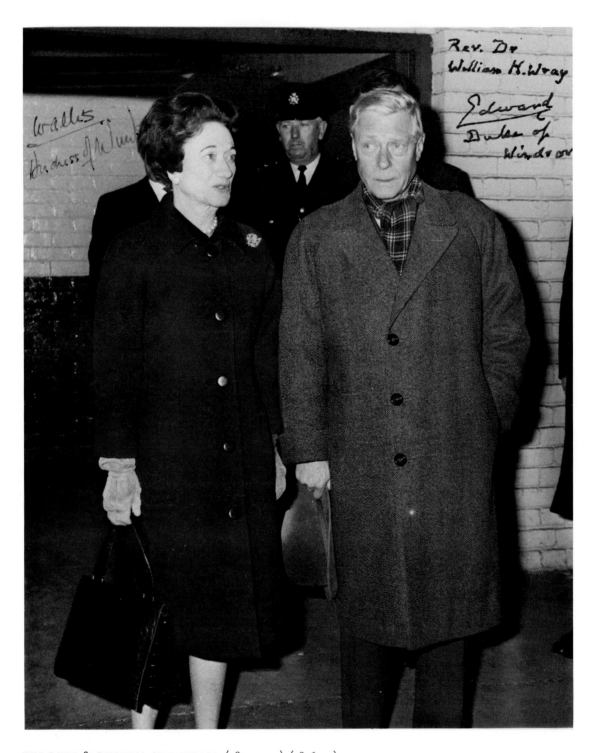

THE DUKE & DUCHESS OF WINDSOR (1894–1972) (1896–)

Circa 1965. The twice-divorced lady from Baltimore could never become Wallis, Princess of Wales, much less queen. He would not be king "without the help and support of the woman [he] loved." So their lives were spent embarking/disembarking, with style rather than substance. But they *were* stylish.

WITH BEST WISHES FOR

CHRISTMAS AND THE NEW YEAR

1947

George R.I. Elizabeth R

KING GEORGE VI (1895–1952) & QUEEN ELIZABETH (1900–)

Dated Christmas 1947. The shy family man who became Rex Imperator after his brother's abdication and his queen (a commoner, but a suitable one), with their daughters – Margaret Rose at the piano, the future Elizabeth II at right.

KING GUSTAF V (1858–1950)

Dated 1938. The tennis-playing king of Sweden, who pursued the sport up to the last years of his long life, was a gifted statesman who initiated Sweden's policy of neutrality during the First World War and maintained it through the Second.

95

GENERAL NAGAOKA (1858–1933)

Dated 1932. The father of Japanese aviation. His mustache, in the shape of an airplane propellor, was reputedly the longest in Japan. When he was buried, it was cut off and placed beside him in a specially made casket.

>

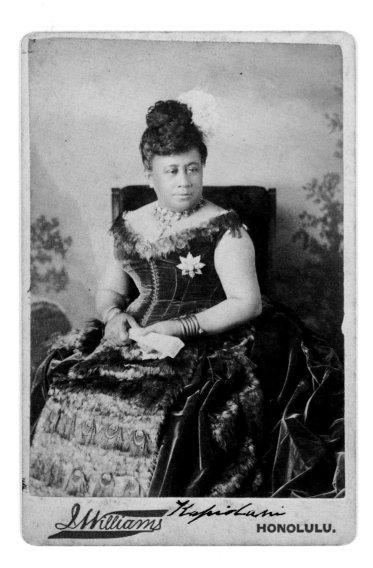

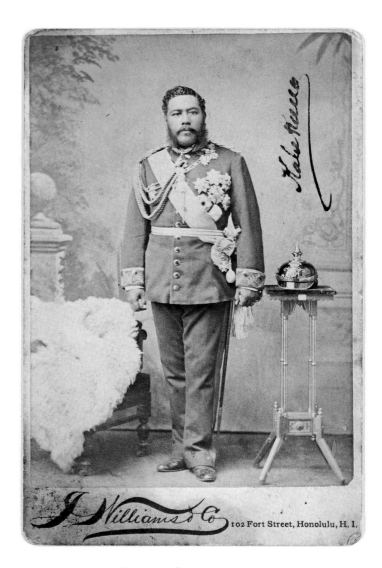

QUEEN KAPIOLANI

Circa 1880. Queen of Hawaii, wife of King Kalakaua. This charming, ebullient woman, here in a peacock-feathered gown, was the unquestioned hit of Queen Victoria's Golden Jubilee in London in 1887.

KING KALAKAUA (1836–1891)

Circa 1880. The king of Hawaii traveled widely in America. Known as "The Merry Monarch," he could, and often did, polish off five bottles of champagne in an afternoon.

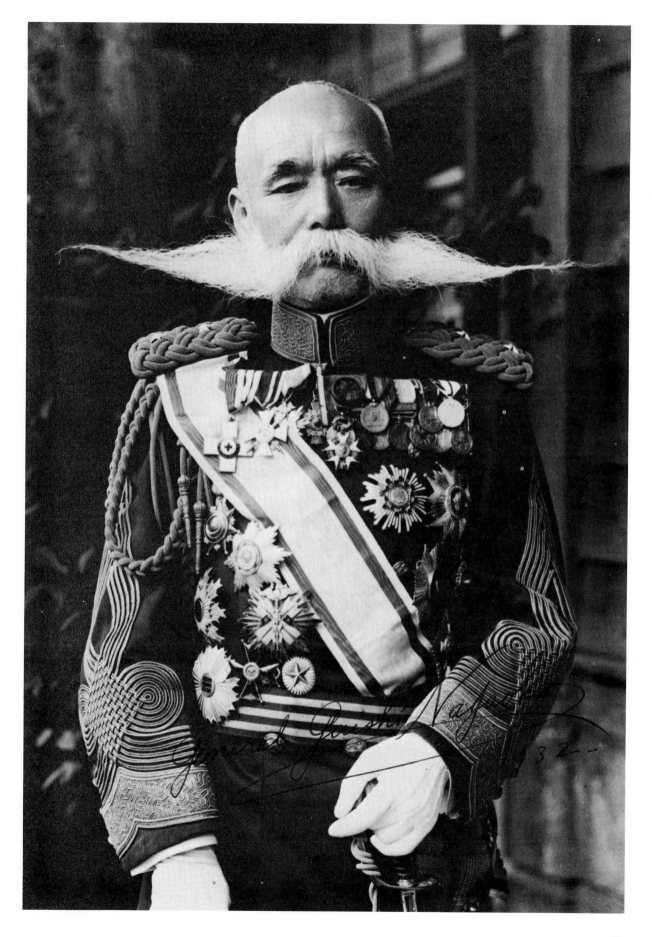

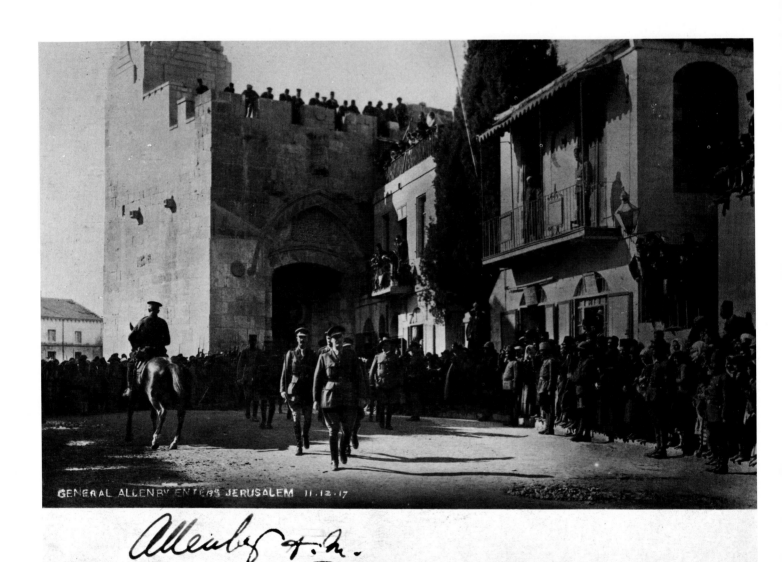

GENERAL ALLENBY ENTERS JERUSALEM 11.12.17

EDMUND ALLENBY (1861–1936)

1917. This photograph records one of the most cherished moments for both Jews and Christians in the history of the Holy Land. General Allenby enters the Jaffa Gate of Jerusalem on December 9, 1917 after his British forces have driven out the Turks. This may be the only copy that Allenby signed; the print was made directly from the negative and bears the stamp of the Imperial War Museum.

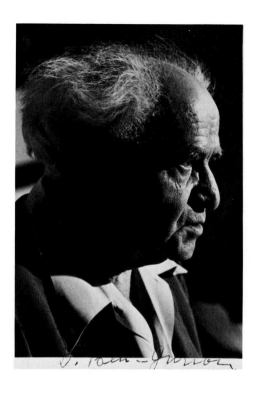

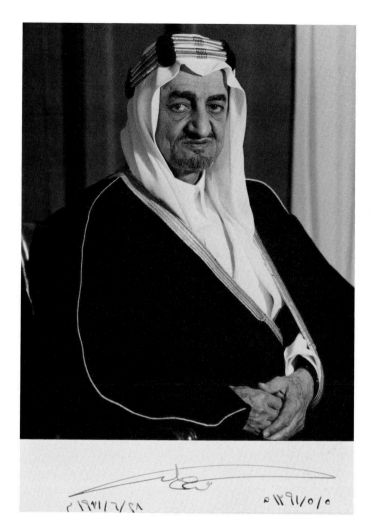

FAISAL IBN ABDUL-AZIZ AL SAUD (1905–1975)

Dated (by Islamic calendar) 5/5/1391 [June 6, 1971]. Faisal was called to the throne of Saudi Arabia in 1964 when the extravagant reign of his half-brother King Saud threatened to ruin the House of Saud. Quite the opposite of his predecessor, Faisal was unostentatious, very religious, and a widely respected leader. He was assassinated by a nephew.

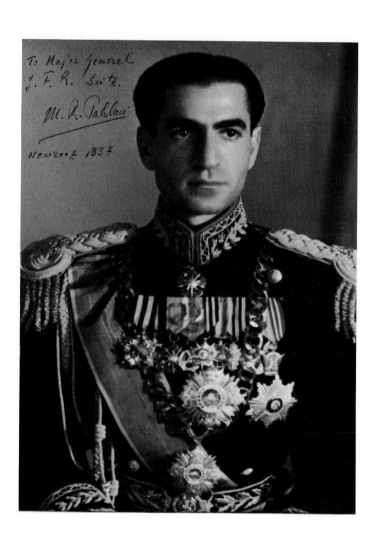

MOHAMMED RIZA SHAH PAHLAVI (1919–1980)

Dated (by Islamic calendar) 1337 [1959]. Ruler of Iran from 1941, the Westernized Shah seemed the pillar of stability in the volatile Middle East until fundamentalist Muslims overthrew his regime in 1979.

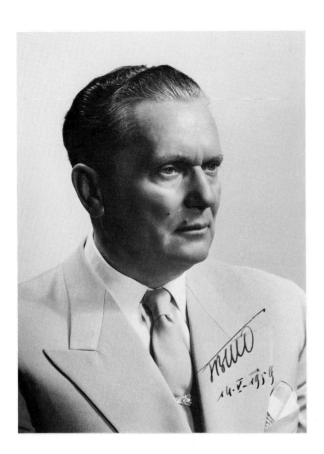

JOSIP BROZ (MARSHAL TITO) (1892–1980)

Dated May 14, 1959. The late powerful Communist boss of Yugoslavia was a maverick in his relations with Moscow. He refused to join the Warsaw Pact alliance against NATO and criticized the Soviets for their goonlike tactics in Czechoslovakia.

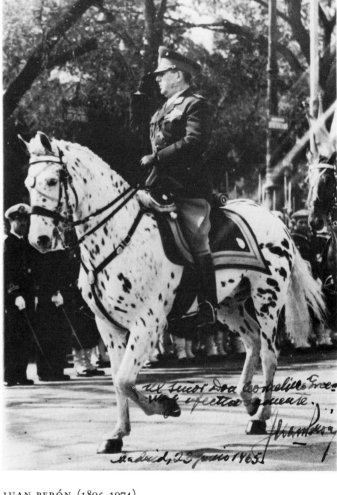

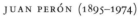

JUAN PERÓN (1895–1974)

June 23, 1965. Admiring the accomplishments of the Fascist regimes in Italy and Germany, the Argentine dictator – seen here appropriately riding a white (well, piebald) horse – tried to build a similar society in his own country. Perón's fame has been enhanced by that of his charismatic first wife, Eva – "Evita" of the Broadway musical.

NIKITA KHRUSHCHEV (1894–1971)

Circa 1960. The extravagant, shoe-pounding Russian leader who faced off against Kennedy in the Cuban missile crisis has come to seem, by contrast with his successors, a jovial character.

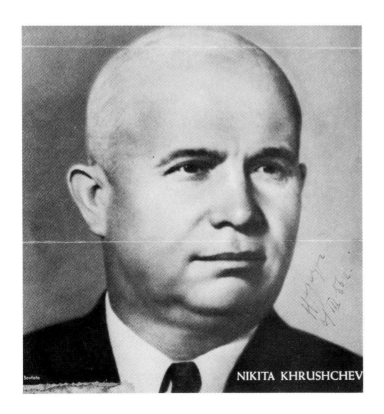

NIKITA KHRUSHCHEV

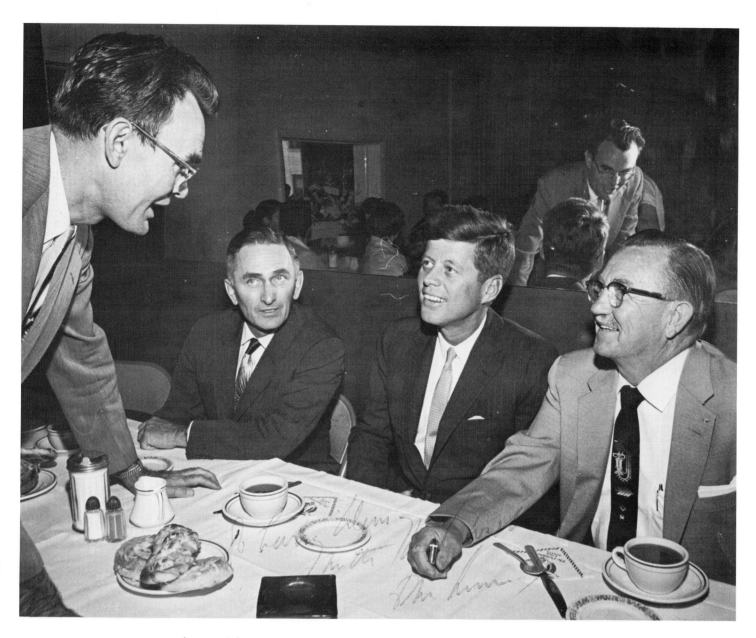

JOHN FITZGERALD KENNEDY (1917–1963)

Circa 1958. Photographs actually signed by the thirty-fifth president of the United States are rare, as most were signed by secretaries or autopen. This photograph was taken in Denver, on a campaign tour.

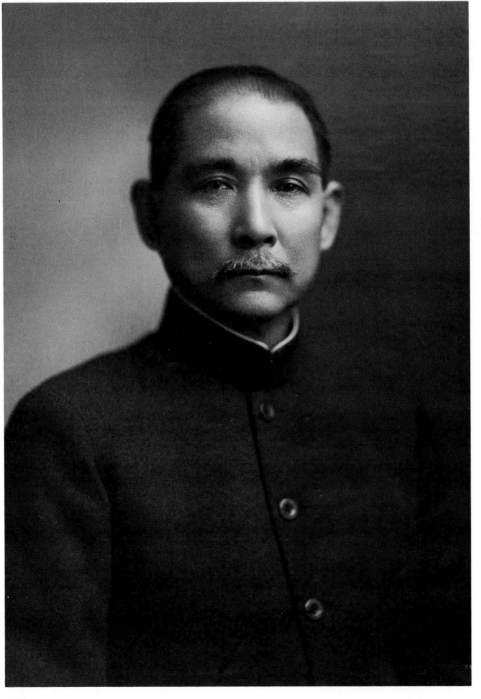

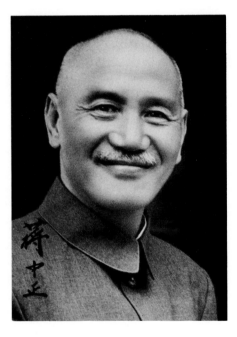

CHIANG KAI-SHEK (1887–1975)

Circa 1950. A military aide to Sun Yat-sen, Chiang initiated the long civil war between his Nationalist forces and the Communists. He lost, and was forced to retreat to the island of Taiwan in 1950.

SUN YAT-SEN (1866–1925)

Circa 1910. Much as George Washington was revered by both sides during the American Civil War, this revolutionary who overthrew the Manchu Dynasty is hailed "Father of China" by Nationalist and Communist Chinese alike.

INDIRA GANDHI (1917–)

Circa 1970. The daughter of India's first prime minister, Jawaharlal Nehru, Indira Gandhi has been the controversial ruler of her country on and off for almost two decades.

MOHANDAS GANDHI (1869–1948)

Dated 1931. Called Mahatma, or "great soul," by his millions of followers, he was able to exact political concessions from the British rulers of India by threatening "fasts unto death" and exhorting his followers to mass acts of civil disobedience. Indian independence came at last in 1946; two years later Gandhi was assassinated by a fanatical follower.

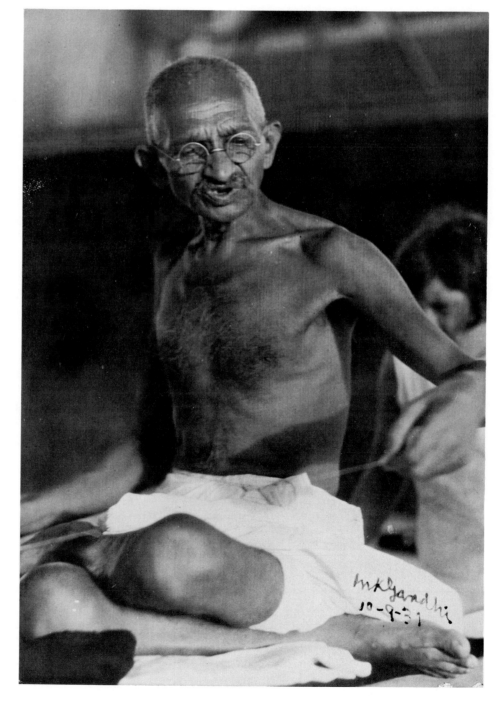

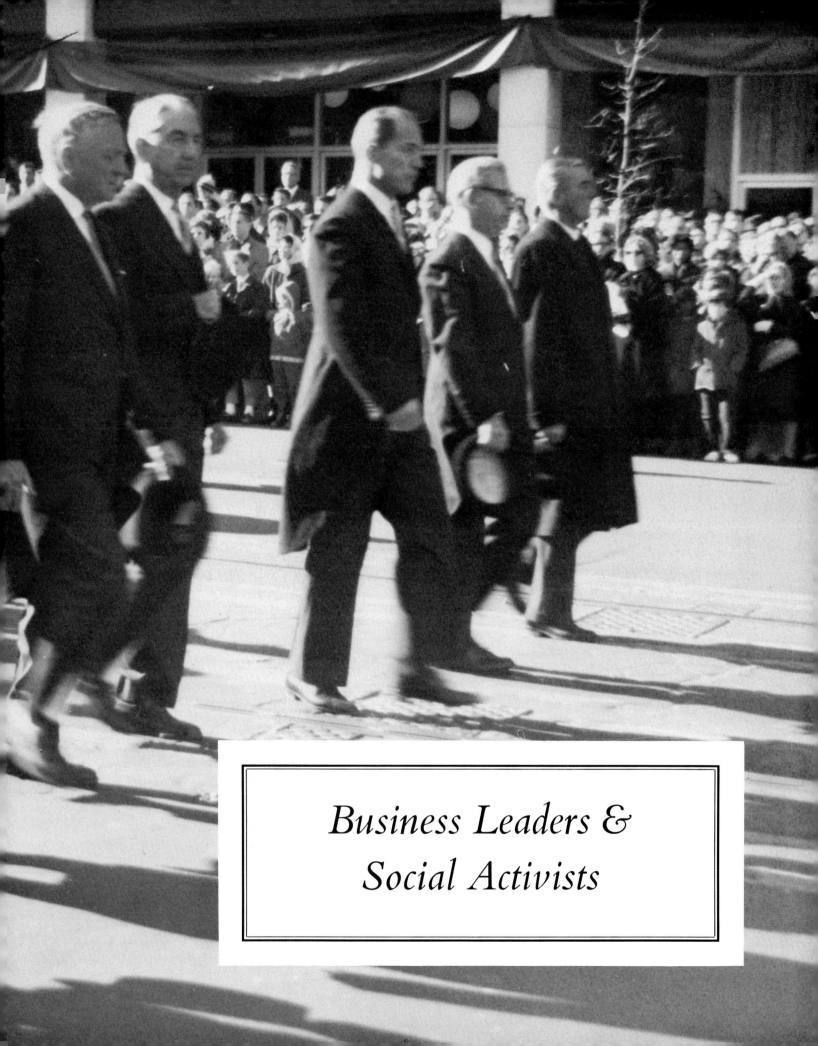

*Business Leaders &
Social Activists*

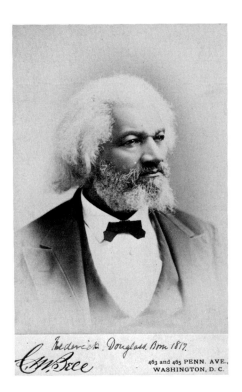

FREDERICK DOUGLASS (1817–1895)

Circa 1885. Born a slave, at the age of twenty-one he escaped to Massachusetts, where he became a fiery spokesman for abolition. After the Civil War Douglass held a number of positions in the United States government, and he has long been revered as the first great leader of the black people in America.

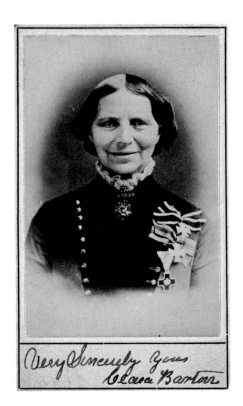

CLARA BARTON (1821–1912)

Circa 1875. The "Angel of the Battlefield" ministered to wounded soldiers in the Civil War and later in the Franco-Prussian War. Her accomplishments (which include founding the American Red Cross) were honored with numerous decorations.

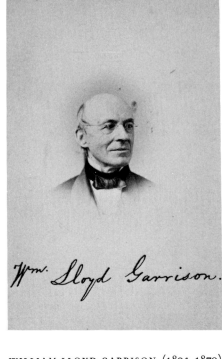

WILLIAM LLOYD GARRISON (1805–1879)

Circa 1865. The famous New England abolitionist branded the U.S. Constitution "an agreement with Hell" because it permitted slavery. Garrison actually advocated Northern secession from the Union some years before the Southern states managed it.

MARY WALKER (1832–1919)

Circa 1877. A Civil War surgeon, she was the first woman to win the Congressional Medal of Honor (which she wears in this photo). Walker called attention to herself and to her advocacy of women's rights by wearing men's attire.

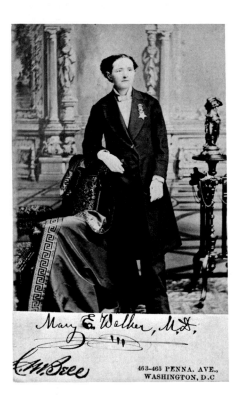

JOHN BROWN (1800–1859)

Circa 1859. John Brown came close to igniting the Civil War a full year before Fort Sumter by organizing a raid on a government arsenal at Harpers Ferry, Virginia, with the plan of arming a slave insurrection. He was quickly captured by troops under U.S. Army Colonel Robert E. Lee and later executed. Also at the scene was a militiaman named John Wilkes Booth.

>

OVERLEAF:

The Warren Court walking nine abreast in the funeral procession of President John F. Kennedy (see page 121).

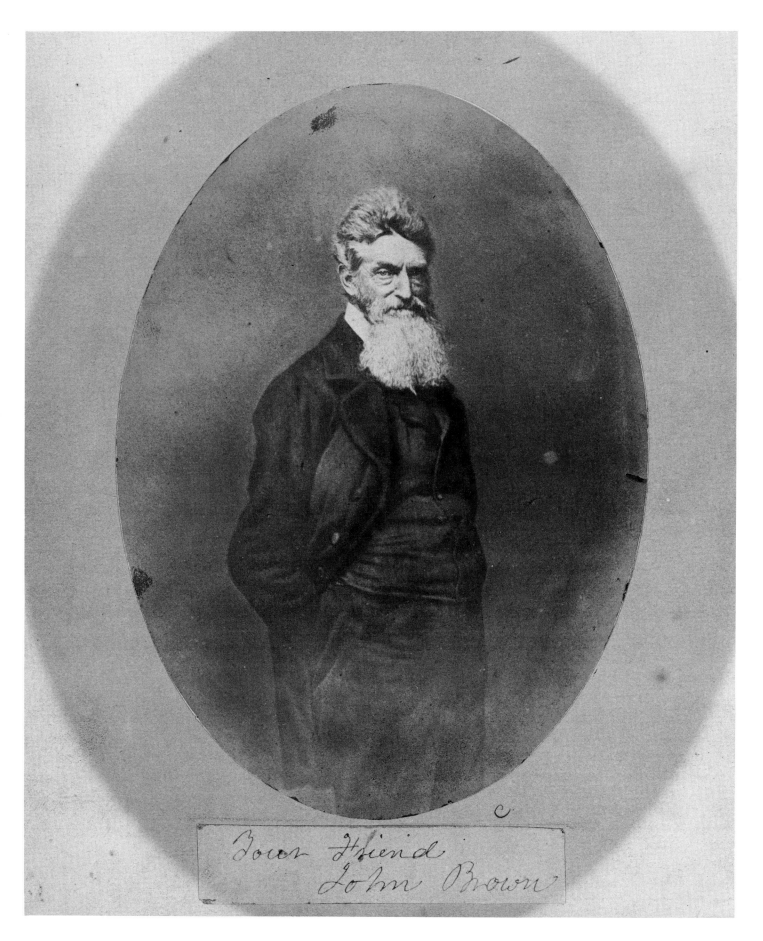

Your Hiend
John Brown

107

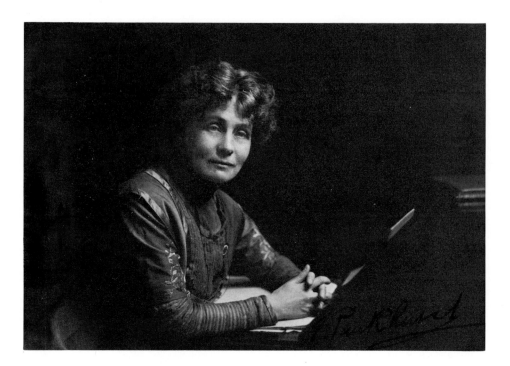

EMMELINE PANKHURST (1858–1928)

Circa 1910. An indefatigable fighter for women's suffrage, she and her supporters employed unusually militant means to bring the vote to English women, using both nonviolent (hunger strikes) and violent (window smashing, arson) means to call attention to the cause.

SUSAN B. ANTHONY (1820–1906)

Dated 1896. The founder of the women's movement in America would be gladdened by the steady gains for women since her death, and astonished to see her portrait on the current one-dollar coin, assuming she could find one.

E. SYLVIA PANKHURST (1882–1960)

Circa 1920. The daughter of Emmeline Pankhurst was an equally militant suffragist, and saw a prison record as a badge of honor. She created a sensation by opposing the institution of marriage, and dared to practice her doctrine by bearing and raising an illegitimate son.

CARRY AMELIA NATION (1846–1911)

Circa 1900. The self-styled "Home Defender" holds the famous hatchet that smashed saloons across America. Her size (6 feet, 175 pounds) and her stern demeanor made her more than a match for her often besotted opposition.

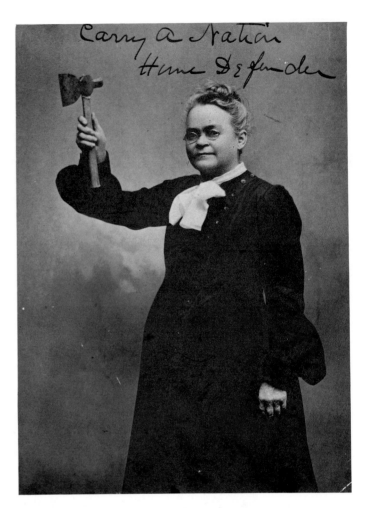

HENRY WARD BEECHER (1813–1887)

Circa 1875. The famous preacher, abolitionist, and orator was brother of the author of *Uncle Tom's Cabin* (page 52). His outspoken support for women's rights had been carried too far, in the opinion of some, when he was named in a sensational adultery trial.

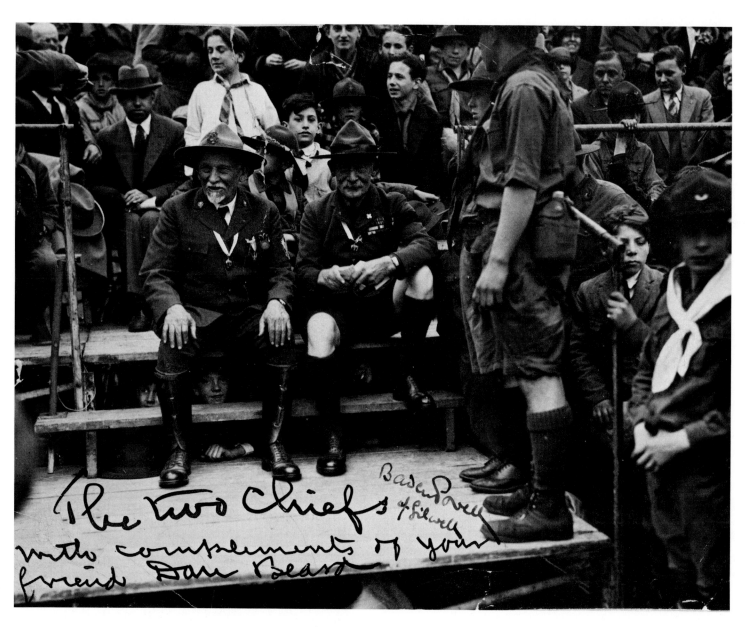

The two Chiefs with compliments of your friend Dan Beard

Baden Powell & Gilwell

WILLIAM BOOTH (1829–1912)

Circa 1900. The founder and first general of the Salvation Army, this Englishman successfully spread his troops of charity worldwide.

<

DANIEL BEARD (1850–1941) &
ROBERT BADEN-POWELL (1857–1941)

Circa 1925. "The two Chiefs" are the American and English founders of the Boy Scouts. Beard was a prominent artist, while Lord Baden-Powell was a professional soldier, commander at Mafeking during the famous siege in the Boer War.

TOM MOONEY (1883–1942)

Dated January 8, 1939. A labor leader convicted of bomb killings, Mooney was widely thought to be innocent. He was pardoned after twenty-two years behind bars, some of that time on death row. The day after his release in 1939 he marched at the head of this parade in San Francisco.

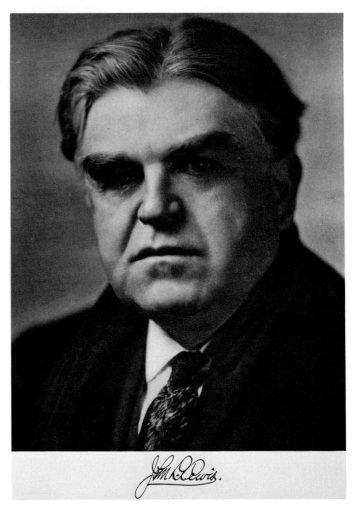

JOHN L. LEWIS (1880–1969)

Circa 1935. The stormy and colorful labor leader headed the United Mine Workers for forty years. He also founded the Congress of Industrial Organizations (CIO) in protest of policies of the American Federation of Labor (which he also helped found), but lived to see the two merge and become the most powerful union in the country.

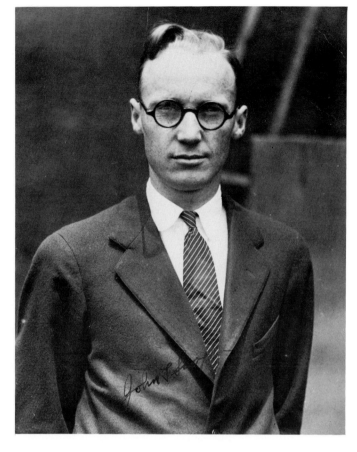

JOHN T. SCOPES (1900–1970)

Circa 1925. A Tennessee schoolteacher blinking in the glaring light of a cause célèbre. The defendent in the famous "Monkey Trial" of 1925, he was charged with violating state law by teaching the theory of evolution. Defended by Clarence Darrow, he was found guilty and fined $100.

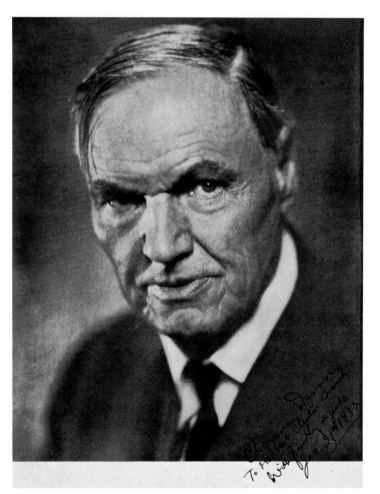

CLARENCE DARROW (1857–1938)

Dated Jan. 31, 1935. A passionate advocate of liberal causes, he defended Scopes against a prosecution led by the great orator William Jennings Bryan. Though Darrow argued persuasively, he lost his case in what was regarded as a Pyrrhic victory for the anti-evolution forces, though the Bible-versus-Darwin debate has never really ended. A superb portrait by Nickolas Muray.

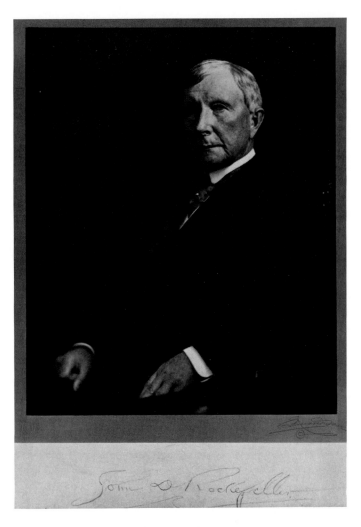

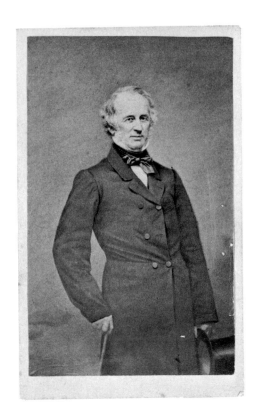

JOHN D. ROCKEFELLER (1839–1937)

Circa 1900. The world's most famous tycoon personified the Horatio Alger myth of rags to riches: he advanced from bookkeeper to ruler of the world petroleum business. He usually signed in pencil.

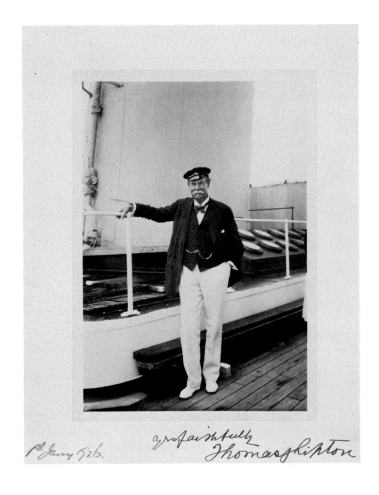

THOMAS LIPTON (1850–1931)

Dated 1926. Lipton built a small grocery in Glasgow into a worldwide tea empire by the age of thirty. He devoted the rest of his life to yachting.

114

CORNELIUS VANDERBILT (1794–1877)

Circa 1865. A man of commanding presence known as "The Commodore" for his steamboat fleet on the Hudson River, Vanderbilt soon expanded into railroads and became the richest man in America.

<

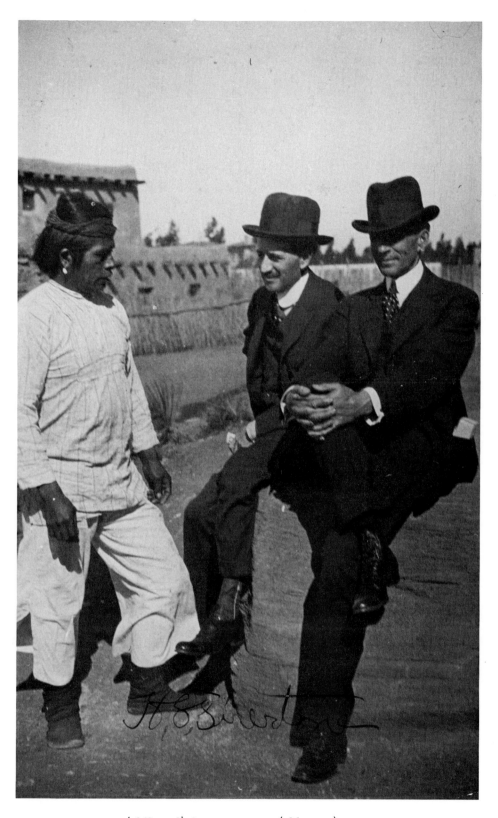

HARVEY FIRESTONE (1868–1938) & HENRY FORD (1863–1947)

1915. The Model T Ford, equipped with Firestone's pneumatic tires, revolutionized American society. Here the automobile and tire tycoons are seen enjoying themselves at an Indian pueblo. The apparently unsuitable attire is explained by the fact that they are visiting the San Diego International exposition.

ANDREW MELLON (1855–1937)

Circa 1930. A Pittsburgh millionaire with major holdings in oil, steel, railroads, and aluminum, he was U.S. secretary of the treasury at the onset of the Great Depression. His deep, and well-funded, interest in art collecting led to the foundation of the National Gallery in Washington, D.C.

ANDREW CARNEGIE (1835–1919)

1905. This immigrant weaver from Scotland built Pittsburgh into the steel capital of the world and then retired to disburse his wealth for the benefit of arts and learning.

JAMES CASH PENNEY (1875–1971)

Circa 1925. The founder of the J. C. Penney mercantile empire started modestly enough with a one-third interest in a dry goods store in Kemmerer, Wyoming.

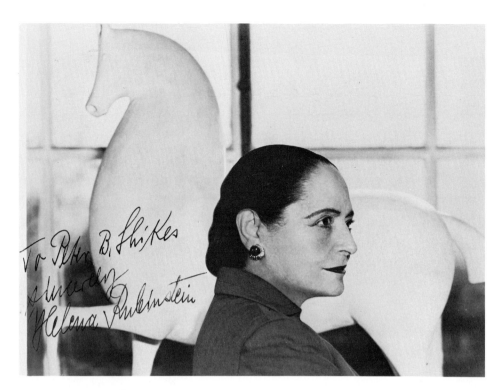

HELENA RUBINSTEIN (1870–1965)

1962. A child of the Krakow ghetto, she came to America, and at her death was one of the ten richest women in the world, with a fortune based on a skin cream she first concocted in her basement. The sculpture in the background, in the foyer of her apartment, is by Elie Nadelman.

JEAN PAUL GETTY (1892–1976)

Circa 1960. In 1958 this little-known oil investor, operating with a single secretary from a London hotel, was revealed to be the world's richest man. "I'm a small-sized fellow, a small-sized outfit, so I've never had delusions of grandeur," he told reporters. The J. Paul Getty Museum in California is now – appropriately – the world's most richly endowed museum.

Entered according to Act of Congress, in the year
1864, by C. R. SAVAGE, in the Clerk's Office of the
3rd Judicial District of the Territory of Utah.

BRIGHAM YOUNG (1801–1977)

1864. Young led the great migration of
Mormons to Utah in 1847 and presided
over the phenomenal growth of their
colony. He is remembered for his wise
leadership and moral life – as well as for
his numerous wives.

BOOKER T. WASHINGTON (1856–1915)

Dated June 7, 1909. The former slave and
coal miner set up the Tuskegee Institute
in 1881 to give the recently emancipated
black man the skills to become
economically independent.

Montgomery, Alabama's
REV. MARTIN LUTHER KING

"The strong man is the man who can
stand up for his rights and not hit back

With Best Wishes
Martin L. King Jr.
4/1/57

MARTIN LUTHER KING (1929–1968)

Dated April 1, 1957. His leadership in the civil rights movement
helped to reverse centuries of discrimination and won for him a
Nobel Peace Prize, before he was assassinated at the age of thirty-
nine. The inscription may be the only existing statement of his
credo written in his own hand, making this an historic document.

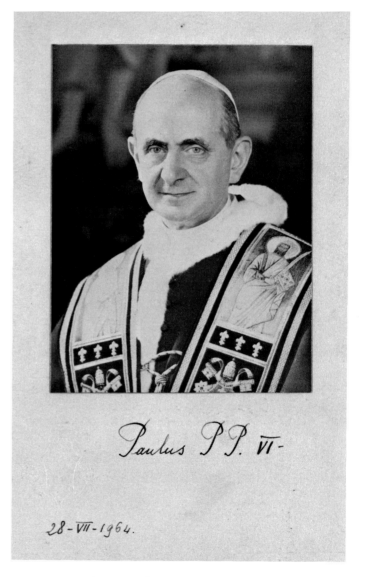

Paulus P.P. VI

28-VII-1964.

POPE PAUL VI (1897–1978)

Dated July 28, 1964. The two hundred sixty-first pope (1963–1978)
in the succession from Saint Peter was the first to visit America,
where he said a mass before thousands assembled at Yankee
Stadium.

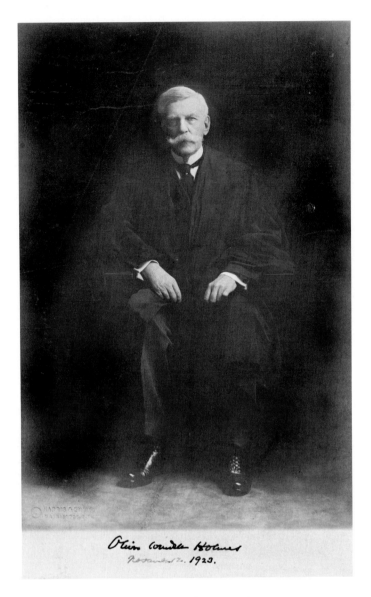

OLIVER WENDELL HOLMES, JR. (1841–1935)

Dated 1923. The distinguished jurist served on the Supreme Court for thirty years, from the presidency of Theodore Roosevelt to that of Franklin Roosevelt. Still dashing in his nineties, he is said to have remarked on passing a pretty girl, "Oh, to be eighty again!"

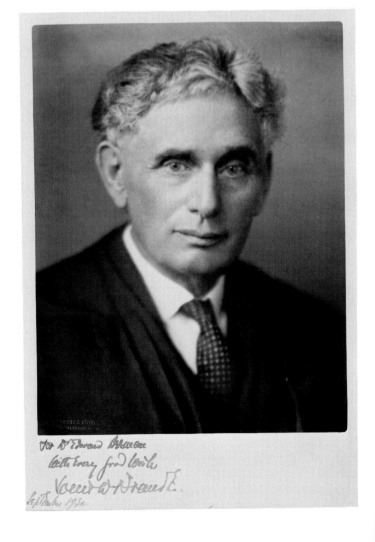

LOUIS BRANDEIS (1856–1941)

Dated September 1934. Appointed by Woodrow Wilson to the High Court, Brandeis was the first Jewish member in its history. He and Holmes were for many years the Supreme Court's sole voices for judicial liberalism.

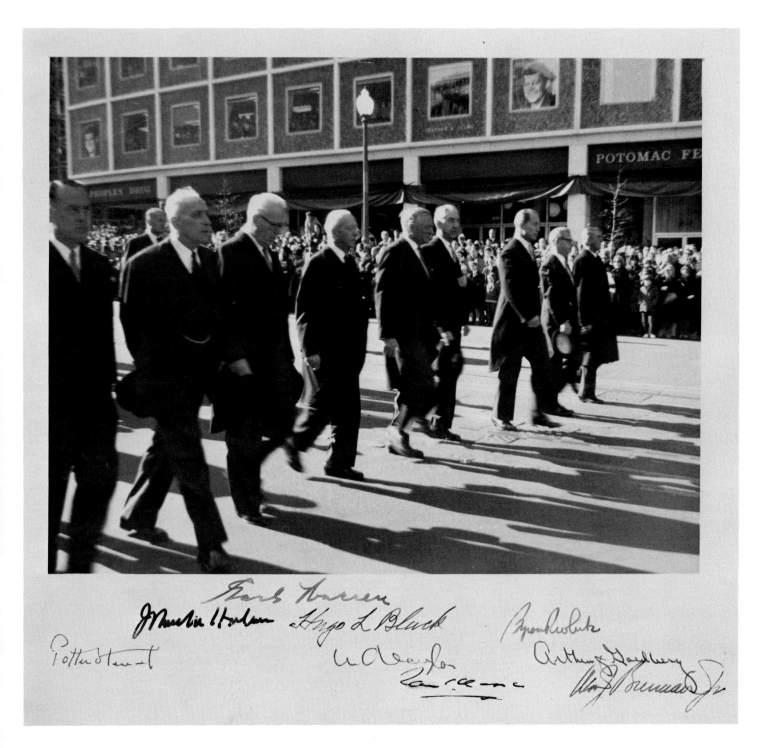

THE WARREN COURT

1963. This unusual photograph, taken during the funeral of
President John F. Kennedy, shows the nine justices of the historic
Warren Court, which was responsible for many landmark decisions
in civil rights and civil liberties.

Potter Stewart (1915–); John M. Harlan (1899–1971);
Chief Justice Earl Warren (1891–1974);
Hugo L. Black (1886–1971); William O. Douglas (1898–1980);
Tom C. Clark (1899–1977); Byron R. White (1917–);
Arthur J. Goldberg (1908–); William J. Brennan (1906–).

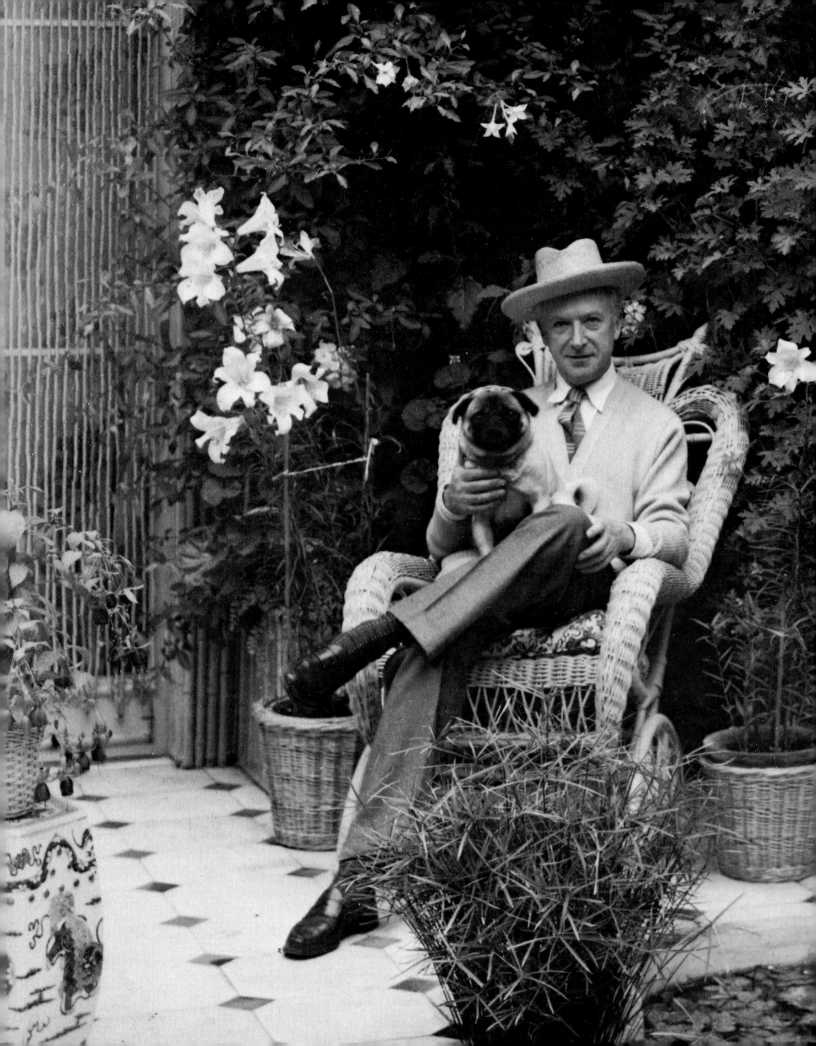

Artists

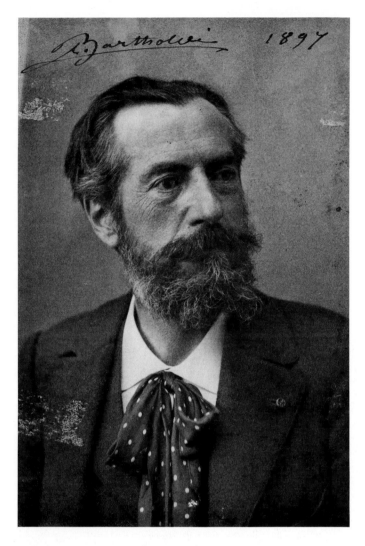

FRÉDÉRIC BARTHOLDI (1834–1904)

Dated 1897. The French sculptor who created the American symbol: the Statue of Liberty erected on Bedloe's Island, in New York Harbor, in 1886. Another Frenchman, Gustave Eiffel, was responsible for its inner structure.

OVERLEAF:

Cecil Beaton (see page 138)

ALEXANDRE GUSTAVE EIFFEL (1832–1923)

Circa 1885. An engineer, and apparent magician, Eiffel used webbings of iron and steel to build structures of poetic beauty. The Eiffel Tower (which has been called the world's most expensive elevator shaft) was created for a passing event, the Exposition Universelle of 1889, but it became a permanent symbol of the city of Paris. The photograph is by Nadar.

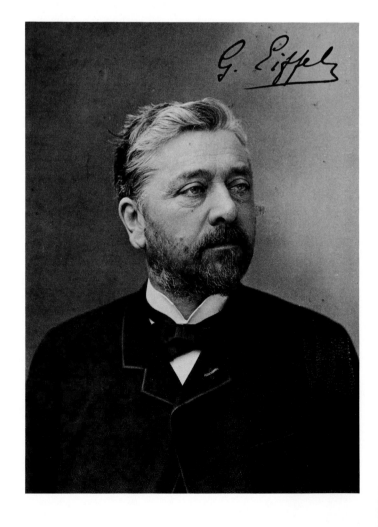

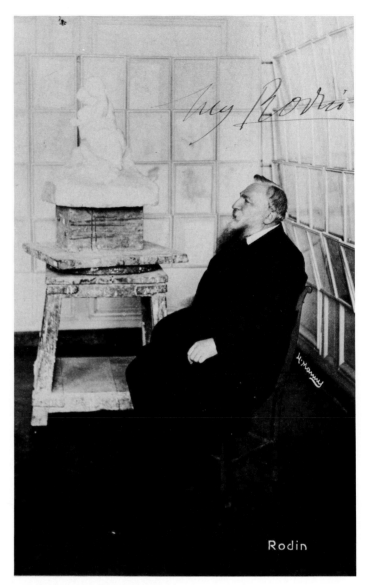

Rodin

AUGUSTE RODIN (1840–1917)

Circa 1910. This French sculptor was the most famous artist in the
world at the beginning of the century, and his *Thinker* is part of
everyone's mental furniture. Modernist sculptors *had* to revolt
against such a towering figure, but they owed much to his
innovations, like the use of fragmentary figures as finished works.

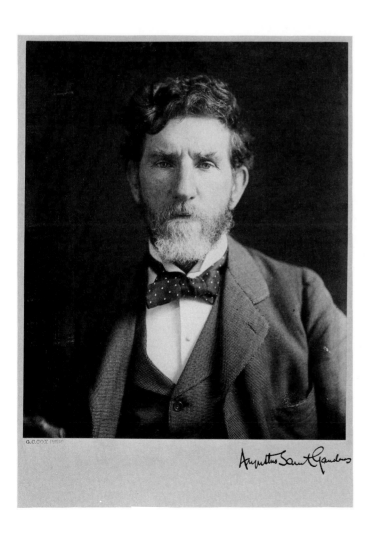

AUGUSTUS SAINT-GAUDENS (1848–1907)

Circa 1890. Many say the finest American sculptor. He revitalized
the public monument and memorial with a vigorous, coherent
realism. Passersby should take a fresh look at familiar landmarks
like the Shaw memorial on Boston's Beacon Hill and the equestrian
General Sherman at the entrance to New York's Central Park.

AUBREY BEARDSLEY (1872–1898)

Circa 1896. This English illustrator died of tuberculosis at twenty-six, but he had already made his mark with illustrations for *Yellow Book* and the *Salomé* of Oscar Wilde (page 56) – highly stylized black-and-white drawings, drenched in eroticism and *fin-de-siècle* spirit. The photo is inscribed to Mrs. Beerbohm.

JAMES MONTGOMERY FLAGG
(1877–1960)

Circa 1925. The signature shows the flair and forcefulness that marked the work of this very popular American illustrator. He was best known for his immensely effective recruiting poster for World War I (reissued during World War II) showing a stern Uncle Sam – modeled on himself – pointing directly at the viewer with the caption "I Want You."

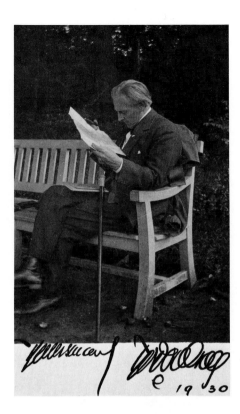

GORDON CRAIG (1872–1966)

Dated 1930. The English director and stage designer was known especially for his expressive use of lighting – and he chose to autograph a picture in which the light streams expressively onto the paper he holds. His immensely creative signature is at once illegible, energetic, and aesthetically interesting. Craig was the son of actress Ellen Terry (page 182) and the longtime lover of Isadora Duncan (page 143).

MAXFIELD PARRISH (1870–1966)

Circa 1935. By the 1920s this American illustrator was one of the most widely reproduced artists in the world, and his exotic gold-and-blue dream world (*The Garden of Allah*) has never lost its charm. (Like the photos of Flagg and Gibson, and others in these pages, this one is inscribed to Edgar A. Moss, an enterprising autograph collector who had an advertising agency in Greensboro, North Carolina.)

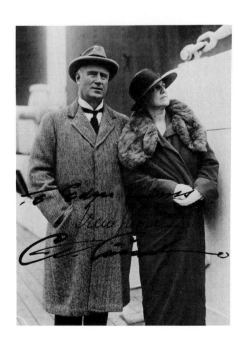

CHARLES DANA GIBSON (1867–1944) & IRENE GIBSON

Circa 1920. His stylish and skillful pen-and-ink drawings of the doings of high society had an unexpected side effect, changing America's concept of the beautiful woman from the buxom Lillian Russell type (page 182) to the wasp-waisted, haughty, athletic "Gibson Girl." Her beaux were beardless, and suddenly beards were out.

CLAUDE MONET (1840–1926)

Circa 1920. "Only an eye, but what an eye!"
Cézanne is supposed to have said of the
great French impressionist. Monet is seen
in his late years, spent contently and
productively in Giverny, painting, creating
his extraordinary garden, and receiving
the hommage denied him in the early
days of impressionism.

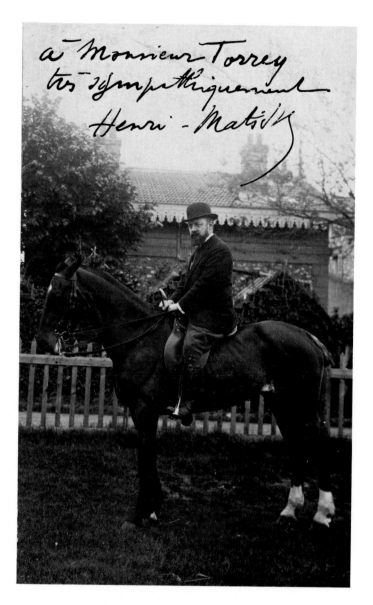

HENRI MATISSE (1869–1954)

Circa 1910. The bourgeois gentleman on horseback was also a
revolutionary master. The leader of the *Fauves* ("Wild Beasts"),
he gave a new direction to twentieth-century painting with his
brilliant color, arabesques, and flat patterns.

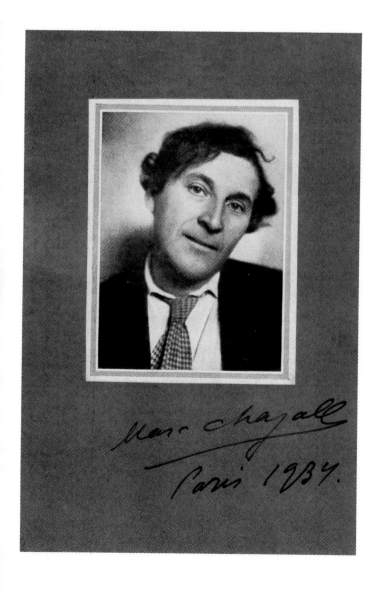

MARC CHAGALL (1887–)

Dated 1934. The face of a witty dreamer. The Russian-born painter
spent much of his life in Paris, but the cats and cows and villagers
of his homeland float through his colorful, poetic fantasies on
canvas.

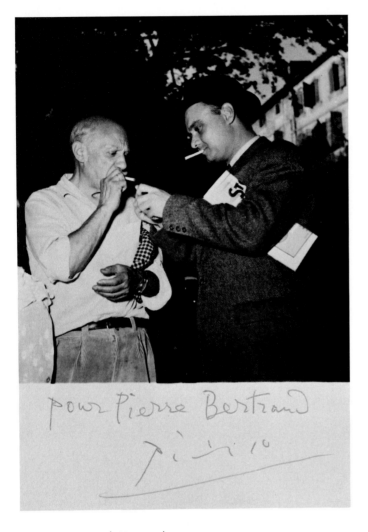

PABLO PICASSO (1881–1973)

Circa 1945. The most prodigious creative talent of the twentieth century came from his native Spain to settle in Paris at the turn of the century, and art and the art world were never the same again. His companion is writer Pierre Bertrand, to whom the photo is inscribed.

SALVADOR DALI (1904–)

Dated 1956. Unforgettable imagery – such as melting watches rendered with reassuring realism and dazzling technical skill – along with an outrageous personal style made this Spanish painter one of the most widely known artists of his time, and to many his brand of surrealism was synonymous with "modern" art. In this photo, as in some of his drawings, he turns his signature into a delightful design element.

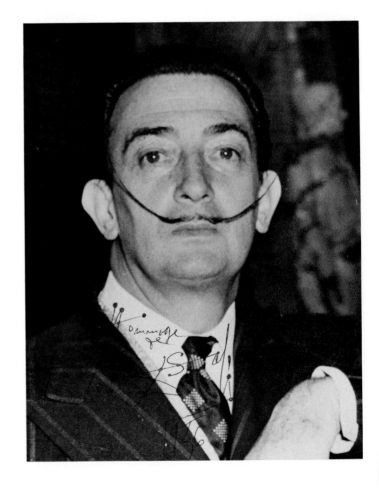

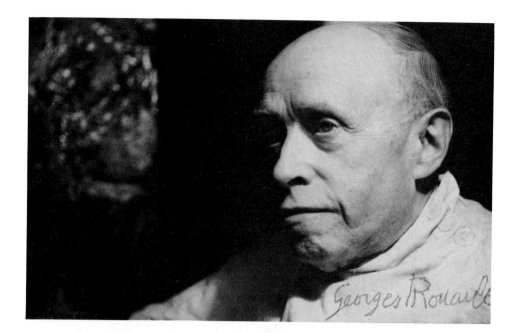

GEORGES ROUAULT (1871–1958)

Circa 1948. A sense of sin and a powerfully expressive style make the work of this French painter and graphic artist unmistakable. Leering prostitutes, complacent judges, tragic clowns emerge from brutal contours and violent colors.

MARCEL DUCHAMP (1887–1968)

Dated 1963. He intended to scandalize and succeeded, first with *Nude Descending a Staircase* ("an explosion in a shingle factory," said the philistine), then with the nonsense works of the Dada movement (a reproduction of the *Mona Lisa* decorated with a mustache and an obscene caption). Cerebral, inventive, influential, he gave up art for chess, but remains a modernist saint.

LE CORBUSIER (1887–1965)

Dated August 1931. Charles Edouard Jeanneret, the high priest of architectural functionalism ("a house is a machine for living"), in a less austere moment – poking his head through a carnival bullfight scene in Spanish Morocco. The hastily written, tongue-in-cheek inscription ("to my passionate admirer") runs over image and mat.

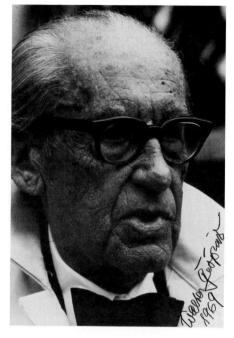

WALTER GROPIUS (1883–1969)

Dated 1969. The glass and steel curtain wall of his Fagus factory (1911) is a landmark of modern architecture, but Gropius's innovations as one of the major architects of the twentieth century are often overshadowed by his enormously influential role as teacher: as founder (1919) and director of the Bauhaus, and then, after he fled Hitler's Germany, as a professor at Harvard.

FRANK LLOYD WRIGHT (1867–1959)

Circa 1935. Flamboyant, opinionated, egocentric – a proper genius. The dominant figure in American architecture in the first half of the twentieth century, he was a modernist who shunned the international style of Le Corbusier and Gropius in favor of a more organic expression, as in his private houses with horizontal lines that linked them to their sites.

Circa 1945. Here with their signatures and some drawings are the creators of some of the great comic strips of the '30s and '40s: from the left, Alex Raymond (*Flash Gordon*), Otto Soglow (*The Little King*), Harry Foster Welch (*Popeye* although Welch was not the creator of this cartoon), Arthur "Bugs" Baer (sports cartoonist who incorporated strange little insects into his drawings), George McManus (*Maggie and Jiggs*), Russ Westover (*Tillie the Toiler*).

HAROLD GRAY (1894–1968)

Circa 1930. For forty-four years, beginning in 1924, Harold Gray drew Little Orphan Annie, her faithful dog Sandy, and her guardian and mentor, Oliver "Daddy" Warbucks. Spunky Annie's life of adventure and intrigue inspired the charming Broadway musical *Annie.* Gray incorporated a drawing of Annie in this inscription.

WALT DISNEY (1901–1966)

Circa 1940. Cartoonist, motion-picture producer, businessman; creator of Mickey Mouse, Donald Duck, and Disneyland. Disney is rare in authentically signed photographs, as most were signed by his staff artists.

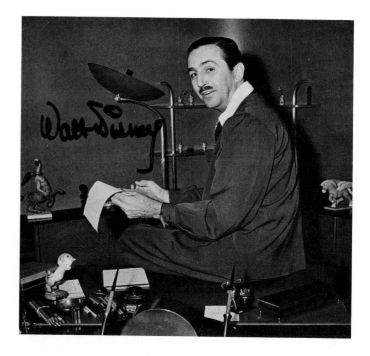

ROBERT RIPLEY (1893–1949)

Dated March 2, 1932. Ripley's *Believe It or Not*, in which bizarre (and sometimes not at all bizarre) facts were illustrated with simple sketches, was one of the most widely syndicated newspaper features of the 1930s and '40s. By calling attention in 1929 to the lack of a national anthem, Ripley played a major role in the adoption of "The Star-Spangled Banner." Tourist Ripley inscribed this photo to Mayor Jimmy Walker of New York City.

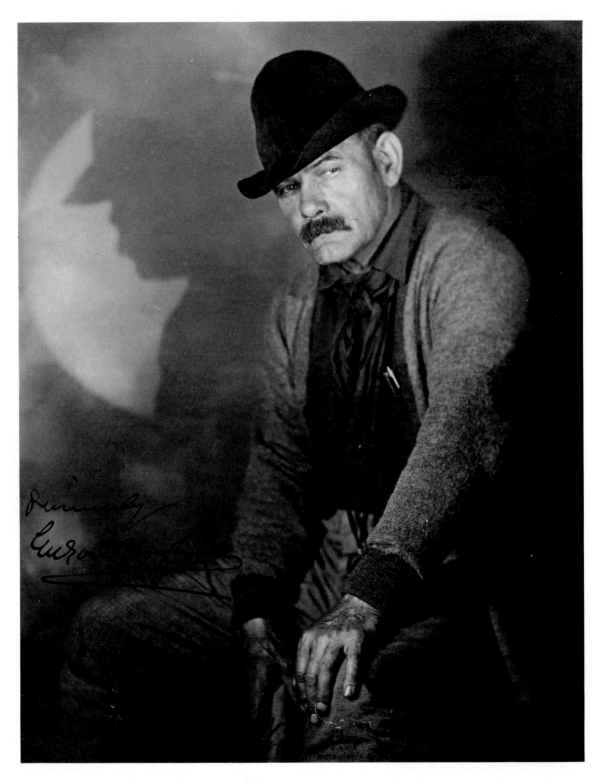

GUTZON BORGLUM (1867–1941)

Circa 1930. The American sculptor who conceived and developed the Mount Rushmore (South Dakota) monument – four 60-foot-high heads of presidents Washington, Jefferson, Lincoln, and Theodore Roosevelt carved from living rock. "Captured in this photograph with a fineness that Weston would have envied are hands that tell why this man sculptured mountains." (J. D. Reed, *Time*)

MARIE COSINDAS

Circa 1955. The pioneer of Polacolor, renowned for her glowing, carefully ordered portrait and still-life photographs. "Marie Cosindas," wrote Tom Wolfe, "has advanced the state of the art in color photography to a plateau that only she has been able to occupy." An old friend, she responded to my request for an autographed picture with this amusing photograph of a photograph.

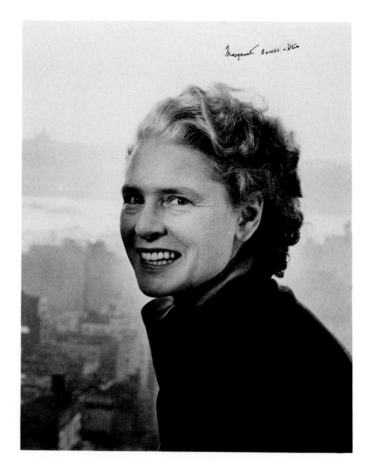

MARGARET BOURKE-WHITE (1904–1971)

Circa 1955. A trailblazer. Photojournalist, pioneer of the photoessay (a Bourke-White image was on the first cover of *Life*), photographer of Stalin, Gandhi, and the survivors of Buchenwald. Still handsome at the time of this photo, she was forced to cut short her career because of Parkinson's disease, whose inroads are apparent in the signature here.

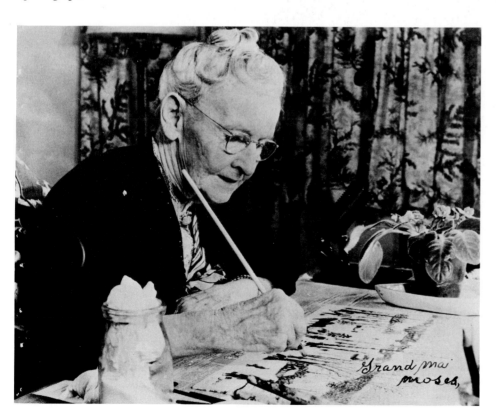

ANNA MARY ROBERTSON MOSES (1860–1961)

Circa 1950. Everybody's Grandma. Discovered at age eighty-one, this upstate New York farmwife charmed us all with her naive scenes of rural and village life. *The New York Times* art critic John Canaday summed it up: "Her magic was that she knew how magical it is to be alive, and in her painted records of her life she managed to relay some of that magic to the rest of us."

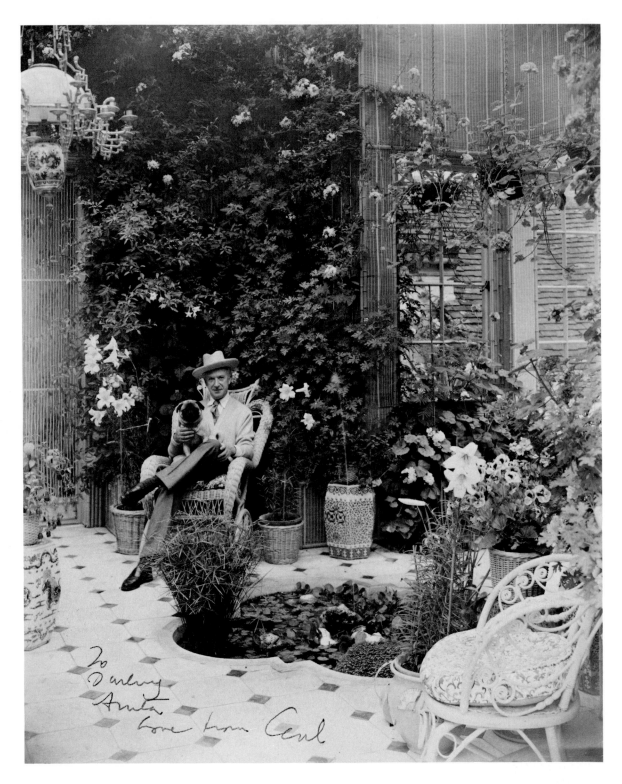

CECIL BEATON (1904–1980)

Circa 1965. Beaton (ultimately Sir Cecil) was at home in the circles of British royalty and celebrities of the fashion and entertainment world (notably Greta Garbo) he photographed so memorably, but his penetrating war photographs show another side. The famous black-and-white costumes he created for *My Fair Lady* seem appropriate to someone of his elegant personal style. This self-portrait is inscribed to the writer Anita Loos.

138

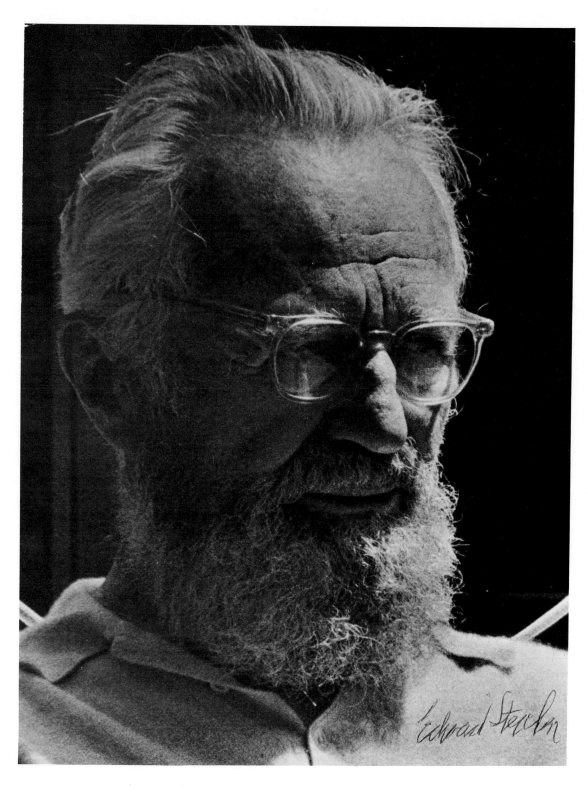

EDWARD STEICHEN (1879–1973)

Circa 1960. One of the great photographers of the century. His own
superb works, his long career, and his energetic participation in the
photography world made him one of its most significant figures. As
director of the influential photography department of the Museum
of Modern Art in New York, he organized its famous show
The Family of Man. (He was, incidentally, married to the sister of
Carl Sandburg, page 53.)

Musicians & Dancers

OVERLEAF:

Arturo Toscanini (see page 148).

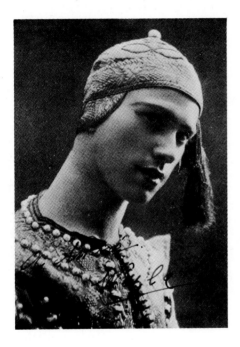

WASLAV NIJINSKY (1890–1950)

Circa 1915. The legendary star of the Ballet Russe, Nijinsky went insane at the peak of his career and was committed to an asylum for the rest of his life. Autographed photographs of the dancer are very rare; this one is inscribed to "André."

ANNA PAVLOVA (1881–1931)

Circa 1920. Pavlova first achieved renown dancing for the Ballet Russe with Nijinsky. Her perfect technique and ethereal charm made her the most acclaimed ballerina of her time.

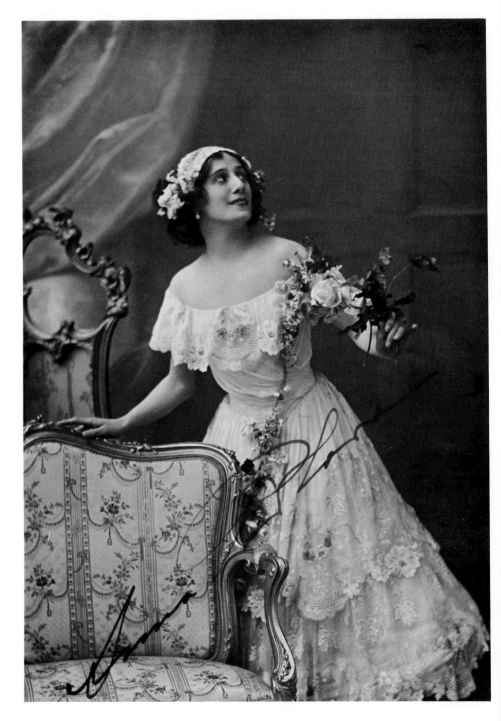

ISADORA DUNCAN (1878–1927)

Dated 1914. In her Greek tunic and flowing scarves, Isadora invented modern dance by moving to music that was not written to be danced. She died in a bizarre accident when her flowing scarf caught in the wheel of a moving car.

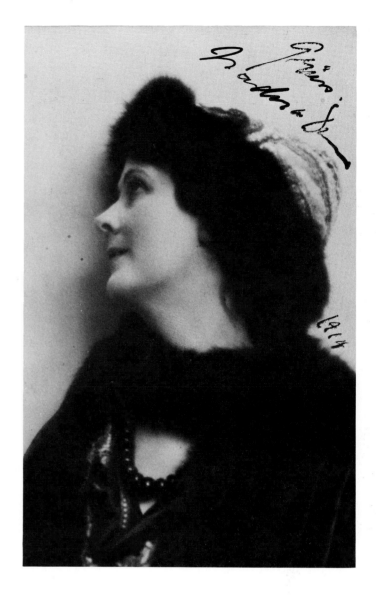

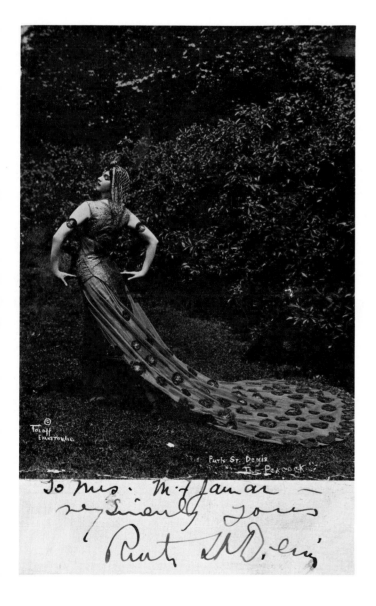

RUTH ST. DENIS (1878–1968)

Circa 1910. Known as the "First Lady of American Dance," she studied the cultures, religions, and dances of ancient Egypt and India, and her notions of spiritual expression profoundly influenced the course of modern dance. Martha Graham (page 154) was one of her students.

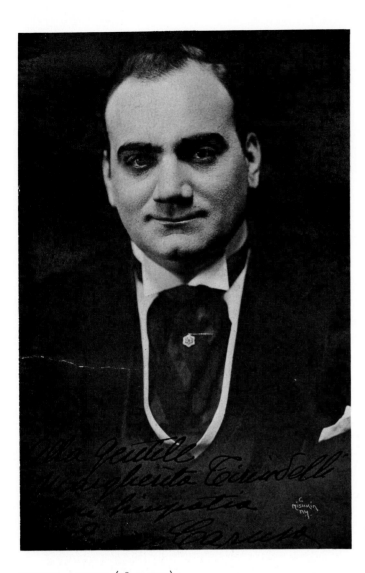

ENRICO CARUSO (1873–1921)

Circa 1910. The legendary Italian tenor lived into the age of the phonograph, and his recordings support the claim that he was probably the greatest of all opera singers.

LUISA TETRAZZINI (1871–1940)

Dated 1908. The Italian coloratura was one of the great opera stars of the pre-World War I era, and *prima donna assolutà*. Her fame as an opera singer has been submerged in the chicken casserole named in her honor.

Dated 1907. The Australian operatic soprano, who took her name from the city of Melbourne, conquered continents with her coloratura. Dame Nellie inspired two elegant creations: a peach dessert and a very light toasted bread.

>

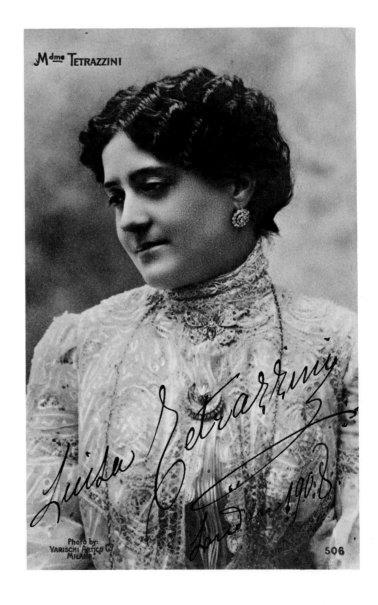

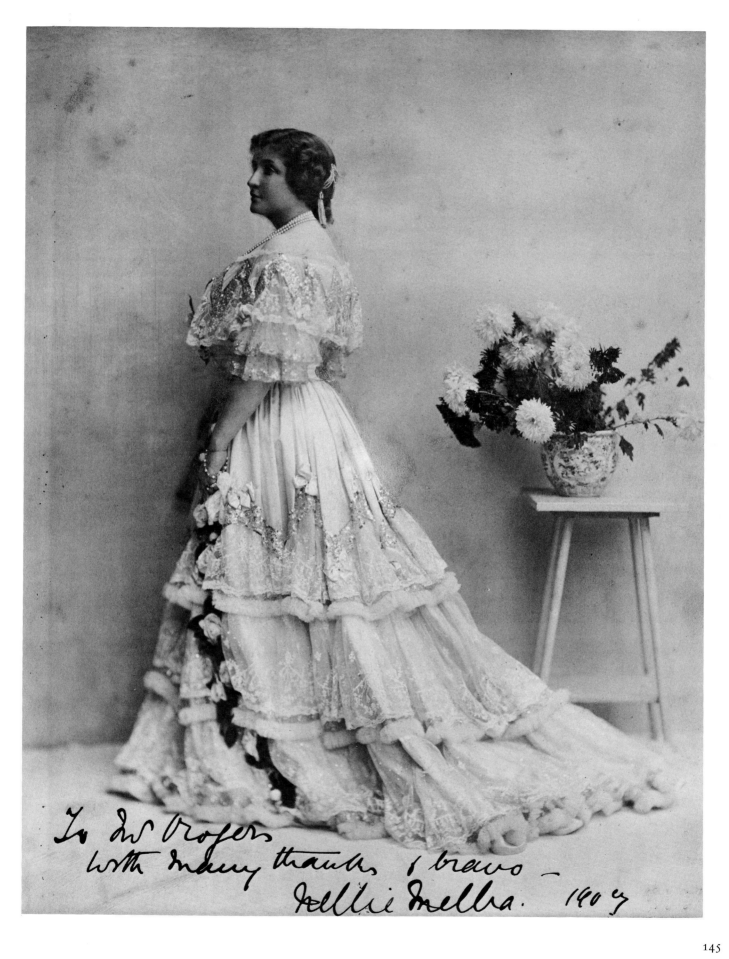

To Lw Rofers
with many thanks / bravo —
Nellie Melba. 1907

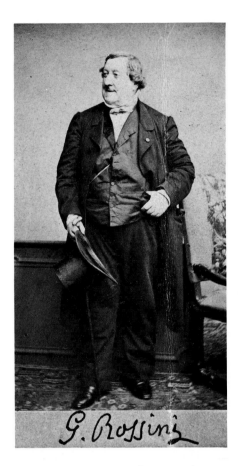

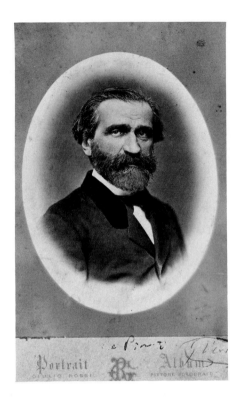

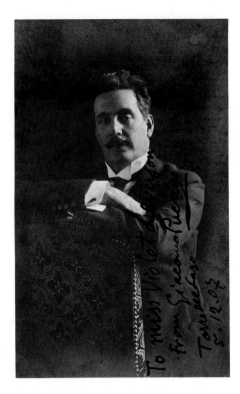

GIOACCHINO ROSSINI (1792–1868)

Dated January 26, 1866. The enduring *Barber of Seville* was hissed at its first performance in 1816. Undaunted, Rossini went on to write thirty-five more operas by the time he was thirty-seven, and then abandoned the form. He might have been amused to see the Lone Ranger riding across the screen to the strains of his *William Tell* overture.

GIUSEPPE VERDI (1813–1901)

Circa 1882. The prolific master of Italian grand opera composed such masterpieces as *Aida*, *Rigoletto* and *Il Trovatore*, finishing up with *Falstaff* in his eightieth year. A fervent fighter for liberty, he was a member of the Italian Parliament and was made senator in 1874 by King Victor Emmanuel.

GIACOMO PUCCINI (1858–1924)

Dated December 5, 1907. His heartrending, lushly romantic tragic operas (including *Madama Butterfly* and *La Bohème*) live up to the ideal expressed by one of his heroes: "He who has lived for love, has died for love."

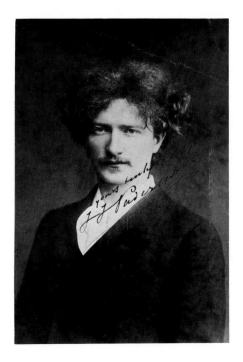

IGNACE PADEREWSKI (1860–1941)

Circa 1895. The world-famous pianist was an ardent patriot of his native Poland, and twice served as head of its government.

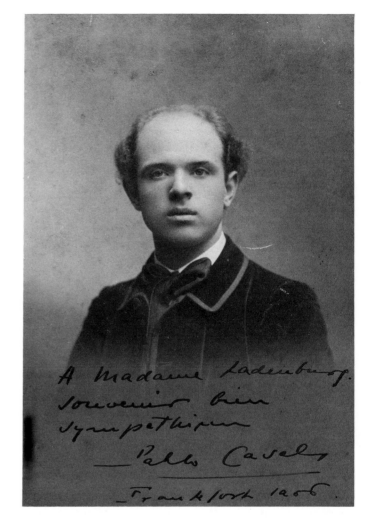

PABLO CASALS (1876–1973)

Dated 1906. The supreme – and long-lived – cellist spent his last years in voluntary exile (like his countryman Picasso) to protest the Franco dictatorship in Spain.

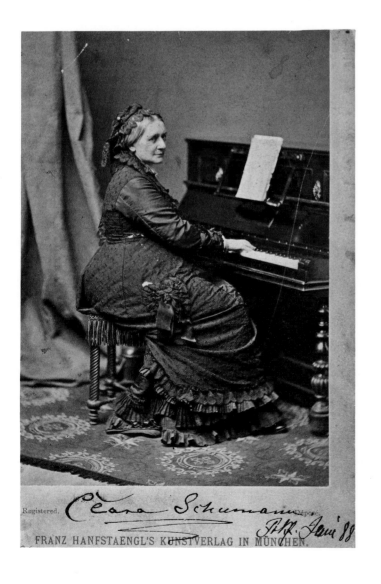

CLARA SCHUMANN (1819–1896)

Dated June, 1888. Clara Schumann, married to Robert Schumann, was a brilliant musician. She was also the lifelong confidante and unrequited love of Johannes Brahms.

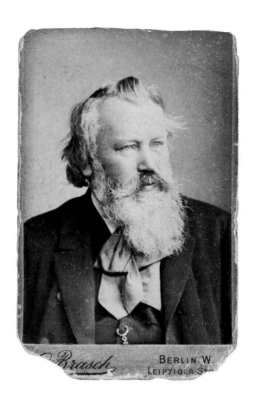

JOHANNES BRAHMS (1833–1897)

Dated 1896. As a music director in Vienna, he put on programs of such unremitting gloom that it was said, "When Brahms is in good spirits, he sings 'The Grave Is My Joy.'" The great composer is remembered for many extravagantly romantic compositions, from towering symphonies to his beloved "Lullaby."

FRANZ LISZT (1811–1886)

Circa 1875. He was in his time an avant-garde composer, a fiery pianist, and a world-famous lover (the actress Lola Montez was one of his many mistresses).

ARTURO TOSCANINI (1867–1957)

Dated 1931. The tempestuous Italian conducted many of the great orchestras of his day. He has inscribed this photograph with a passage from Richard Wagner's opera *Parsifal.*

GUSTAV MAHLER (1860–1911)

Dated 1909. A spiritually tormented German composer, his ten symphonies and numerous songs are pervaded with powerful tension and obsession with death. His popularity has grown considerably during recent years.

>

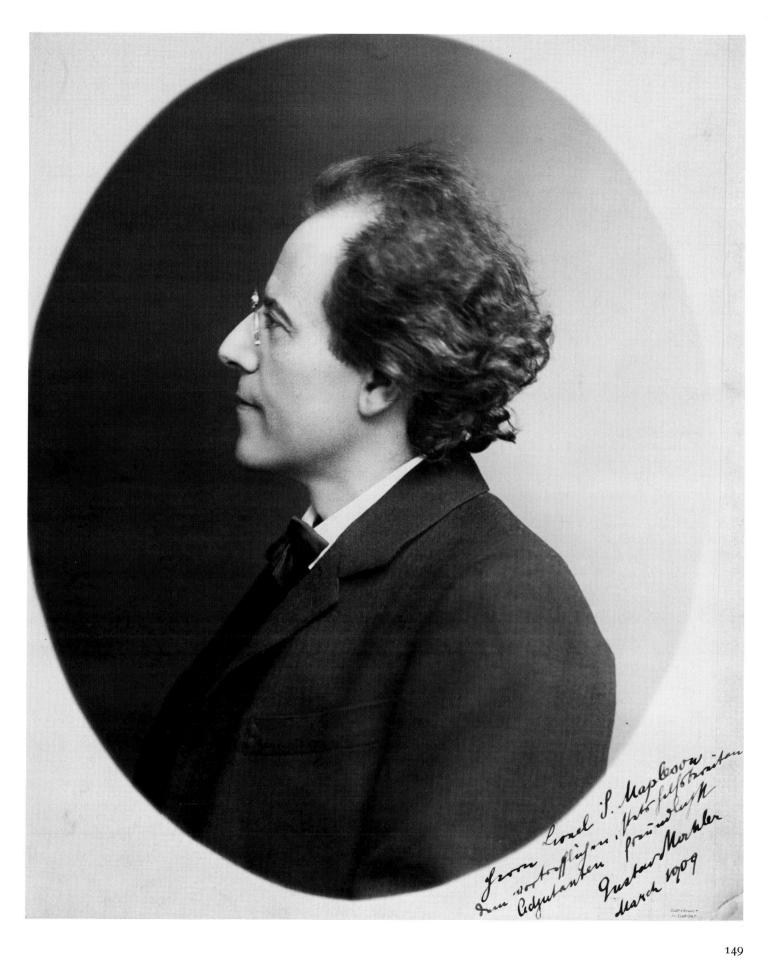

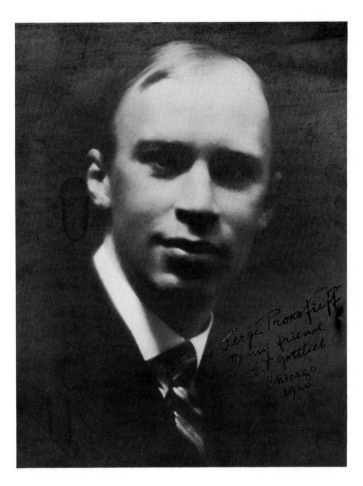

Dated 1950. Generally considered the most important composer of the twentieth century. His avant-garde ballet *The Rite of Spring* caused a riot at its first performance in Paris in 1913.

>

SERGEI PROKOFIEV (1891–1953)

Dated 1920. Prokofiev is best known in the United States for his symphonic fairy tale *Peter and the Wolf.* His numerous symphonies, operas, ballets, and film scores are much beloved in his native Russia.

JEAN SIBELIUS (1865–1957)

Circa 1930. At age thirty-two the Finnish composer was awarded a lifetime government grant to devote his career to the glory of Finnish music. He responded appropriately and brilliantly: his great masterpiece is *Finlandia*, composed in 1900. This somber portrait seems in keeping with his music.

150

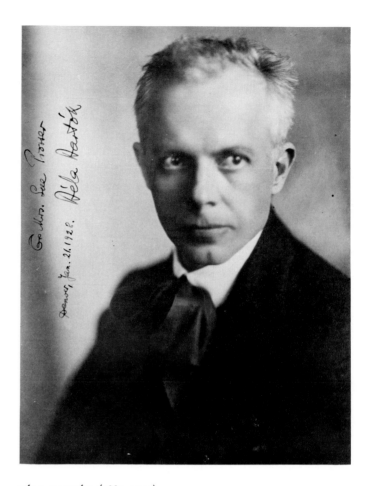

BÉLA BARTÓK (1881–1945)

Dated January 21, 1928. Inspired by peasant songs from his native Hungary, Bartók transformed them into some of the most innovative modern music of this century.

MAURICE RAVEL (1875–1937)

Circa 1928. A French exponent of the impressionist style, his compositions have something of the atmosphere of his compatriots' impressionist paintings.

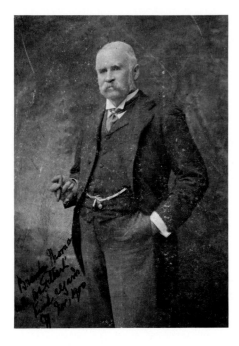

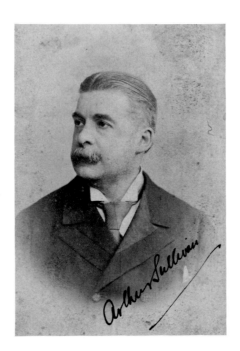

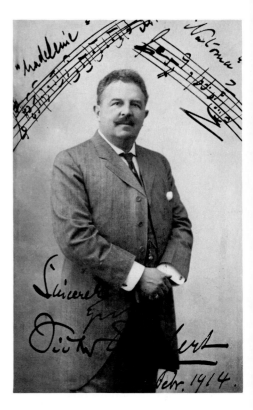

WILLIAM S. GILBERT (1836–1911)

Dated November, 1900. His witty lyrics to the music of Sir Arthur Sullivan poked fun at Victorian England in such famous operettas as *H.M.S. Pinafore, The Pirates of Penzance,* and *The Mikado.*

ARTHUR SULLIVAN (1842–1900)

Circa 1890. Sir William Gilbert's collaborator is also noted for his more sobering short compositions, such as the hymn "Onward, Christian Soldiers."

VICTOR HERBERT (1859–1924)

Dated February, 1914. The popular composer has here inscribed some bars from his operas *Madeleine* and *Natoma,* but his lighter works – like the operettas *Babes in Toyland* and *Naughty Marietta* and sentimental songs like *Kiss Me Again* – are what we remember.

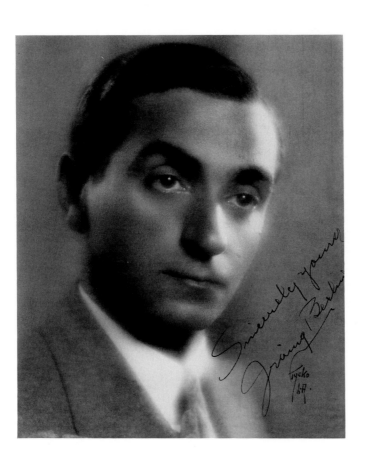

IRVING BERLIN (1888–)

Circa 1915. The impoverished Russian-born singing waiter achieved his first songwriting success with "Alexander's Ragtime Band" in 1911. There followed numerous Broadway musicals, film scores, and such enduring hits as "God Bless America," and "White Christmas."

GEORGE GERSHWIN (1898–1937)

Dated July, 1929. Gershwin juggled old musical styles to create a new type of American music in symphonic jazz pieces like *Rhapsody in Blue*, and his popular folk opera *Porgy and Bess*.

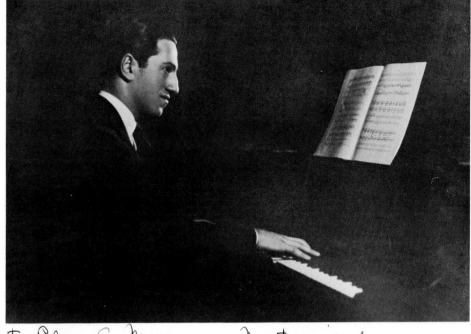

COLE PORTER (1893–1964)

Circa 1930. American lyricist and composer, the master of urbane, witty lyrics and sinuous music: "Night and Day," "Begin the Beguine" (and oh yes, "Bulldog, Bulldog, Bow-Wow-Wow," a Yale fight song).

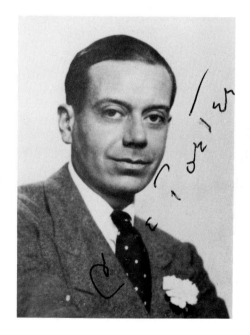

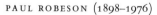

PAUL ROBESON (1898–1976)

Circa 1928. In addition to possessing a superb bass voice, Robeson was Phi Beta Kappa, a football star, a Columbia Law graduate, star of Broadway plays including *Othello*, and sympathizer and friend of Nehru, Kenyatta, and Nkrumah. His passport was temporarily revoked in 1950 because of his political activism, but he managed to give a Welsh concert by transatlantic telephone.

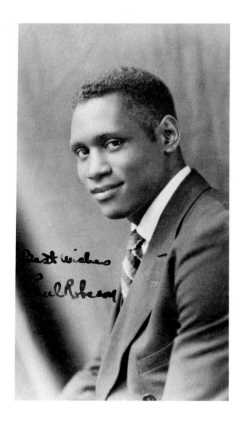

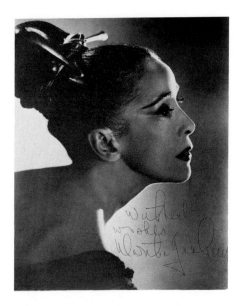

MARTHA GRAHAM (1895–)

Circa 1940. American dancer and choreographer who gave shape to modern dance with compositions like *Primitive Mysteries* and *Letter to the World. Appalachian Spring,* with Aaron Copland's score, is perhaps her most delightful work.

BILL ROBINSON (1878–1949)

Dated 1928. "Bojangles," starring in *Blackbirds of 1928,* the all-black revue. The brilliant tap-dancer was famous for his stairway dance, put to good use in *The Little Colonel* and other Shirley Temple mini-epics.

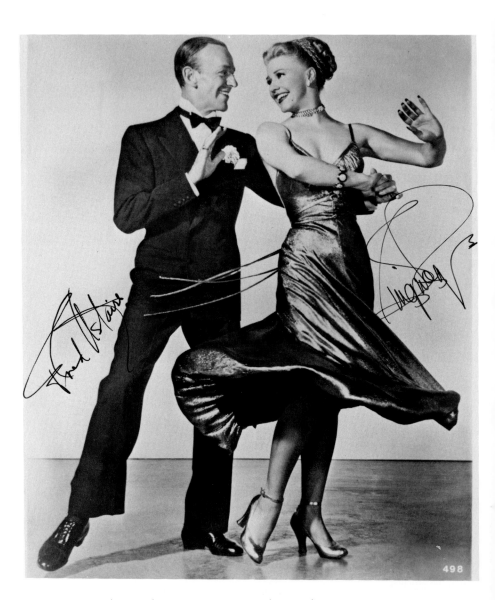

FRED ASTAIRE (1899–) & GINGER ROGERS (1911–)

1949. The studio report on his first screen test was "can't act; can dance a little," but Astaire went on to become America's First Dancer in films like *Flying Down to Rio* and *Top Hat.* At right is a sometime band singer named Virginia McMath who had the good fortune to team up with a gangly young fellow once named Frederick Austerlitz, and the talent to deliver. (The still is from their last collaboration, *The Barkleys of Broadway.*)

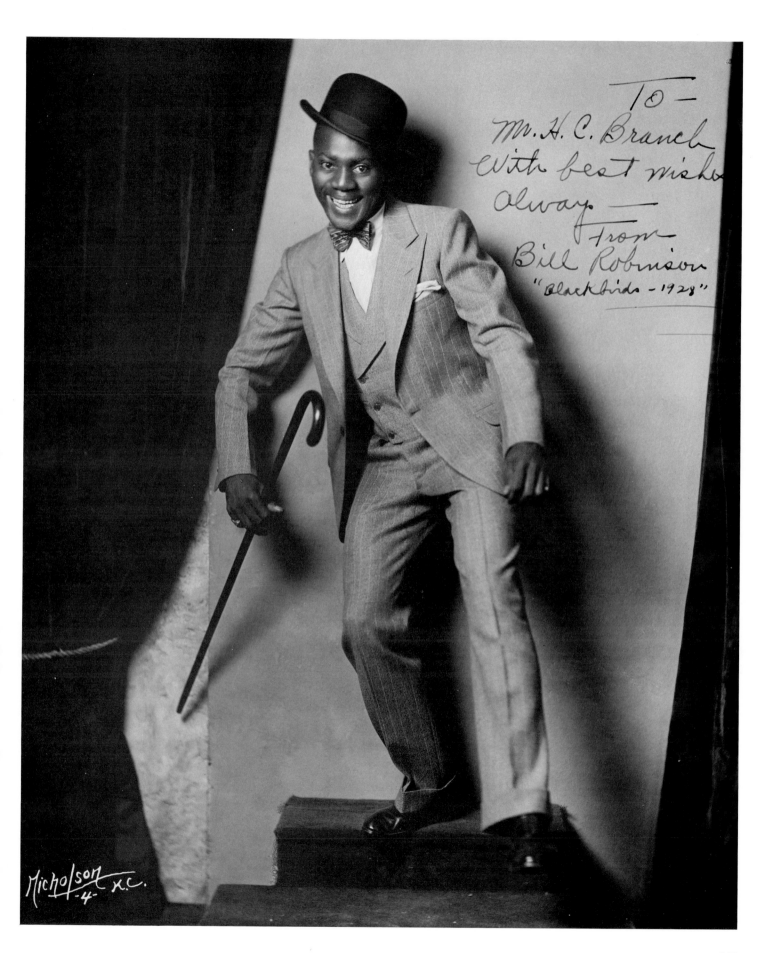

TO —
Mr. H. C. Branch
With best wishes
Alway —
From
Bill Robinson
"Blackbirds - 1928"

Nicholson
-4- X.C.

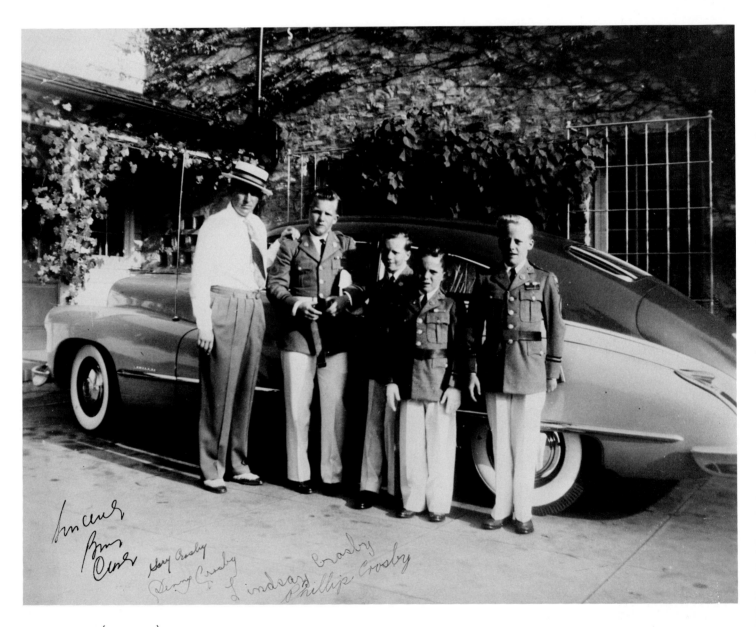

BING CROSBY (1904–1977)

Circa 1948. His crooning style was something new, and through
radio, records, and films this American vocalist became one of the
most successful and influential entertainers of all time. In 1982 his
second wife, Kathryn, auctioned off many of his personal possessions
– one of which was this autographed photo of Bing and his four
sons by first wife Dixie.

MAURICE CHEVALIER (1888–1972)

Dated 1928. The French film actor and singer won international audiences with his Continental flair and dazzling smile. Incurably lovable, he won a new generation of the American audience as the forgetful old flame in *Gigi*, and the understanding old husband in *Fanny*.

FRANK SINATRA (1915–)

Circa 1943. As a singer with Tommy Dorsey's band in the early 1940s, he was the idol of swooning, screaming bobby-soxers across America. Personality and a surprising talent as an actor carried him through the rough spots of his singing career, and finally he was the superstar and "Old Blue Eyes."

157

BILLIE HOLIDAY (1915–1959)

Circa 1950. "Lady Day." Her deeply moving and inimitable singing
style made her the leading jazz singer of her time.

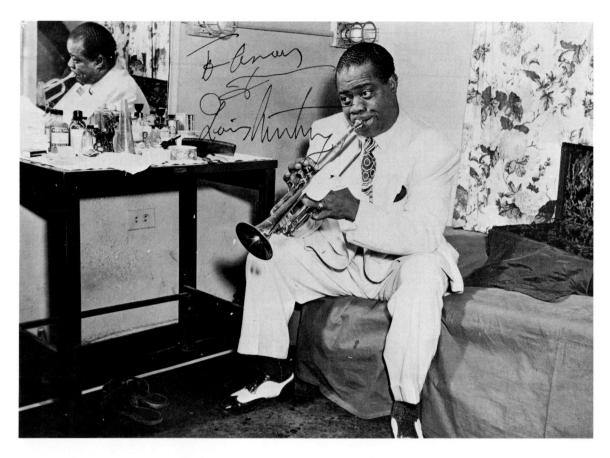

LOUIS ARMSTRONG (1900–1971)

Circa 1940. "Satchmo." The great trumpeter with a genius for improvisation. He introduced "scat" singing, using his gravelly voice as a musical instrument and singing nonsense syllables instead of words.

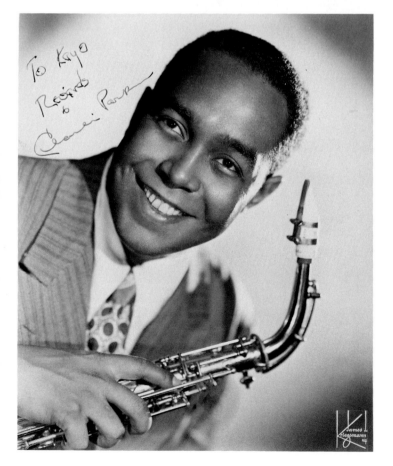

CHARLIE PARKER (1920–1955)

Circa 1950. "Bird." He influenced a generation of jazz musicians. His extemporaneous style was an amazing synthesis of rhythm, tone, melody, harmony, and form. He was the leading exponent of bop and bebop, which is improvised on chords rather than themes.

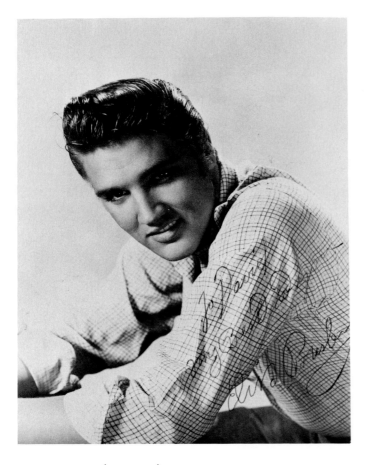

ELVIS PRESLEY (1935–1977)

Circa 1960. "If I could find a white man who had the Negro sound and the Negro feel, I could make a billion dollars." So said the record producer who was to discover Elvis. The "King's" combination of country music and blues, with a gyrating pelvic delivery, drove teenagers wild and skyrocketed him to riches.

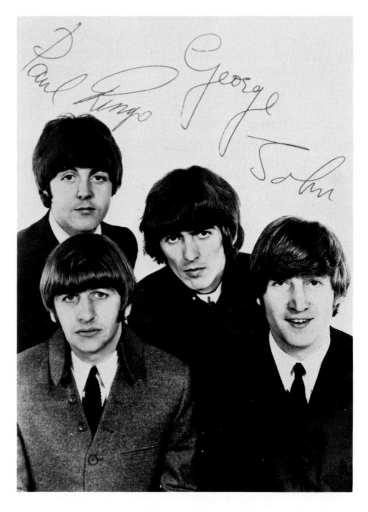

THE BEATLES

Circa 1965. This phenomenally creative and influential rock quartet just about owned the 1960s. All born in the Liverpool area in the early 1940s, its members (as everyone knows by now) were: John Lennon (died 1980), Paul McCartney, George Harrison, and Ringo Starr. In 1964, Queen Elizabeth made the boys Members of the Order of the British Empire in frank appreciation of their contribution to Britain's economy.

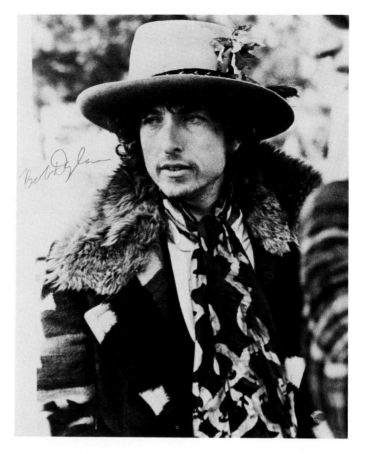

BOB DYLAN (1941–)

Circa 1970. The brilliant successor to folk singer Woody Guthrie caused a scandal when he introduced electric instruments at the 1964 Newport Folk Festival. He has been immensely influential throughout his journey through musical styles from folk, to rock, to country, to blues.

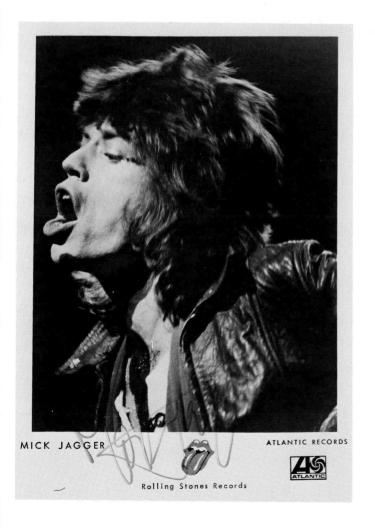

MICK JAGGER (1943–)

Circa 1976. For over twenty years the swaggering lead singer of the Rolling Stones, the rock group second only to the Beatles in fame. Jagger's education at the London School of Economics was an unusual, but no doubt useful, background for the leader of an immensely successful band.

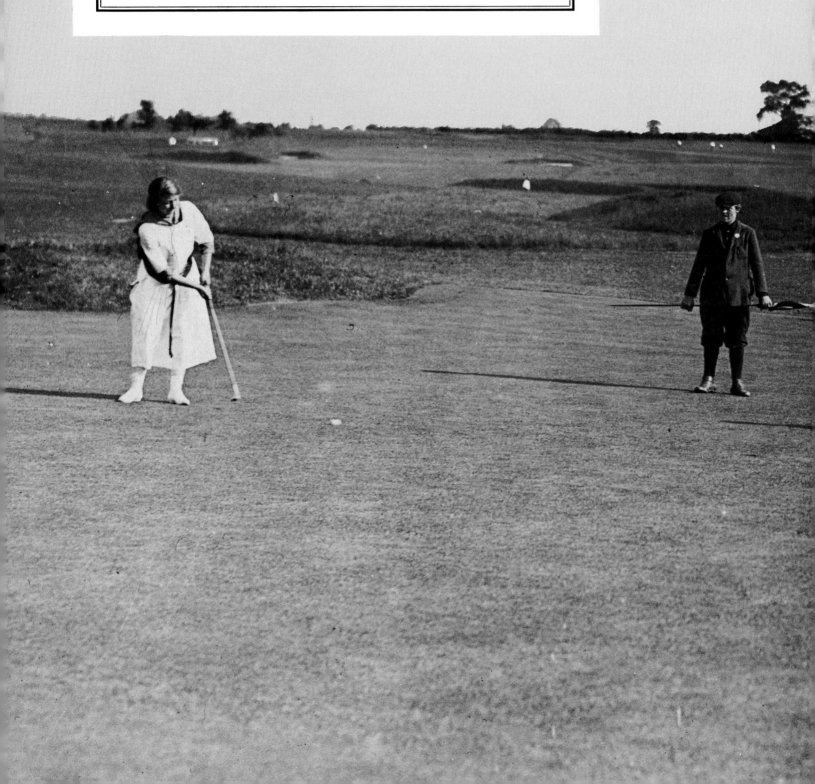

Sportsmen & Sportswomen

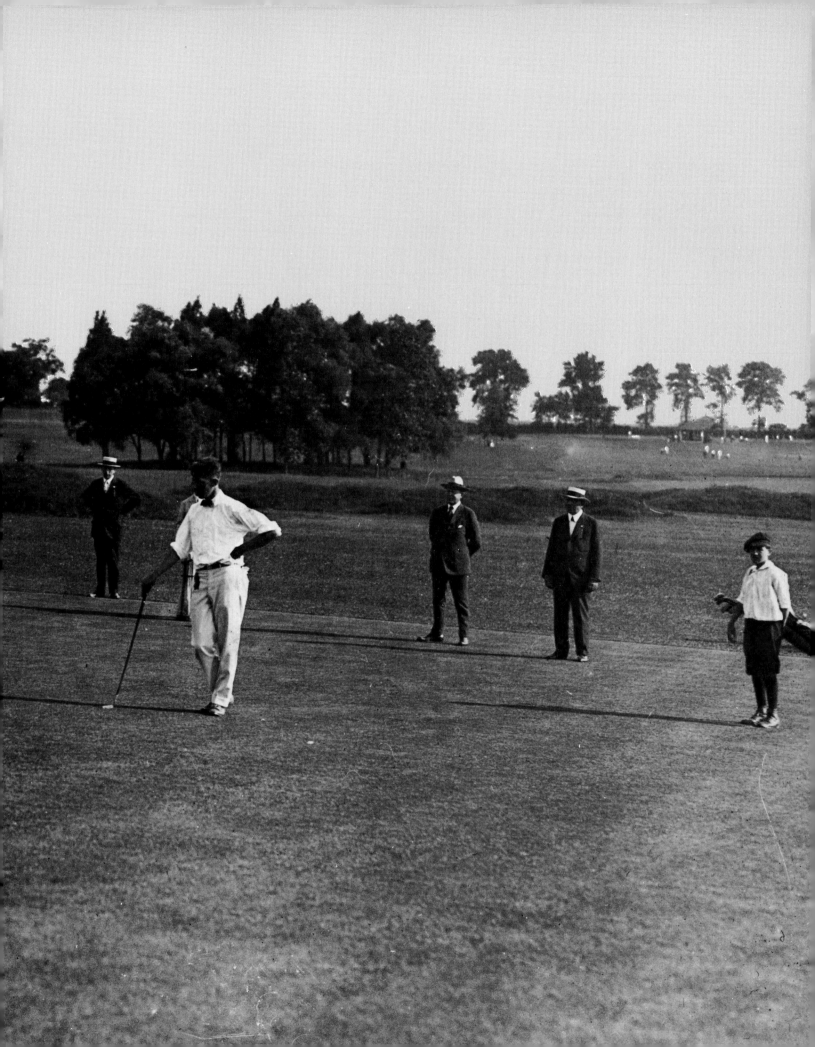

Circa 1921. Ouimet and Higbie on the green.

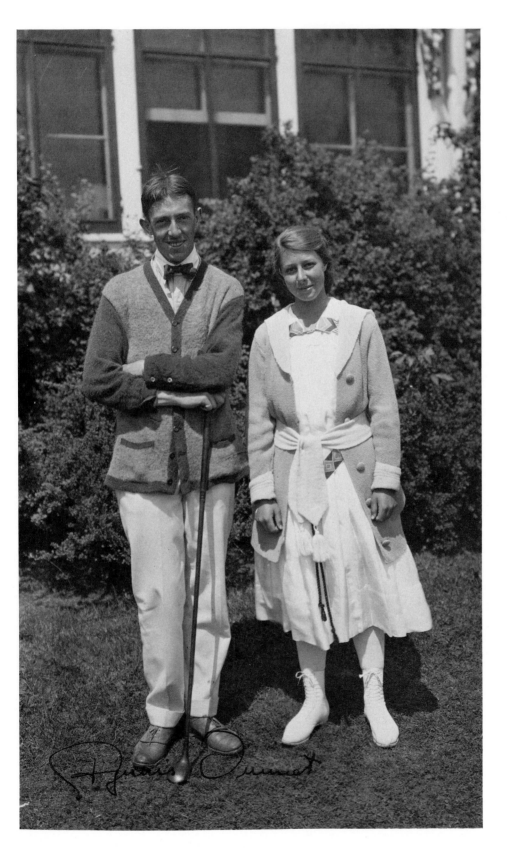

FRANCIS OUIMET (1893–1967)

Circa 1921. He popularized golf as a game for the common man. In 1913 this twenty-year-old unknown caddy from Boston electrified the sports world by beating British stars Vardon and Ray for the United States Open Championship. He became a national hero and golf's popularity boomed. On the right is Dorothy Higbie, an outstanding golfer herself.

WILLIAM TILDEN (1893–1953)

1920. Undeniably the greatest tennis player of the first half of the twentieth century, Big Bill Tilden led the U.S. Davis Cup team to victory in seven consecutive years.

>

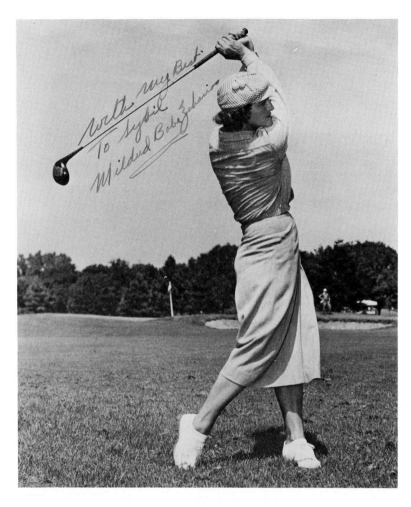

MILDRED DIDRIKSON ZAHARIAS
(1914–1956)

Circa 1950. In 1950 an Associated Press poll named Babe Zaharias the outstanding woman athlete of the century. An Olympic gold medalist in track, she also excelled at swimming, basketball and baseball; when she turned to golf she won her greatest fame and most of the tournaments in which she played.

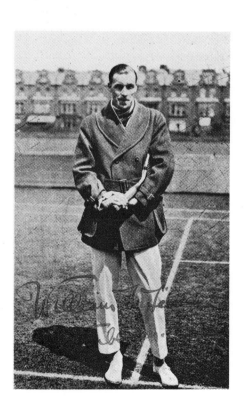

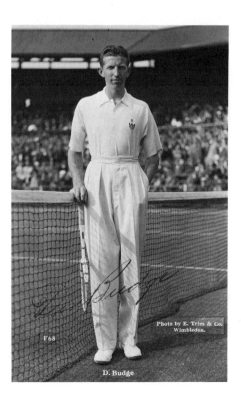

DON BUDGE (1915–)

1938. American Don Budge won the Australian, French, British, and U.S. singles titles, the "grand slam" of tennis, in 1938. Not even Bill Tilden had accomplished this unprecedented feat, and it was not to be duplicated for twenty-four years.

GEORGE HERMAN RUTH (1895–1948)

Circa 1930. Baseball's most legendary figure, with an all-around talent to match his reputation. The Babe was an outstanding pitcher, but Ed Barrow had the bright idea he would be even more valuable playing every day. He was – establishing some of the game's longest enduring records.

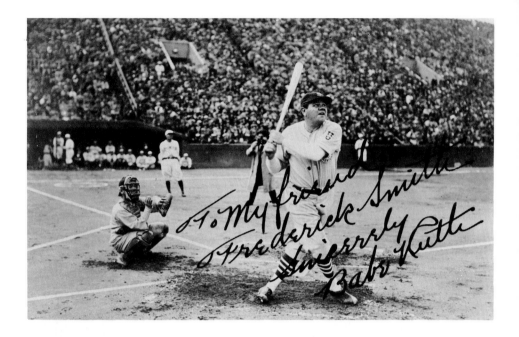

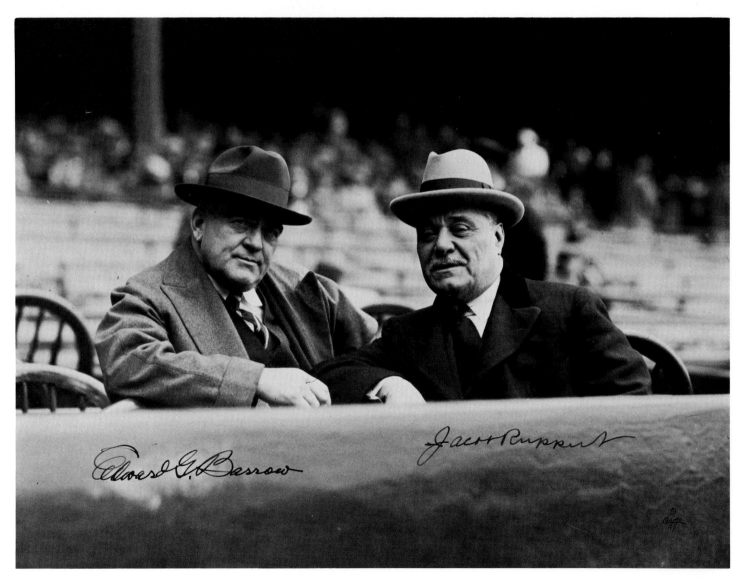

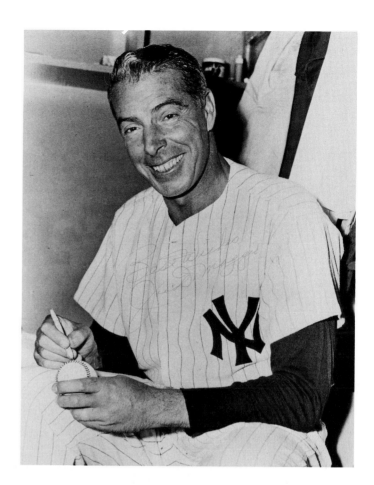

JOSEPH DIMAGGIO (1914–)

Circa 1950. Connie Mack called him "the greatest team player of all time." A graceful outfielder who made it look easy, a consistent hitter and a favorite with the fans, DiMaggio was second only to Ruth as Yankee hero and record-holder.

HENRY LOUIS (LOU) GEHRIG (1903–1941)

Circa 1935. Another Yankee in the Hall of Fame. The quiet first baseman was a murderous hitter, and it took a fatal form of paralysis to end his incredible record of playing in 2,130 consecutive baseball games. Extremely rare in an autographed photo.

EDWARD GRANT BARROW (1868–1953) &
JACOB RUPPERT (1867–1939)

Circa 1925. The Yankee general manager in the great days of Murderers' Row and the brewer who owned the club. They are no doubt seated in the new (1923) Yankee Stadium – the "House that Ruth Built" with his box-office appeal.

<

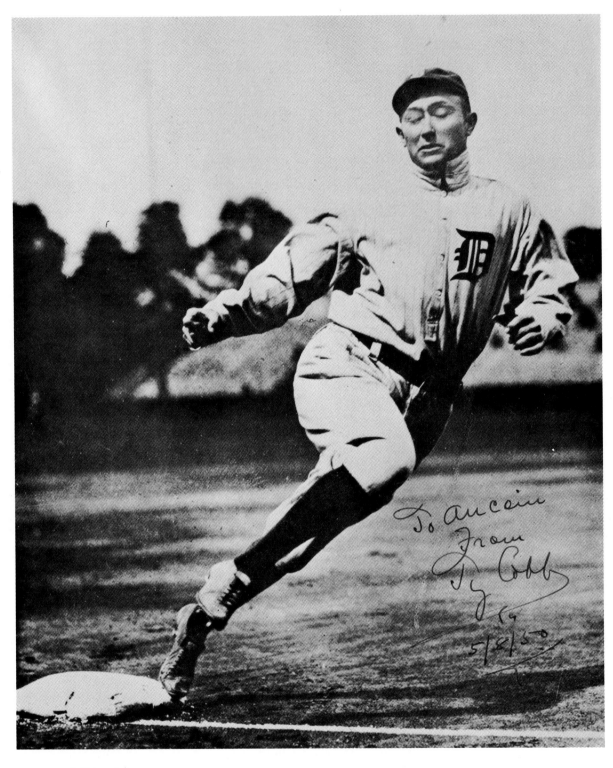

TY COBB (1886–1961)

Dated May 8, 1950 (but photo is probably circa 1915). The greatest baseball player of all? The first of the first five elected to the Hall of Fame (the others were Babe Ruth, Walter Johnson, Christy Mathewson, Honus Wagner). Some career statistics, mostly piled up playing centerfield: 4,191 hits; 2,244 runs; 892 stolen bases; .367 batting average. The aggressiveness and intensity he was known for are evident in this picture.

DAZZY VANCE (1891–1961) & WALTER JOHNSON (1887–1946)

Circa 1924. Vance, a fast ball pitcher and Hall of Famer, didn't win his first major league game until he was thirty-one, but he went on to win 197 of them and became the National MVP in 1924, the same year Johnson won the accolade in the American League. Johnson, a nice guy who didn't finish last, had a fast ball that was probably the fastest of all time. Even pitching with the Senators, usually at the bottom of the league, he compiled 414 wins and 3,497 strikeouts.

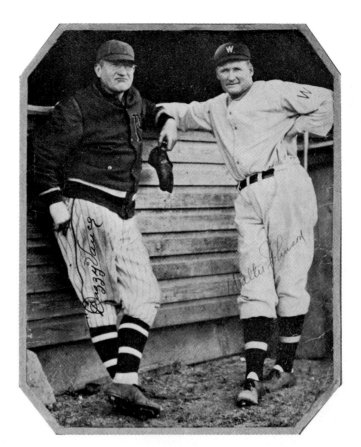

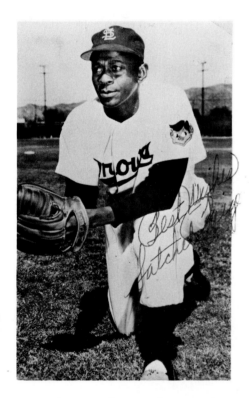

LEROY (SATCHEL) PAIGE (1906–1982)

Circa 1940. Satchel Paige was born too soon. He was already a pitcher of legendary skill when he was brought to the majors in 1948 after Jackie Robinson had broken the color barrier. But he was also already forty-one years old (some say considerably older). Even so, he helped the Cleveland Indians win the pennant with a 6–1 record. Paige himself was philosophical: "Don't look back. Someone may be gaining on you."

ROBERT THOMSON (1923–)

Dated 1948. A single hit brought baseball immortality to this fine outfielder. "Bobby Thomson's home run" was a ninth-inning two-men-on, one-out blow in the playoff game against the Dodgers, and climaxed the Giants' drive from 13½ games behind to win the National League pennant in 1951.

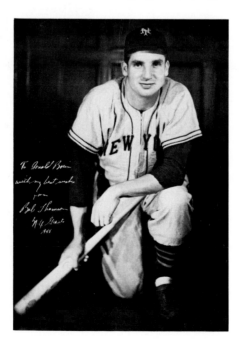

JACK ROOSEVELT ROBINSON (1919–1972)

Circa 1960. As the first black player in the major leagues, Jackie Robinson's character was as important as his talent, and he fulfilled the expectations of the man who brought him to the Brooklyn Dodgers in 1947, its creative general manager, Branch Rickey (he also developed the farm system). They are seen here with Mrs. Robinson.

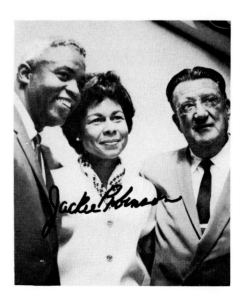

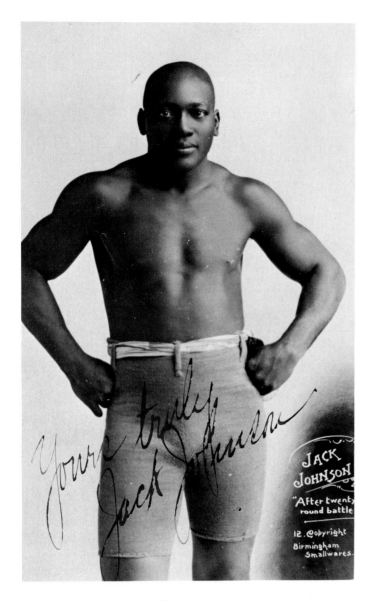

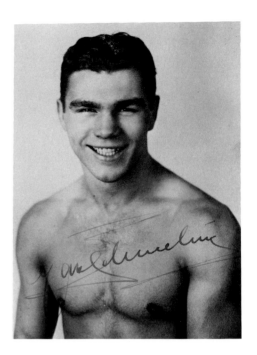

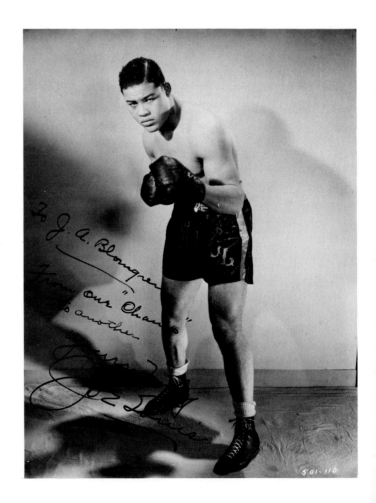

JACK JOHNSON (1878–1946)

Circa 1910. On Christmas Day, 1908, in Sydney, Australia, he became the first black boxer to win the world heavyweight championship. In racist reaction, some cried for a "white hope" to retrieve the title, which in fact Johnson held until defeated by Jess Willard in 1915. James Earl Jones played the role of the boxer in the Broadway play *The Great White Hope.*

JOE LOUIS (1914–1981)

Circa 1940. Heavyweight champion from 1937 to 1949, the Brown Bomber is ranked by many as the greatest boxing champion of all.

MAX SCHMELING (1905–)

Circa 1936. The German heavyweight's knockout of the undefeated Joe Louis took on political overtones in the tense period of the mid-thirties. Louis soon made his own statement, however, by knocking out Schmeling in the first round of the return bout, the title fight of 1938.

<

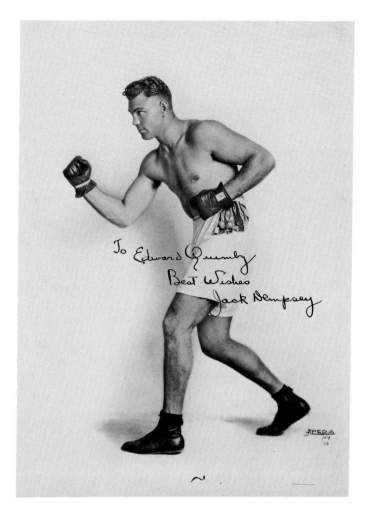

JACK DEMPSEY (1895–1983)

Circa 1915. Considered the most exciting, the most colorful, the most dynamic, and the most savage fighter of all, this heavyweight champion (whose best fighting weight was only 188 pounds) was one of the greatest celebrities of the Roaring Twenties.

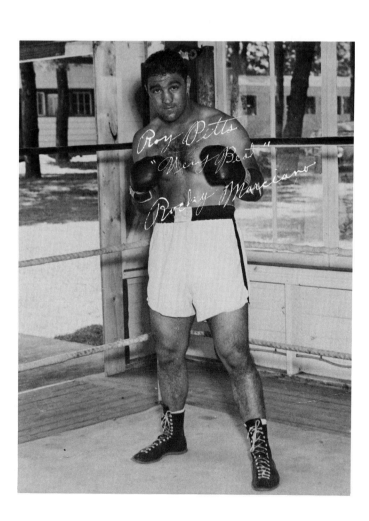

ROCKY MARCIANO (1924–1969)

Circa 1952. He ended the career of Joe Louis, who had been forced out of retirement by money troubles. Marciano was heavyweight champion from 1952 to 1956, when he retired undefeated – and unlike Louis, stayed retired.

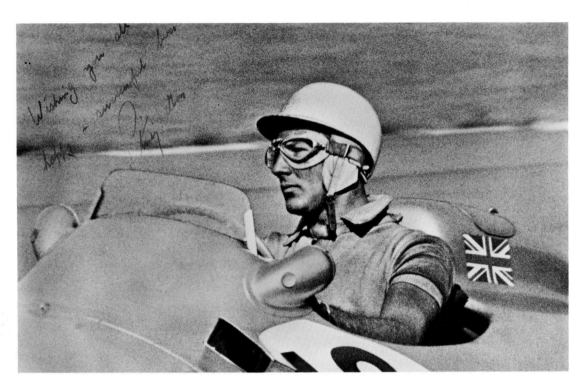

STIRLING MOSS (1929–)

Circa 1955. Although the world championship eluded him, Moss was Britain's foremost racing driver, and in his prime perhaps the most respected and charismatic personality in international sports. His career ended effectively in a near-fatal crash at Goodwood in the early '60s.

ENZO FERRARI (1898–)

Circa 1955. A racing driver himself, he put together the design team and supervised the manufacture of Ferrari Motors, which contributed so much to Grand Prix racing in terms of technological development. The forceful Commendatore was known for his detailed attention to every aspect of his racing teams.

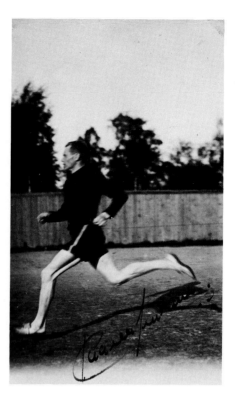

ROGER BANNISTER (1929–)

1954. Running a four-minute mile once seemed as unlikely as flying faster than the speed of sound. This photo, taken on May 6, 1954, at Oxford, shows British runner Roger Bannister breaking the tape at 3 minutes 59.4 seconds (shattering Gunder Haegg's 1945 record of 4:01.4). The involved expressions on the faces of the timers say it all.

PAAVO NURMI (1897–1973)

Circa 1925. They used to say Paavo "ran the name of Finland onto the world map." Between 1920 and 1932 "The Flying Finn" set twenty world running records and won nine Olympic gold medals, holding a stopwatch in his hand.

EDDIE ARCARO (1916–)

Circa 1948. This American jockey retired in 1962 after thirty-one years of racing during which he won 4,779 races worth $30,000,000 (of which he received 10 percent). He won the Kentucky Derby a record-breaking five times and was the first jockey to win the Triple Crown twice – in 1941 on Whirlaway, and in 1948 on Citation, which he called the best horse he ever rode.

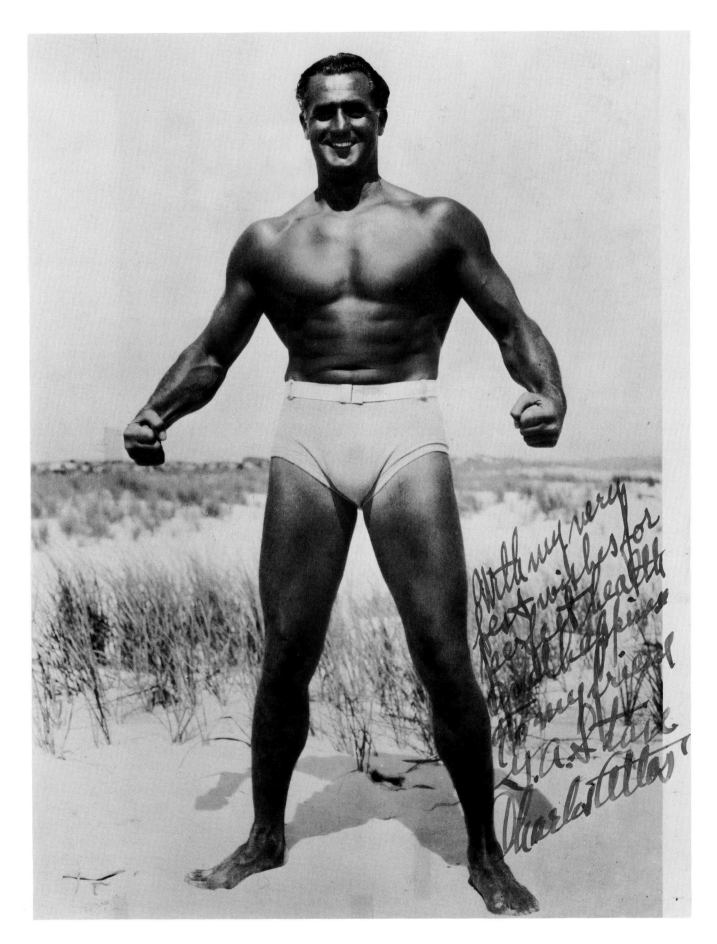

With my very
best wishes for
best health
and happiness
To my friend
Y. A. Stein
Charles Atlas

174

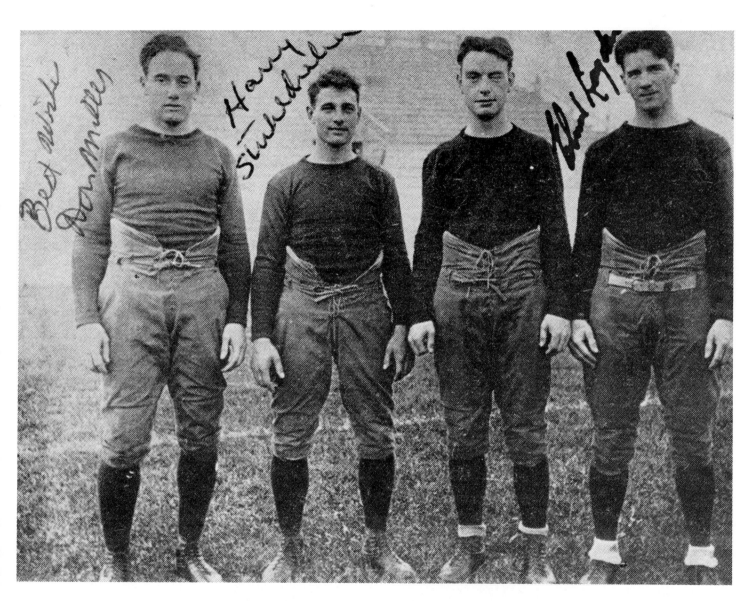

THE FOUR HORSEMEN OF NOTRE DAME
Don Miller, Harry Stuhldreher, Jim Crowley, Elmer Layden

1924. The fabled backfield of Knute Rockne's 1924 team. In describing the victory over Army, Grantland Rice conferred immortality: "The Four Horsemen rode again. In dramatic lore they are known as Famine, Pestilence, Destruction, and Death. These are only aliases. Their real names are Stuhldreher, Miller, Crowley and Layden."

CHARLES ATLAS (1893–1972)

Circa 1935. American strongman, whose eye-catching advertisements in national magazines ("I was a 96-pound weakling") helped to promote his muscle-building course. Angelo Siciliano really was a puny kid, and claimed he got his inspiration for building up his body from a statue of Hercules in the Brooklyn Museum.

<

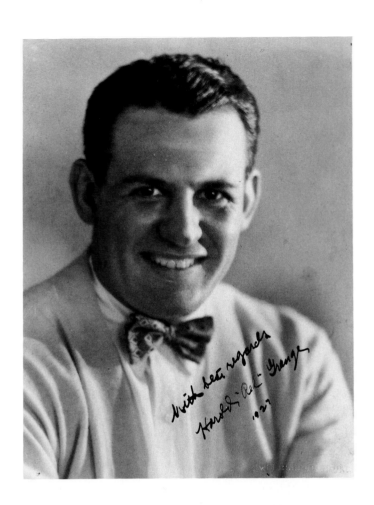

HAROLD GRANGE (1903–)

Dated 1927. Red Grange, "The Galloping Ghost" of Illinois, the halfback marvel of the '20s. His pro football career (with the Chicago Bears) was brief, but the appearance of this national idol gave an invaluable boost to the fledgling National Football League. He is pictured here during a brief Hollywood career.

THOMAS HARMON (1918–)

Circa 1939. Michigan's "Old Ninety-Eight" was the most exciting player to come out of the Big Ten since Red Grange, to whom he was inevitably compared. He flashed through enemy backfields with sudden deceptive bursts of speed, scoring thirty-three touchdowns (to Grange's thirty-one).

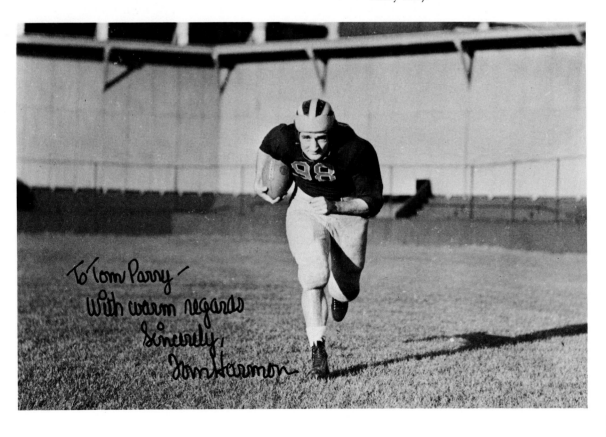

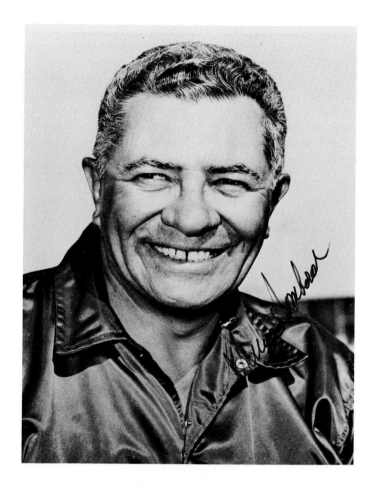

VINCENT LOMBARDI (1913–1970)

Circa 1965. "Winning isn't everything. It's the only thing." The legendary coach of the Green Bay Packers took over a mediocre outfit and transformed it into the super team of the 1960s.

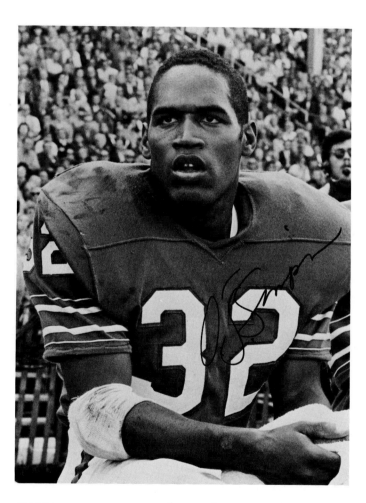

ORENTHAL JAMES SIMPSON (1947–)

Circa 1970. The outstanding college football player (USC) of 1968, the NFL draft system took O.J. to the lackluster Buffalo Bills, where he shone like a diamond, becoming one of pro football's greatest runners. One of the most successful of athlete-pitchmen since his retirement, a new generation may associate him as much with rental cars as with footballs.

WILT CHAMBERLAIN (1936–)

Circa 1972. The son of five-foot eight-inch parents, seven-foot one-inch Wilton Norman Chamberlain still claims the most baskets (12,681), the most rebounds (23,924), and the most points (31,419) of any professional basketball player in history. In 1972 he led the Los Angeles Lakers to the NBA championship, climaxing a season which included a thirty-three-game winning streak. He is currently seen in commercials extolling ample head room in cars and ample leg room in airplanes.

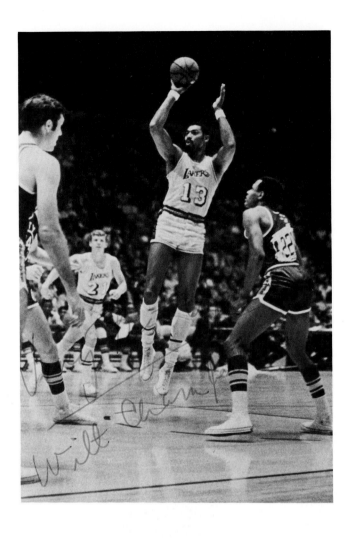

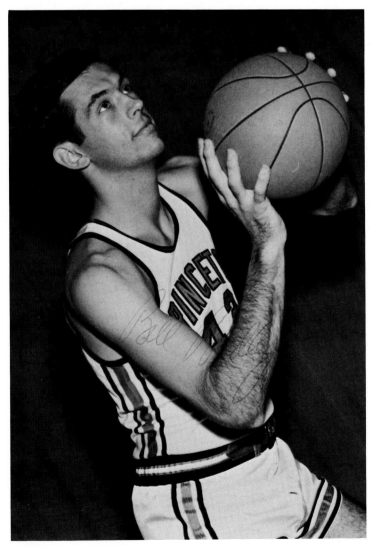

WILLIAM BRADLEY (1943–)

Circa 1964. A super-achiever: All-American basketball player at Princeton, a Rhodes scholar, he played professionally with the New York Knicks ("I just had to know how I would do against the best players in the world") and helped them win the world championship. Now he is the highly respected U.S. senator from New Jersey.

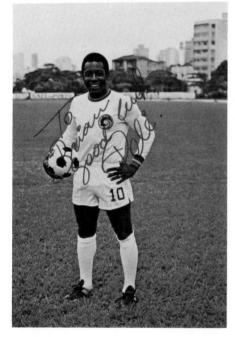

PELÉ (1940–)

Circa 1970. Brazil's Pelé – Edson Arantes Do Nascimento – was for twenty years the world's most popular player in the world's most popular sport, soccer. He had led Brazil to World Cup championships in 1958, 1962 and 1970, scoring a record 1,281 goals. His brief career in the North American Soccer League (with a $4.7 million contract) helped further the growing interest in soccer in the United States.

THEODORE SAMUEL WILLIAMS (1918–) & JIM THORPE (1888–1953)

Circa 1950. At right, the "Carlisle Indian," the greatest athlete of the first half of the twentieth century. All-American footballer, baseball and track star, winner of both the decathlon and pentathlon at the 1912 Olympic games, Thorpe's achievements have never been repeated. With him is Boston Red Sox outfielder (and enthusiastic fisherman) Ted Williams, perhaps the greatest hitter of the modern era, who won his sixth batting championship when he was forty years old.

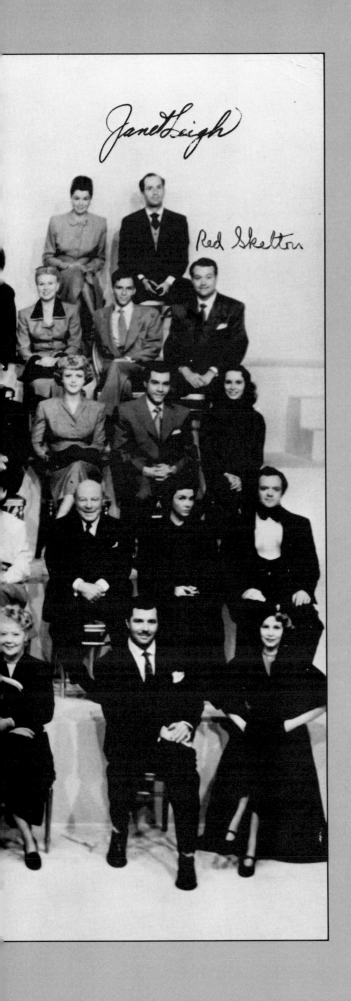

Janet Leigh

Red Skelton

Actors & Actresses

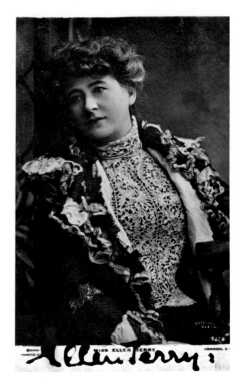

LILY LANGTRY (1852–1929)

Circa 1885. "The Jersey Lily"; English actress, famous beauty, friend of Edward VII. The town of Langtry, Texas, was so named by a local judge who was smitten with her during one of her American tours.

ELEONORA DUSE (1859–1924)

1896. Celebrated Italian actress and sometime mistress of Gabriele D'Annunzio (page 17), she appeared on the New York stage in three of his plays – in Italian. In 1895, she and Bernhardt appeared on the London stage in the same role. Some critics, including Shaw, preferred Duse.

ELLEN TERRY (1847–1928)

Circa 1900. English actress for whom Shaw (page 56) wrote *Captain Brassbound's Conversion* and of whom he said, "The whole age is in love with her." Mother of Gordon Craig (page 127).

LILLIAN RUSSELL (1861–1922)

Circa 1890. Much-married American actress, star of burlesque shows and comic operas. Her repertoire included such favorites as *Fiddle-dee-dee* and *Whoop-de-doo.* Her well-upholstered figure, aided by all those late suppers with Diamond Jim Brady, was much admired and emulated.

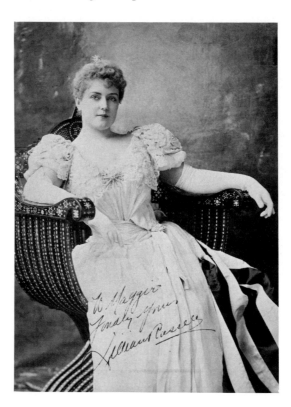

OVERLEAF:

Stars of Metro-Goldwyn-Mayer

1949. This remarkable photograph celebrating M-G-M's Silver Jubilee, with Lassie front and center, shows 58 stars (in roughly alphabetical order) from the studio that boasted "more stars than there are in heaven." (Key on page 214.)

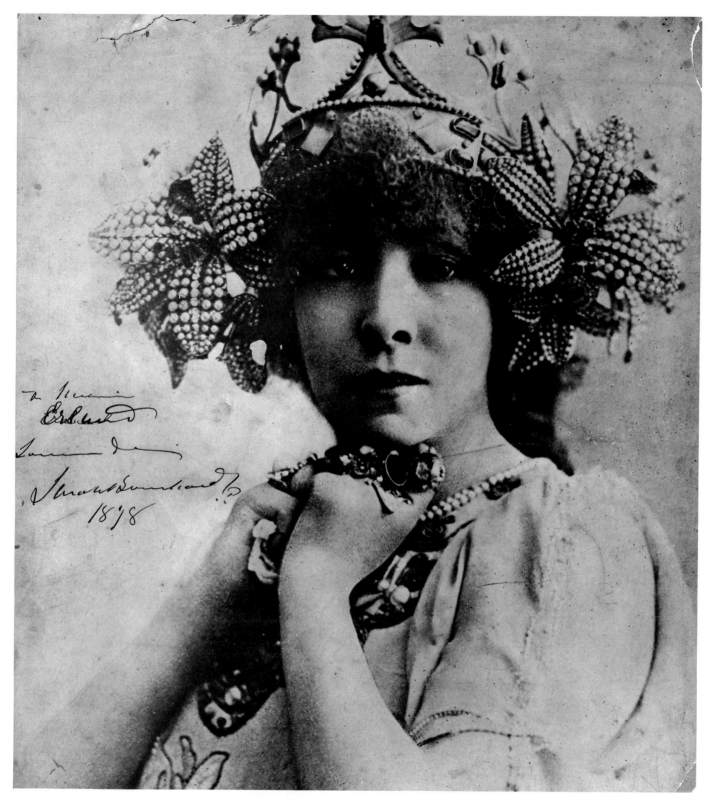

SARAH BERNHARDT (1844–1923)

Dated 1898. A legendary figure in the theater, renowned for her golden voice, "The Divine Sarah" was one of the most versatile actresses of any age, and also wrote plays in which she appeared. Admired almost as much in the United States as in her native France, she made frequent "final" appearances in America.

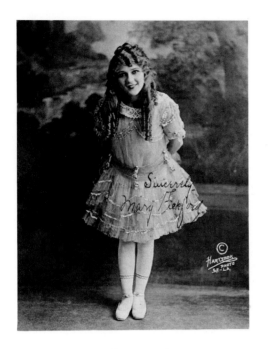

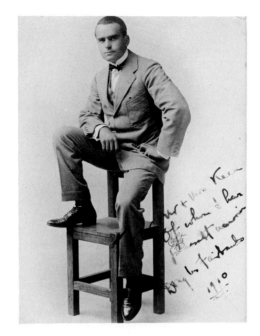

DOUGLAS FAIRBANKS (1883–1939)

Dated 1910 (while Fairbanks was still a stage actor). The other half of the famous couple, and hardly just Mr. Pickford. Not a great actor, he exhibited an astonishing athleticism, grinning charm and gusto in fast-moving adventure films (*The Mark of Zorro*, *Robin Hood*) that made everyone feel good. Soon, like Mary, Fairbanks was commanding an enormous salary . . .

MARY PICKFORD (1893–1979)

Circa 1914. Real name: Gladys Smith. One-half of the most famous couple in the world at the time. For two decades the queen of Hollywood, Little Mary managed to be convincing as *Rebecca of Sunnybrook Farm* at age twenty-four, but she rarely had a chance to show her talents in adult roles. America's Sweetheart was also a competent businesswoman . . .

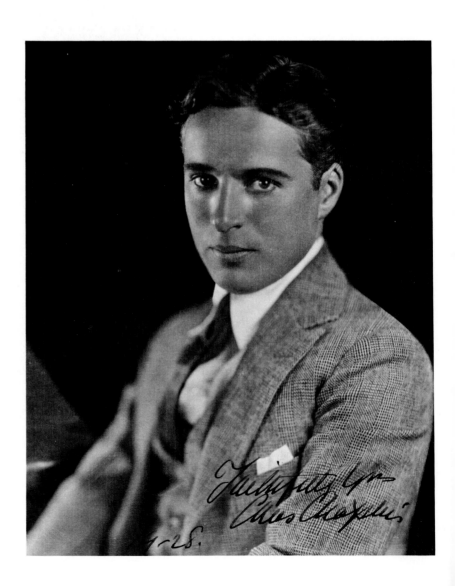

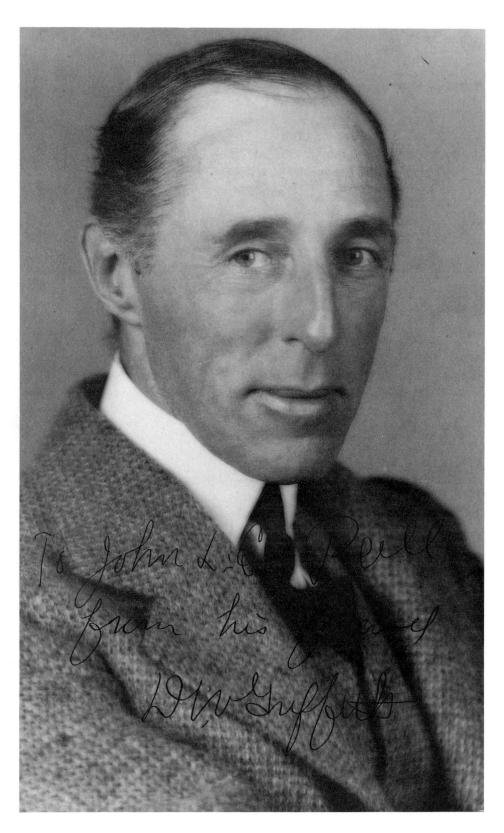

CHARLES CHAPLIN (1889–1977)

Dated 1928. And so was Doug and Mary's good friend, who signed a million-dollar contract in 1917. Chaplin had created his universal character, the Tramp, in 1915, and his genius was almost immediately recognized all over the world. The photo is from a decade later, about the time Chaplin retired the Tramp with the coming of the talkies. But back to those salaries . . .

<

DAVID WARK GRIFFITH (1875–1948)

Circa 1920. Director D. W. Griffith was the fourth of Hollywood's Big Four, who began to realize that if their salary demands were met they could bankrupt their own studios. Therefore, in 1919 these four formed United Artists Corporation, a company to produce and distribute their own films – and keep the profits at home. Griffith's talents were not financial, however. He is credited with inventing the modern film, introducing fundamental techniques (the close-up, cross-cutting, the fade-out), new social and psychological values, and creating the "spectacular," notably *The Birth of a Nation* (1915).

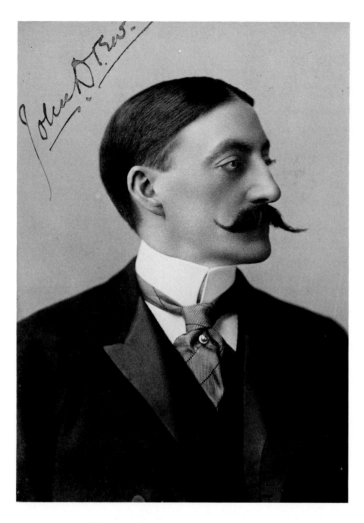

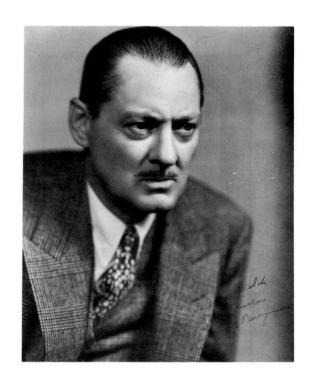

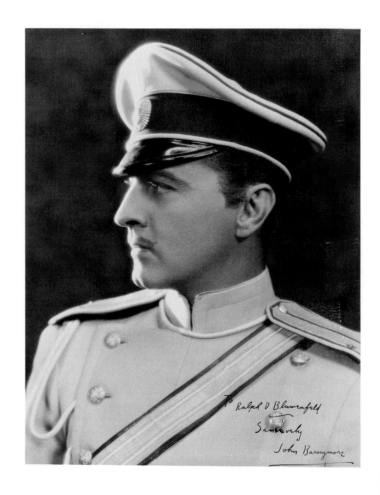

JOHN DREW (1853–1927)

Circa 1900. The senior member of the theatrical dynasty, son of actor parents, brother-in-law of actor Maurice Barrymore, and uncle of the three famous Barrymores here. For many years each Broadway season saw Drew starring in a new vehicle at the Empire Theater, sometimes with his niece and nephews in supporting roles.

JOHN BARRYMORE (1882–1942)

Circa 1930. The kid brother, "The Great Profile," squandered his tremendous talent. Famous for his stage portrayal of Hamlet (which some say was the greatest), he later became the black sheep of the Barrymores by making films like *Hold That Co-ed* and *The Invisible Woman.*

LIONEL BARRYMORE (1878–1954)

Circa 1925. Like Ethel and John, Lionel was prominent on the New York stage for three decades, but the public today remembers the films. He began his movie career in 1909, and became M-G-M's stock crusty old curmudgeon in films like *Captains Courageous* and *It's a Wonderful Life*, but he is perhaps most famous as lovable old Dr. Gillespie, Dr. Kildare's mentor.

<

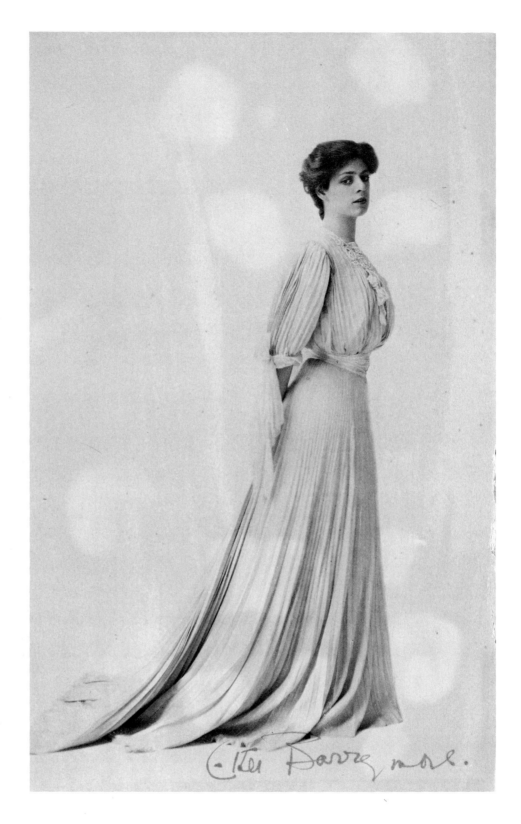

ETHEL BARRYMORE (1879–1959)

Circa 1905. Ethel made her stage debut at fifteen and went on to become the first lady of the American stage, being especially remembered in *The Corn is Green* (1940). Younger generations associate her mostly with her grande dame or crotchety old lady roles in Hollywood, where she was a kind of queen mother. This photograph was made about the time (according to his daughter Mary) that she rejected the marriage proposal of Winston Churchill (page 82).

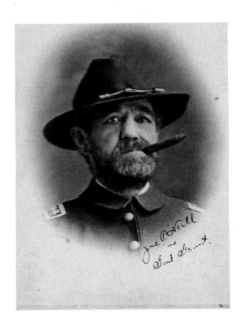

JAMES O'NEILL (1847–1920)

Circa 1913. The father of playwright Eugene O'Neill (page 61) was one of the stage actors brought to Hollywood in the early days of the silents when the movie moguls decided to film Broadway plays. Here he is in costume as General Grant.

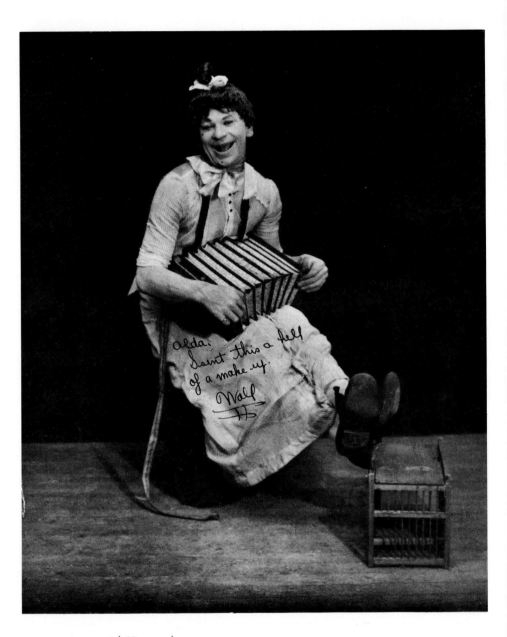

WALLACE BEERY (1885–1949)

Circa 1913. One of the most popular performers of his time, here he plays a Swedish maid in the comedy series in which he made his first Hollywood appearance. Beery was most often the amiable tough guy, an image that overshadowed the gifted actor of *Viva Villa!*

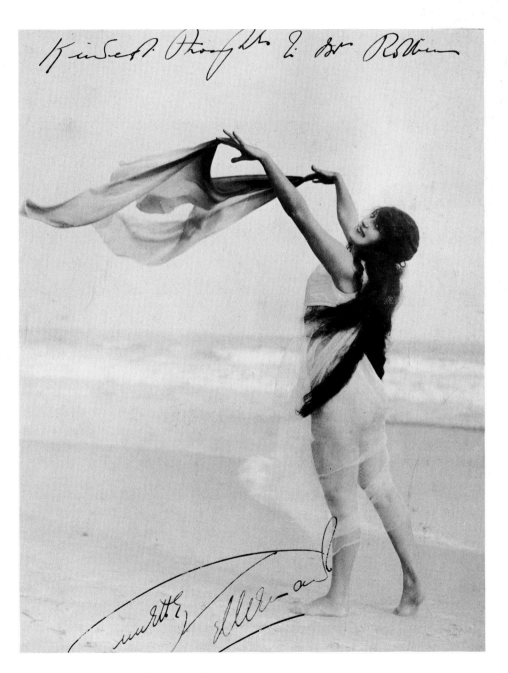

LON CHANEY (1883–1930)

Circa 1925. "The Man of a Thousand Faces" hiding one of them. A fine actor, his talents were diverted into creating a remarkable gallery of grotesques. Among the most hair-raising: *The Hunchback of Notre Dame* and *The Phantom of the Opera.*

ANNETTE KELLERMAN (1888–1975)

Circa 1915. The Australian dancer and swimming star made her most lasting contribution not through her films (like *Neptune's Daughter,* 1914), but in popularizing the one-piece swimsuit. Though considerably more discreet than the get-up pictured here, her form-fitting tank suits were frightfully shocking.

EVELYN NESBIT (1884–1967)

1902. "The Girl in the Red Velvet Swing." Her fatal beauty led to the murder of architect Stanford White by Harry K. Thaw in 1906, and the scandal that made her the best-known woman in America. Toward the end of her long life she is said to have commented: "Stanford White was the lucky one. He died." The identity of "Dearest," to whom the photograph is inscribed on the back, is unknown.

MAUDE ADAMS (1872–1953)

Dated 1899. An American stage star of luminous beauty, she was most famous for her portrayal of Peter Pan in over 1,500 performances. Here she is costumed for her role in *The Little Minister.* The photos of Nesbit and Adams, like many in this book, are by the Sarony studio, which was known for portraits of theatrical personalities.

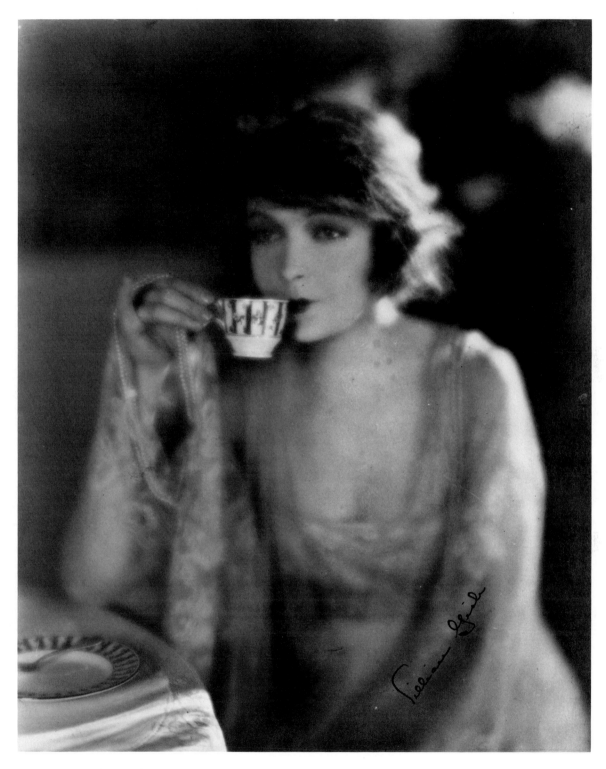

LILLIAN GISH (1896–)

Circa 1920. This immensely popular silent screen star was most often
seen as the idealized, vulnerable heroine. Throughout her career,
like many of the early Hollywood stars, she returned frequently to
the New York stage where her talents could find broader
expression. Elegant and beautiful in her eighties, the actress was
honored by President Reagan in a gala at the Kennedy Center.

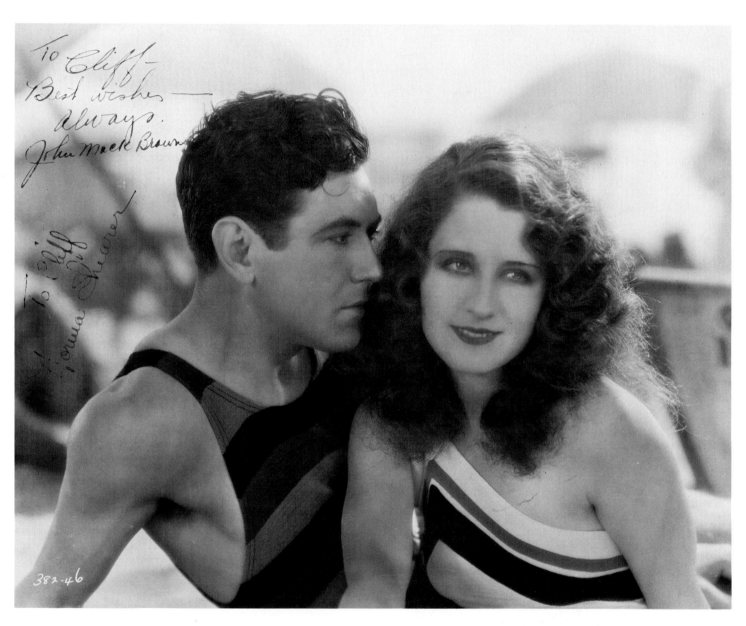

JOHN MACK BROWN (1904–1974) &
NORMA SHEARER (1900–1983)

Circa 1926. Usually the lead in low-budget Westerns, here in *The Little Angel*, Brown proposes to one of the screen's future first ladies. Brains and elegant bone structure took Shearer to the top, and she and husband Irving Thalberg, M-G-M executive producer and wunderkind, succeeded Fairbanks and Pickford as Hollywood's first couple.

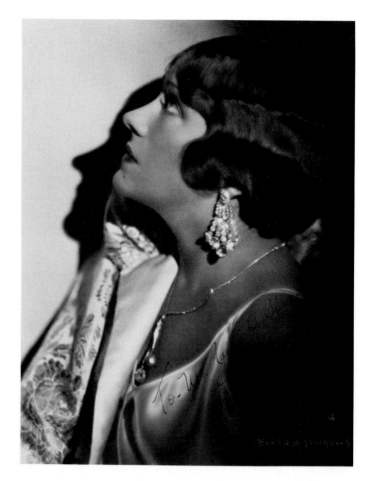

GLORIA SWANSON (1898–1983)

Circa 1928. A Mack Sennett bathing beauty who became the reigning film queen of the '20s and married a French marquis, she carried off the transition with style. Swanson is best remembered today for her role as the forgotten silent-screen star in *Sunset Boulevard* (1950).

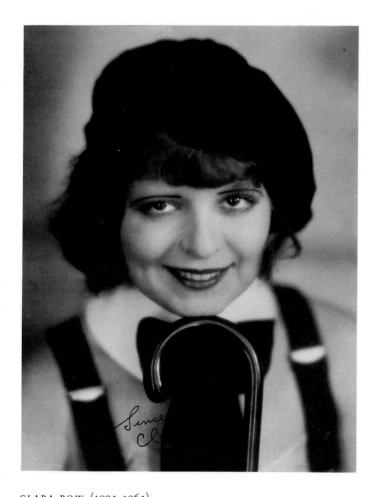

CLARA BOW (1905–1965)

Circa 1925. Dubbed the "IT Girl" by novelist Elinor Glyn, Bow was the epitome of the flapper, one of the first in a long, sinuous line of Hollywood sex goddesses.

FLORENZ ZIEGFELD (1869–1932)

Circa 1920. Each year his *Ziegfeld Follies* featured America's most beautiful women. The taste and standards of this American theatrical producer popularized the revue and created productions of a lavishness and complexity never before achieved on the musical stage.

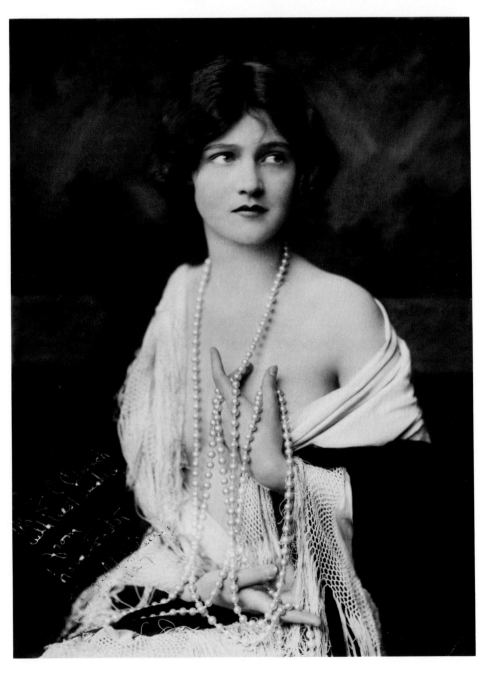

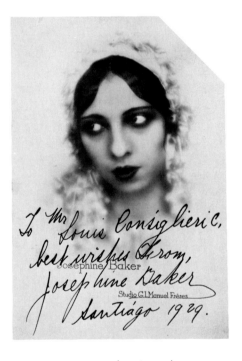

JOSEPHINE BAKER (1906–1975)

Dated 1929. The sparkling American-born singer-entertainer who became the toast of Paris and the highest paid entertainer in Europe in the 1920s. Her costumes at the Folies-Bergères sometimes consisted only of bananas.

LORA FOSTER

Dated 1927. One of Flo Ziegfeld's last and loveliest Girls, and evidence of how much styles in beauty had changed since the days of Lillian Russell (page 182) – a change greatly influenced by the Gibson Girl and the Ziegfeld Follies Girl.

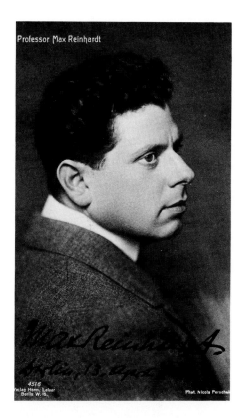

MAX REINHARDT (1873–1943)

Dated August 13, 1914. This great German stage producer and director was responsible for many theatrical innovations and trained an international flock of important movie directors and actors.

ERICH VON STROHEIM (1885–1957)

Dated 1941. Austrian-born actor and director who emigrated to the United States in the early days of film. A brilliant director of the silent screen, he is best remembered as an actor, as "the Man You Love to Hate" – the Prussian officer with the cruel lips and the sneer – and more importantly, as the prison commandant in Jean Renoir's *Grand Illusion.*

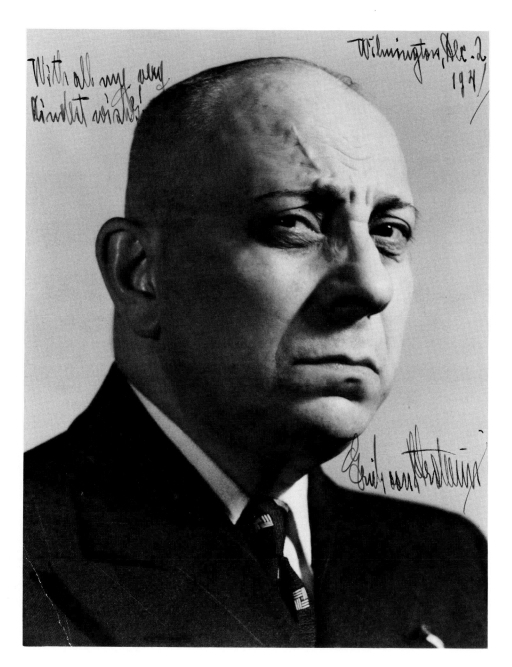

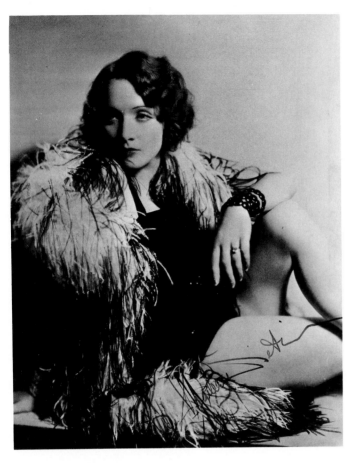

MARLENE DIETRICH (1901–)

1930. Josef von Sternberg's discovery is shown, plumply, at the beginning of her American career, apparently in costume for her Hollywood debut, opposite Gary Cooper in *Morocco*, 1930.

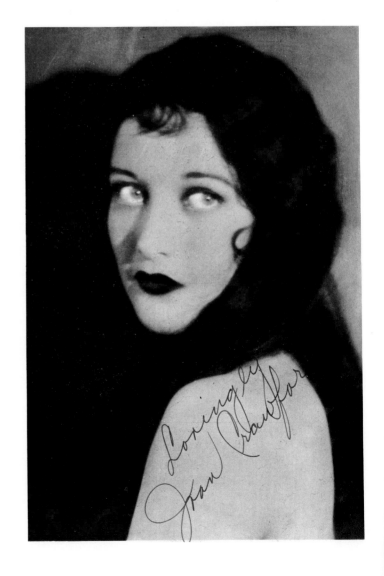

JOAN CRAWFORD (1904–1977)

Dated 1927. It's hard to recognize the imposing Crawford in this wide-eyed starlet near the beginning of one of the longest careers of all. Her roles evolved with Hollywood fashion, from madly dancing flapper to bored socialite, strong-willed career woman, and finally Baby Jane and Grand Guignol.

196

CLAUDETTE COLBERT (1905–)

Circa 1930. A fillip of laughter along with the sex-appeal. She had just the right looks, voice, and mannerisms for the madcap movie comedies of the 1930s, notably *It Happened One Night*. The French-born actress thought she photographed better from the left and nearly all her movie scenes were planned to accommodate her.

BETTE DAVIS (1908)

Circa 1945. Intelligence and individuality lurked behind those Bette Davis eyes, and she remained one of the most consistent of the great stars of her generation, winning two Academy Awards. Audiences loved her best when she played women at their worst – bitchy, ambitious characters who pursued their selfish goals.

HENRY FONDA (1905–1982)

Circa 1935. This man, who has been called "the definitive American actor," got his start in Omaha, Nebraska, at the behest of a neighbor, the mother of Marlon Brando. Some of his roles, such as Tom Joad in *The Grapes of Wrath* and the title role in *Mister Roberts*, rank among the most memorable in American films.

CLARK GABLE (1901–1960)

Dated October 1, 1931. "The King." A man's man and a woman's dreamboat. His name became synonymous with virility, and there was never a doubt (except his own) that he was born to play the role of Rhett Butler in *Gone with the Wind.* This Hurrell portrait shows Gable at the beginning of his Hollywood career, and is inscribed to a friend making his first movie.

JOHN WAYNE (1907–1979)

Dated May 27, 1940. Over a forty-year career "the Duke" appeared in some 250 films. Usually garbed in a cowboy's outfit or an officer's uniform, he came to project the essence of strength and confidence – a crusader for just causes and a leader of men.

>

JAMES STEWART (1908–)

Circa 1940. A Hollywood star since 1935, he made his mark as a shy, gangling young man with a slow country-boy manner that quickened for the cause of country, honor, or a beautiful woman. He is shown about the time he won an Oscar for *The Philadelphia Story.*

SPENCER TRACY (1900–1967)

Dated 1935. Like Gable, Stewart, Cagney, and Fonda, Tracy's career began on the stage, but he is indelibly associated with Hollywood. The films suited his styleless style, and he was much admired for his wry humor and ability to project sincerity and straightforward manliness.

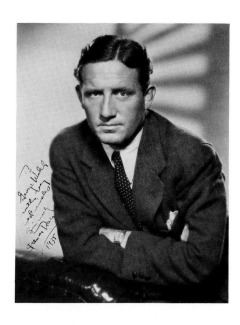

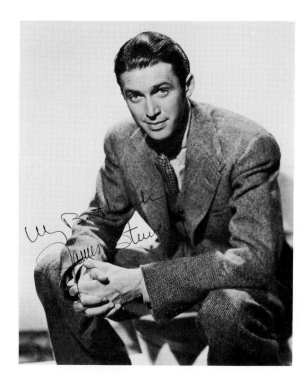

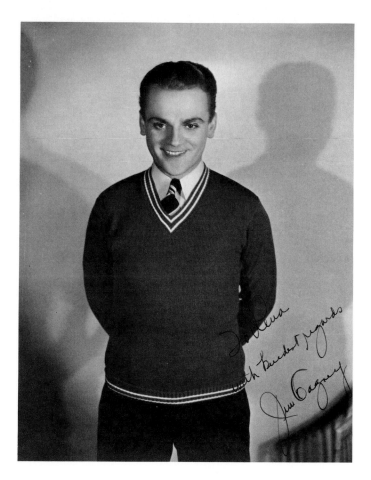

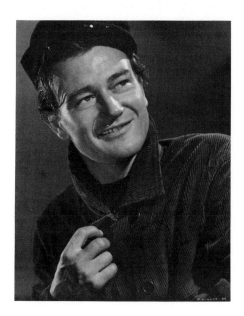

JAMES CAGNEY (1899–)

Circa 1930. Always entertaining and affecting, whether as gangster or *Yankee Doodle Dandy.* After nearly twenty years in retirement and at age eighty-one, he gave a memorable performance in *Ragtime.*

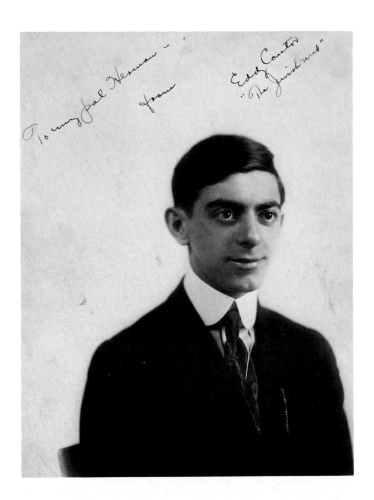

EDDIE CANTOR (1892–1964)

Circa 1915. Comedian and singer with a bubbly, inimitable style. An ex-vaudevillian, he became one of the great radio stars of the 1930s.

W. C. FIELDS (1879–1946)

Circa 1930. The bitter childhood experiences of this American comedian, who ran away from home at the age of eleven, seem to have manifested themselves in the cynicism and misanthropy of his screen roles. ("A man who hates dogs and children can't be all bad," he said.) His inimitable raspy voice provided the final touch to his comic characterizations.

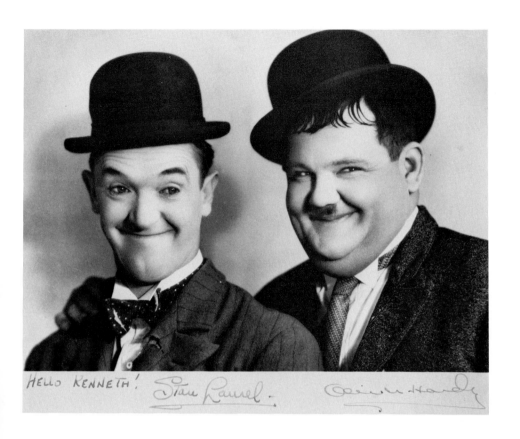

STAN LAUREL (1890–1965) &
OLIVER HARDY (1892–1957)

Circa 1930. The skinny-fat duo symbolized their gentlemanly aspirations with wing collars and bowlers. Their inventive buffoonery and timeless universalities made Laurel and Hardy the most successful comedy team in the history of the screen.

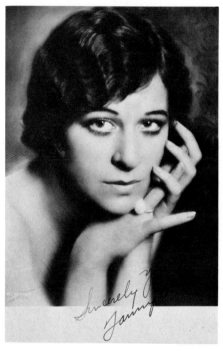

FANNY BRICE (1891–1951)

Circa 1925. The original "Funny Girl." Star of the *Ziegfeld Follies*, she gained an enormous following for her singing ("My Man") and Brooklyn-dialect comedy, but she was best known as radio's "Baby Snooks."

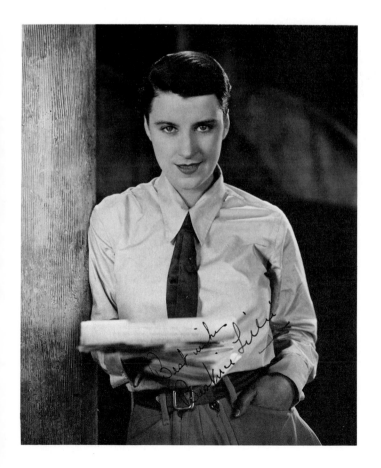

BEATRICE LILLIE (1898–)

Circa 1930. Called "the greatest comedienne of all time," an accolade some of her admirers would regard as a statement of the obvious. The British stage star, who appeared frequently on Broadway and in Hollywood, made sublime aplomb her comic trademark. She is Lady Peel in private life.

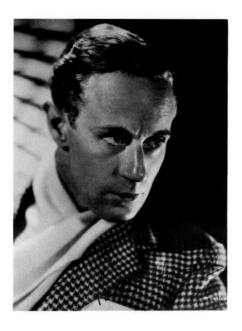

LESLIE HOWARD (1893–1943)

Circa 1938. Suggesting both the romantic and the incisive intellectual, Howard represented the perfect English gentlemen to American audiences – yet he was the inevitable choice to play the Georgian Ashley Wilkes in the American national epic, *Gone with the Wind.* During World War II his plane, returning to London from Lisbon on a secret mission, was shot down by German raiders who suspected that Winston Churchill was among the passengers.

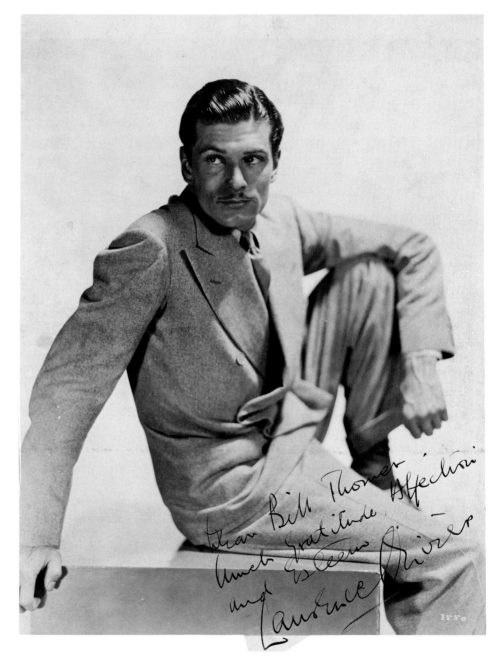

LAURENCE OLIVIER (1907–)

Circa 1938. Actor, producer, director, Hamlet, Heathcliff, and Henry V as well as Othello and Archie Rice, the greatest actor of his generation. Lord Olivier confesses in his autobiography, "I was not conscious of any other need than to show off."

202

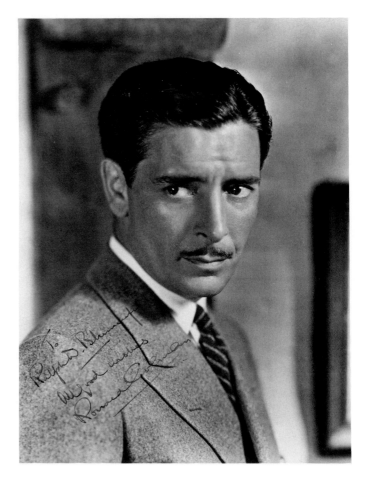

RONALD COLMAN (1891–1958)

Circa 1935. With their dignity, meticulous diction, and sophisticated charm, the British male stars in Hollywood in the '30s and '40s seemed to have a virtual monopoly on the aristocrat roles. Colman, movie-star handsome and with a mellow, richly modulated voice, was one of the best. He was especially memorable in *A Tale of Two Cities* and *Lost Horizon.*

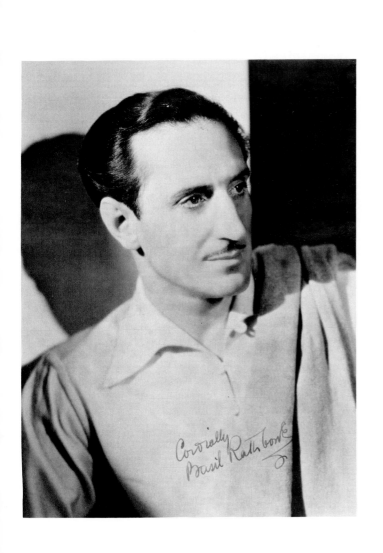

BASIL RATHBONE (1892–1967)

Circa 1936. Apparently also part of the British invasion of Hollywood (though born in South Africa), Rathbone was a constant in American films as the elegant, sneering villain, but he was also the screen's most memorable Sherlock Holmes. He is in costume here, however, for *Romeo and Juliet.*

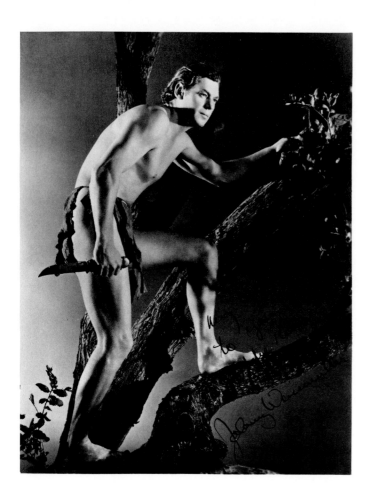

JOHNNY WEISSMULLER (1904–1983)

Dated 1937. Olympic swimmer, winner of five gold medals, the most famous and best of the film Tarzans; his good looks and mighty physique made him a bankable star of the 1930s.

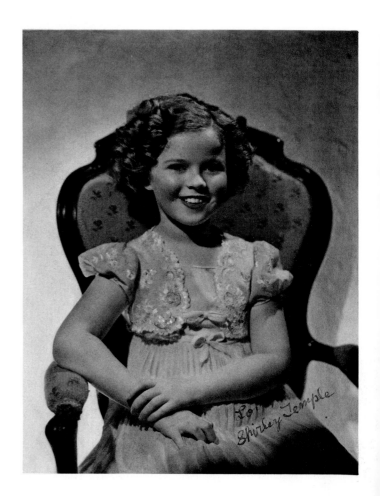

SHIRLEY TEMPLE (1928–)

Circa 1936. The number one box-office attraction of the 1930s, in *Little Miss Marker*, *The Little Colonel*, etc. A precocious song-and-dance man, complete with dimples and curls, Temple provided a bright spot in the Depression years. The transition to more grown-up roles was not very successful, but after years of domesticity, she made a surprising public reappearance as her country's representative at the U.N. and in Ghana.

JAY SILVERHEELS (1919–1980)

Circa 1950. Born on Six Nations Indian Reservation in Ontario, this son of a Mohawk chief played Tonto, the Lone Ranger's loyal sidekick, both in films and on television. Even Tonto could not go on forever, though, and in 1974 Silverheels started a new career as a harness-racing driver.

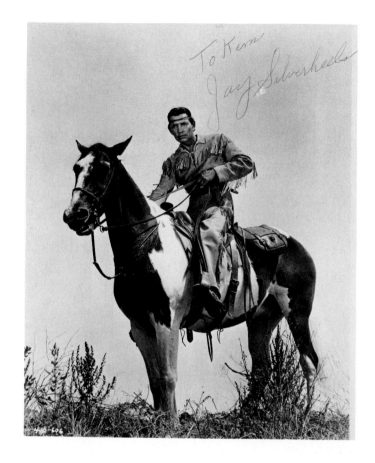

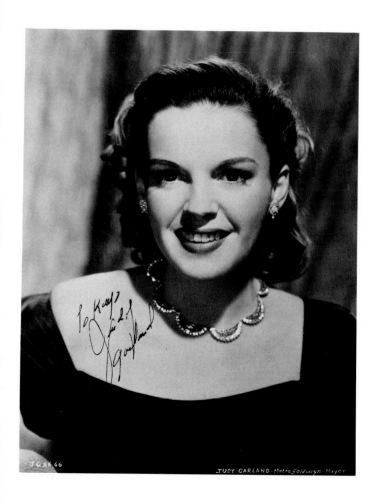

JUDY GARLAND (1922–1969)

Circa 1950. The American actress and singer whose tempestuous Hollywood career began as Andy Hardy's girlfriend and blossomed in *The Wizard of Oz.* Her memorable "Over the Rainbow" number was almost cut from the final version of the film. Graphologists would have a field day with this tense and broken signature.

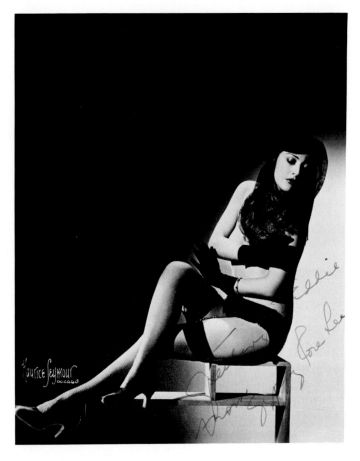

GYPSY ROSE LEE (1913–1970)

Circa 1940. Real name: Louise Hovick. American burlesque queen who, in this photograph, went about as far as she could go. She also revealed humor and brains. Her memoirs were turned into the Broadway hit and movie *Gypsy*, and she was author of a successful whodunit, *The G-String Murders*.

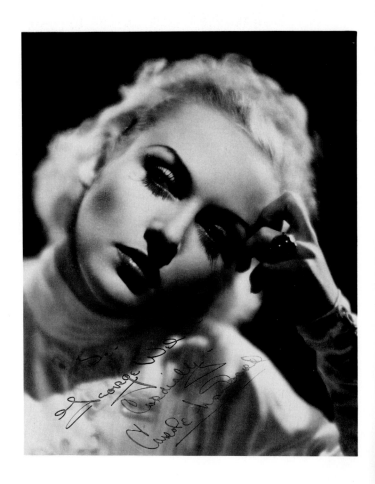

CAROLE LOMBARD (1908–1942)

Circa 1936. A sophisticated Hollywood comedienne of wit, charm, and warmth, star of screwball comedies like *My Man Godfrey* (1936). Her happy marriage to Clark Gable ended with her death in a plane crash while on a trip selling war bonds.

CAROLE LANDIS (1919–1948)

Circa 1942. United Artists' answer to M-G-M's Lana Turner. Star billing at twenty-one, and death from sleeping pills at twenty-nine. In this wartime publicity shot she is apparently painting her beachfront windows as a blackout precaution on the nervous California coast.

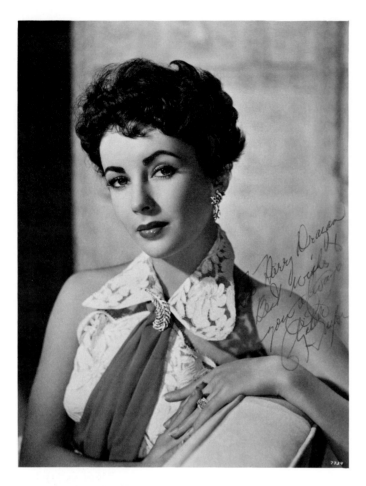

ELIZABETH TAYLOR HILTON WILDING TODD FISHER BURTON
BURTON WARNER (1932–)

Circa 1950. The British-born actress who was evacuated to Hollywood
during World War II made a smashing impact in *National Velvet.*
Very soon very grown up, she made a host of other films, which
perhaps culminated (in personal terms) in *Cleopatra* (1963) and
(professionally) in *Who's Afraid of Virginia Woolf?* (1966).

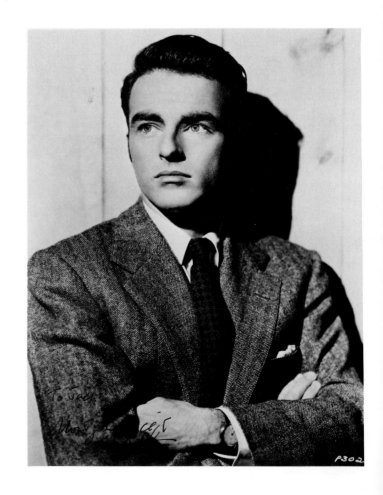

MONTGOMERY CLIFT (1920–1966)

Circa 1955. American leading man, star of *From Here to Eternity, A
Place in the Sun* (with Elizabeth Taylor), and *The Misfits* (with
Marilyn Monroe). His brooding good looks suggested, evidently
correctly, a troubled spirit, and brought out the mother in
countless female fans.

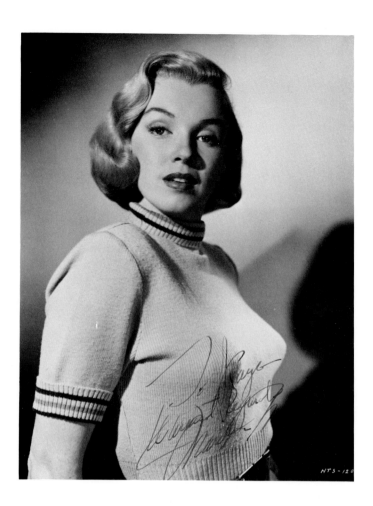

MARILYN MONROE (1926–1962)

Circa 1950. The orphan who became the American sex symbol of the 1950s lives on for her many dedicated fans around the world. Lee Strasberg eulogized her: "For the entire world she became a symbol of the eternal feminine."

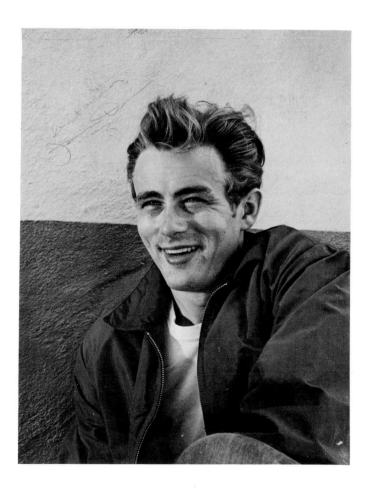

JAMES DEAN (1931–1955)

Circa 1955. His real name was quite suitable: James Byron. The archetypal rebellious American teenager of the 1950s in films like *East of Eden*, *Rebel without a Cause*, and *Giant* (with Elizabeth Taylor). His death in a car crash in 1955 sealed his fate as a perpetual teen idol, and Dean imitators in jeans and T-shirts have spread as far as the Soviet Union.

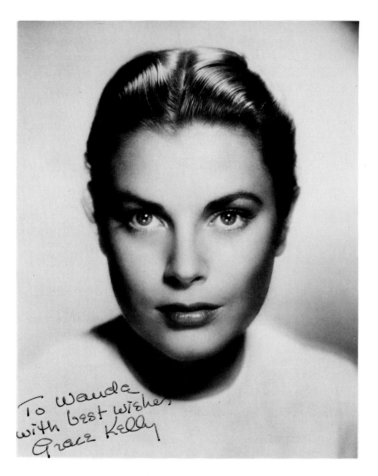

To Wanda
with best wishes,
Grace Kelly

GRACE KELLY (1928–1982)

Circa 1950. The shy blonde actress from Philadelphia, shown here in her early twenties, was to enjoy a short but sparkling movie career that found her starring with such fellows as Gable, Stewart, Cooper, and Cary Grant (in *To Catch a Thief*). She went on to an impeccable performance as Princess of Monaco.

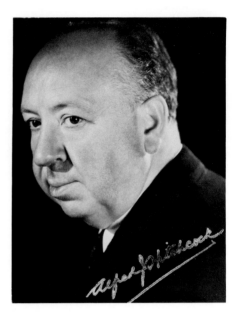

INGRID BERGMAN (1915–1982)

Dated April, 1946. Hollywood's first "natural" star (no "look" was created for her) is shown about the time that Hitchcock's *Notorious* was released. A few years later the Swedish-born actress would be condemned on the floor of the U.S. Senate for her affair with director Roberto Rossellini. A new generation of the audience would be more generous, and she came to be regarded as one of the great ladies of the theater.

CARY GRANT (1904–)

Circa 1950. Real name: Archibald Leach, and he used it for his Broadway debut. But his Hollywood mentors had a good ear as well as a good eye for talent, and "Cary Grant" became synonymous with urbane charm. For thirty years he was everyone's leading man in dozens of films, usually light-hearted. Among them were *Bringing Up Baby*, *The Philadelphia Story*, and Hitchcock's *Notorious* and *North by Northwest*.

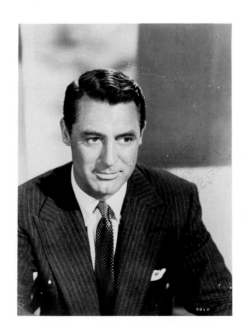

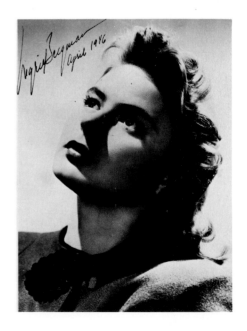

ALFRED HITCHCOCK (1899–1980)

Circa 1950. The British master of suspense, whose half a century of films included such classics as *The 39 Steps*, *Rebecca*, *North by Northwest*, and *To Catch a Thief*, in which he uncovered the sensual side of Miss Kelly. He never won an Oscar, but he was the one director whose name alone drew audiences into the theater.

<

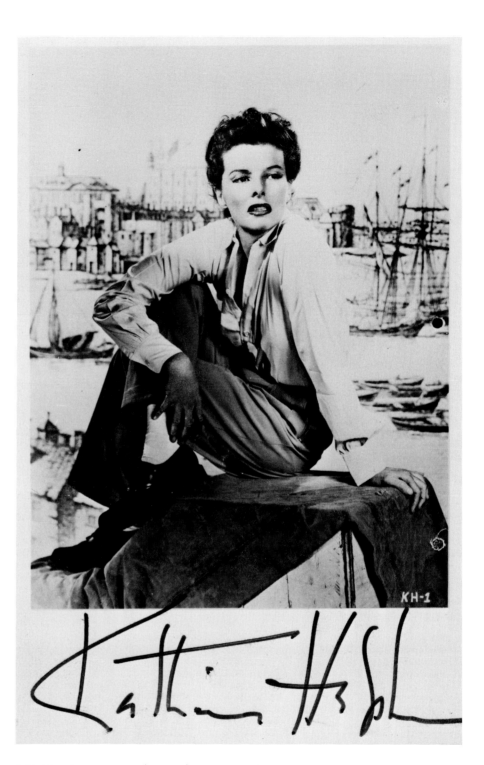

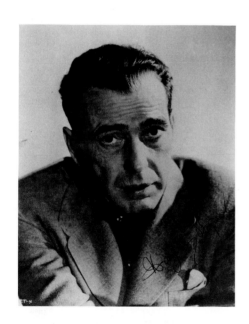

HUMPHREY BOGART (1899–1957)

Circa 1950. The great "Bogie," once a handsome stage juvenile, became the epitome of the antihero, cynical, self-reliant, brooding. His *Casablanca*, with Bergman, became a cult movie; and *The African Queen*, in which John Huston brilliantly cast him opposite Katharine Hepburn, was a surprise success that displayed the actor's comic talent.

KATHARINE HEPBURN (1909–)

Circa 1945. Never just another pretty face, an actress of great comic and dramatic versatility and a decided individualist in private life. She is the most durable star of them all, from a stunning screen debut in *A Bill of Divorcement* (1931) to *On Golden Pond* (and an unprecedented fourth Academy Award) fifty years later.

INDEX

Inscriptions are included below if they are not legible in the reproduction; they are in the hand of the subject unless otherwise noted. Photographic sources are indicated in italics. "Very rare" means that only one to five autographed photographs of that person are known to exist.

Adams, Maude, 190. *Sarony, N.Y.*
Adams, John Quincy, 6. Engraving. *N. Dearborn, Boston.* (Very rare)
Agassiz, Louis, 39. *A. Sonrel, Boston*
Albert, Prince, 74. *C. Silvy.* (Very rare)
Aldrin, Edwin, 25. *NASA*
Allenby, Edmund, 98. *Imperial War Museum, London.* (Very rare for this event)
Anastasia, Albert, 31. *Dahdo, Los Angeles* (Very rare)
Andersen, Hans Christian, 50. *Thora Hallger, Copenhagen.* (Very rare)
Andrews, Roy Chapman, 11
Anthony, Susan B., 108. *Marceau, San Francisco*
Arcaro, Eddie, 173. *Bert and Richard Morgan, Valley Stream, N.Y.*
Armstrong, Louis, 159
Armstrong, Neil, 25. *NASA*
Astaire, Fred, 154, 180
Atlas, Charles, 174. "With my very best wishes for perfect health and happiness to my friend G. A. Stave"

Baden-Powell, Robert, 111
Baer, Arthur "Bugs," 134
Baker, Josephine, 194. *G. L. Manuel Frères*
Bannister, Roger, 173. *Oxford Mail*
Barnum, Phineas T., 26. *Black & Case, Boston*
Barrow, Clyde, 30. (Very rare)
Barrow, Edward Grant, 166. *Cosmo, N.Y.*
Barrymore, Ethel, 187
Barrymore, John, 186
Barrymore, Lionel, 186
Bartholdi, Frederic, 124
Bartók, Béla, 151. "To Mrs. Sue Prosser, Denver"
Barton, Clara, 106. On verso: "I have had some old time pictures brought down to commercial size for letters – will you kindly accept?"
Beard, Dan, 111
Beardsley, Aubrey, 126. (Very rare)
Beatles, The, 159

Beaton, Cecil, 122–123, 138. *Self-portrait*
Beecher, Henry Ward, 110. *Sarony*
Beery, Wallace, 188. "Alda, isent [sic] this a hell of a make up. Wall"
Bell, Alexander Graham, 35. *N.Y. Photographic Co.*
Ben-Gurion, David, 99
Bergman, Ingrid, 210
Berlin, Irving, 152. "Sincerely yours". *Tycko, Los Angeles*
Bernhardt, Sarah, 183
Bismarck, Otto von, 80
Black, Hugo L., 121
Bleriot, Louis, 16
Blixen, Karen, 66. *Ni Nissen*
Bogart, Humphrey, 211
Bohr, Niels, 44
Bonnie and Clyde. See Parker, Bonnie
Booth, William, 110
Borglum, Gutzon, 136. *Q. A. Vik, Rapid City, S.D.*
Bourke-White, Margaret, 137
Bow, Clara, 193
Bradley, William, 178
Brahms, Johannes, 148. *Brasch, Berlin*
Brandeis, Louis, 120. *Harris & Ewing, Washington, D.C.* (Very rare in portrait)
Brennan, William J., 121
Brice, Fanny, 201. "Sincerely Yours". *M. I. Boris, N.Y.*
Brown, John (Harpers Ferry), 107
Brown, John (equerry to Queen Victoria), 75. (The only known signed photograph)
Brown, John Mack, 192
Broz, Josip, 100
Budge, Don, 165. *E. Trim, Wimbledon*
Buffalo Bill. See Cody, William
Bunsen, Robert, 38. (Very rare)
Buntline, Ned, 29. *Sarony.* (Very rare)
Burbank, Luther, 32–33, 47
Burroughs, John, 38. *Edward B. Greene*

Cagney, James, 199. "To Rena with kindest regards"
Cantor, Eddie, 200. "To my pal Herman – from Eddy Cantor 'The Jewish nut'." He later signed "Eddie"
Capone, Al, 30. (Very rare)
Carnegie, Andrew, 117. *Pach Bro's, N.Y.*
Carpenter, Scott, 25. *NASA*
Carson, Rachel, 43. *Brooks, Bethesda, Md.*

Cartoonists of the Golden Age, 134
Caruso, Enrico, 144. "Alla gentile Margherita Giriadelli [?] con simpatia". *Mishkin, N.Y.*
Casals, Pablo, 147. "A Madame Ladenburg. Souvenir bien sympatique . . . Frankfort". *M. Büttinghausen, Amsterdam*
Chagall, Marc, 129
Chamberlain, Neville, 87. "Miss Watson, in grateful appreciation of her unfailing help". *Fayer*
Chamberlain, Wilt, 178
Chaney, Lon, 189
Chaplin, Charles, 184. "Faithfully yrs"
Chevalier, Maurice, 157
Chiang Kai-shek, 102. *Hu Chung Hsien*
Christie, Agatha, 59. *Walter Bird, London*
Churchill, Winston, 82. *Thomson, Rotary Photo, London*
Clark, Tom C., 121
Clem, Johnny, 77. On verso, in another hand: "Sargeant Johnny Clem and his autograph. Photo taken at Chicamauga, at 12 years of age and after two years of service and after promotion for bravery on the field of battle". (Very rare)
Clift, Montgomery, 208
Cobb, Ty, 168
Cocteau, Jean, 69
Cody, William F., 28. *Stacy, Brooklyn*
Colbert, Claudette, 197
Colette, 55. *Henri Manuel, Paris.* (Very rare as Colette Willy)
Collins, Michael, 25. *NASA*
Collins, Wilkie, 58. *Cundall, Downes & Co.*
Colman, Ronald, 203
Cooper, Gordon, 25. *NASA*
Cosindas, Marie, 137. *Self-portrait, in Polacolor*
Coward, Noël, 62. "Sincerely Yours". *Maurice Beck & McGregor*
Craig, Gordon, 127
Crawford, Joan, 196. "Lovingly"
Crosby, Bing, with sons Gary, Denny, Lindsay, and Phillip, 156
Crowley, Jim, 175
Cummings, E. E., 71. "Inscribed at the request of Cornelius Greenway, D.D."
Curie, Marie, 37. *Harris & Ewing.* (Very rare)
Custer, George Armstrong, 77. *Brady, Washington, D.C.*

Dali, Salvador, 130
Dalton, Emmett, 28. On verso, in another hand: "Famous outlaw + Bandit of Okla." (Very rare)
d'Annunzio, Gabriele, 17. "Il Vittoriale" was his bizarre country villa
Darrow, Clarence, 113. "To Herbert Clinton Branch With friendly regards". *Nickolas Muray*
Darwin, Charles, 38. The photographer has written: "From life. Copyright. Julia Margaret Cameron"
Davis, Bette, 197
Dean, James, 209
de Gaulle, Charles, 93
Dempsey, Jack, 171. *Apeda, N.Y.*
de Valera, Eamon, 86
Dickens, Charles, 50. Signed front and back. *John & Chas. Watkins, London*
Dietrich, Marlene, 196
DiMaggio, Joseph, 167
Dinesen, Isak, 66. *Ni Nissen*
Disney, Walt, 135
Douglas, William O., 121
Douglass, Frederick, 106. Signed front and back. *C. M. Bell, Washington, D.C.* (Very rare)
Doyle, Sir Arthur Conan, 58. *Elliott & Fry*
Dreiser, Theodore, 68. *Pacific & Atlantic Photos, Inc.*
Drew, John, 186. *Morrison, Chicago*
Du Chaillu, Paul Belloni, 23. *Markham & Johnson, Brooklyn*
Duchamp, Marcel, 131. "Pour McPherson"
Duncan, Isadora, 143. "Grüss [greetings]"
Duse, Eleonora, 182. *Aimé Dupont, N.Y.*
Dylan, Bob, 161

Earhart, Amelia, 21
Eastman, George, 46. (Very rare)
Edison, Thomas A., 35. *Walter Scott Sherin*
Edward, Duke of Windsor, 87, 94
Ehrlich, Paul, 36. [?], *Hamburg.* (Very rare)
Eiffel, Alexandre Gustave, 124. *Nadar, Paris*
Einstein, Albert, 45. "The man who enjoys marching in line and file to the strains of music falls below my contempt; he received his great brain by mistake – the spinal chord

would have been amply sufficient".
Tycko

Eliot, T. S., 68

Elizabeth, Princess (Elizabeth II), 95.
See George VI

Elizabeth (queen of George VI), 95.
See George VI

Ellis, Havelock, 41. *Studio Hugo,
Cheltenham*

Emerson, Ralph Waldo, 52. *Whipple,
Boston*. (Very rare)

Fairbanks, Douglas, 184. "For Mr. &
Mrs. Keene [?] of whom I have
pleasant memories". *White, N.Y.*

Faisal Ibn Abdul-Aziz al Saud, 99

Farragut, David, 76. *C. D. Fredericks
& Co., N.Y.*

Faulkner, William, 70

Ferrari, Enzo, 172

Fields, W. C., 200. "To Herbert
Clinton Branch"

Firestone, Harvey, 115

Fitzgerald, F. Scott, 61

Flagg, James Montgomery, 127. "To
Edgar A. Moss". *Campbell, N.Y.*

Foch, Ferdinand, 83. *Harris & Ewing*

Fonda, Henry, 198

Ford, Henry, 115

Four Horsemen of Notre Dame, 175

Foster, Lora, 194. *Alfred Cheney
Johnston*

Freud, Sigmund, iii. *Max Halberstadt,
Hamburg*

Gable, Clark, 198. "To Wally Ford
[the actor] / May your first one be
one of your best – I am glad to
have been able to make it with you
– It was my good fortune / Believe
me". *Hurrell, MGM*

Gagarin, Yuri, 24

Gandhi, Indira, 103

Gandhi, Mohandas, 103

Garbo, Greta, iv. Publicity still for
The Temptress. MGM

Garibaldi, Giuseppe, 80. *Alfredo Noack
Foto, Genoa*

Garland, Judy, 205. "To Kayo". *MGM*

Garrison, William Lloyd, 106. *Sonrel*

Gatty, Harold, 21

Gehrig, Henry Louis (Lou), 167.
Morgan. (Very rare in portrait)

George VI (king of England), with
Queen Elizabeth, Princesses
Elizabeth and Margaret, 95. *Raphael
Tuck and Sons, London*

Gershwin, George, 153

Getty, Jean Paul, 117

Gibson, Charles Dana, and Irene
Gibson, 127. "To Edgar A. Moss"

Gilbert, William S., 152. "Brandon
Thomas [author of *Charley's Aunt*] /
with WSGilbert's kind regards"

Gish, Lillian, 191

Gladstone, William Ewart, 75. *Alex.
Bassano, London*

Glenn, John, 25. *NASA*

Goddard, Robert, 44. *Rice.* (Very rare)

Goldberg, Arthur J., 121

Gorki, Maxim, 48–49, 51 (Very rare)

Graham, Martha, 154

Grange, Harold, 176. *Melbourne Spurr,
Hollywood*

Grant, Cary, 210. "Cordially"

Grant, Ulysses S., 76. *E. &
H. T. Anthony, N.Y.*

Gray, Harold, 134. *Butler, Chicago*

Grey, Zane, 65

Griffith, D. W., 185

Grissom, Virgil, 25. *NASA*

Gropius, Walter, 133

Gustav V (king of Sweden), 95.
J. Fenyrol, Cannes

Harding, Warren G., 37. *See*
Curie, Marie

Hardy, Oliver, 201

Harlan, John M., 121

Harmon, Tom, 176

Harrison, George, 160

Hemingway, Ernest, 70. (Very rare)

Hepburn, Katharine, 211

Herbert, Victor, 152. "Sincerely
yours". *Willow Grove Park*

Herschel, John, 38. *Maull & Polyblank,
London*

Higbie, Dorothy, 162–163, 164. *See*
Ouimet, Francis

Hill, Gus, 27

Hindenburg, Paul von, 81

Hirohito, Prince, 91. Photograph taken
in England; frontispiece for *The
Crown Prince's European Tour* by
Count Yoshinori Futara and Setsuzo
Sawada (Osaka Publishing Co.,
Ltd., 1926. English edition)

Hitchcock, Alfred, 210

Holiday, Billie, 158. "For my Names-
sake/Best Always." *Dick Stone*

Holmes, Oliver Wendell, 120. *Harris
& Ewing*

Houdini, Harry, 26

Howard, Leslie, 202

Hughes, Howard, 20. (Very rare)

Hugo, Victor, 54. *Ghémar Frères,
Brussels*

Ibsen, Henrik, 3. *J. C. Schaarwächter,
Berlin*

Jagger, Mick, 161

Jellicoe, John Rushworth, 83

Johnson, Jack, 170. *Birmingham
Smallwares*

Johnson, Walter, 169

Joyce, James, 57. [?], *Zurich*

Juin, Alphonse, 92. Inscribed to
Cornelius Greenway

Kalakaua (king of Hawaii), 96.
J. Williams, Honolulu

Kapiolani (queen of Hawaii), 96.
J. Williams. (Very rare)

Keller, Helen, 12. *Muray*

Kellerman, Annette, 189

Kelly, Grace, 210

Kennedy, Jacqueline, 8

Kennedy, John Fitzgerald, 8, 101

Khrushchev, Nikita, 100. Photo was
sent with letter from a representative
of N.K. to editor Cyril Clemens,
thanking him for his gift to N.K. of
a lifetime subscription to *Mark
Twain Journal*

King, Martin Luther, 119. "The strong
man is the man who can stand up
for his rights and not hit back.
With best wishes." *Time* cover

Kipling, Rudyard, 65. *Elliott & Fry*

Kitchener, Horatio Herbert, 82

Koch, Robert, 37. *Fechner, Berlin.*
(Very rare)

Kruger, Stephanus Paulus, 82.
Ebner – La Haye. (Very rare)

Land, Edwin, 46

Landis, Carole, 207

Langtry, Lily, 182. *Rotary Photo*

Laurel, Stan, 201

Lawrence, T. E., 22. (Very rare)

Layden, Elmer, 175

Le Corbusier, 132. (Very rare)

Lee, Gypsy Rose, 206. *Maurice Seymour,
Chicago*

Lee, Robert E., 76. "*The Lee
Photographic Gallery,*" Richmond

Lehand, Elizabeth, 88. "For the 'one
and only' Doc [Doc O'Connor,
Roosevelt's law partner] – from
Missy"

Lennon, John, 160

de Lesseps, Ferdinand, 8.
Stereoscopic Co.

de Lesseps, Hélène, 8. *Reutlinger*

Lewis, John L., 112

Lillie, Beatrice, 201

Lincoln, Abraham, i. *Brady*

Lindbergh, Charles, 14–15: *Underwood;*
16: *Underwood*

Lipton, Thomas, 114

Liszt, Franz, 148. *Fratelli d'Alessandri,
Rome*

Lloyd George, David, 87. *Olive Edis.,
Sheringham, England*

Lombard, Carole, 206. "To George
Welch"

Lombardi, Vincent, 177

London, Jack, 60. *Arnold Genthe*

Longfellow, Henry Wadsworth, 50.
Warren's Portraits, Boston

Louis, Joe, 170. *Photo Specialty Co.,
Los Angeles*

Luckner, Count Felix von, and his
wife, 85. *F. Langhammer Hofphotogr.,
Cassel*

MacArthur, Douglas, 92

McCartney, Paul, 160

McManus, George, 134

Mahler, Gustav, 149. *A. Dupont*

Mann, Thomas, 68

Manson, Charles, 10

Marciano, Rocky, 171. *Bob Gaffney*

Marconi, Guglielmo, 34. *Rotary Photo*

Margaret, Princess, 95. *See* George VI

Marlborough, Consuelo, Duchess of,
79. *Lafayette.* (Very rare)

Marsh, Ngaio, 59. *Mannering and Assoc.,
Ltd., Christchurch, New Zealand*

Marx, Karl, 42. *Mayall's Photographic
Studio, London.* (Very rare)

Mata Hari, ii

Matisse, Henri, 129. (Very rare)

Maugham, W. Somerset, 62. *Ken Ross-
MacKenzie, Max Rayner Photography
Ltd., London*

Mazzini, Giuseppe, 80. *D,Lama,
London*

Mead, Margaret, 41. *Black Star*

Melba, Nellie, 145. "To [?] with
many thanks and bravo"

Mellon, Andrew, 116. *Underwood &
Underwood, Washington, D.C.*

Mercury Astronauts, 25. *NASA*

Metro-Goldwyn-Mayer, stars of, 180–
181. First row, left to right: Lionel
Barrymore, June Allyson, Leon

Ames, Fred Astaire, Edward Arnold, Lassie, Mary Astor, Ethel Barrymore, Spring Byington, James Craig, Arlene Dahl. 2nd row: Gloria DeHaven, Tom Drake, Jimmy Durante, Vera-Ellen, Errol Flynn, Clark Gable, Ava Gardner, Judy Garland, Betty Garrett, Edmund Gwenn, Kathryn Grayson, Van Heflin. 3rd row: Katharine Hepburn, John Hodiak, Claude Jarman Jr., Van Johnson, Jennifer Jones, Louis Jourdan, Howard Keel, Gene Kelly, Christian Kent (Alf Kjellin), Angela Lansbury, Mario Lanza, Janet Leigh. 4th row: Peter Lawford, Jeanette MacDonald, Ann Miller, Ricardo Montalban, Jules Munshin, George Murphy, Reginald Owen, Walter Pidgeon, Jane Powell, Ginger Rogers, Frank Sinatra, Red Skelton. 5th row: Alexis Smith, Ann Sothern, J. Carrol Naish, Dean Stockwell, Lewis Stone, Clinton Sundberg, Robert Taylor, Audrey Totter, Spencer Tracy, Esther Williams, Keenan Wynn

Millay, Edna St. Vincent, 66. *Mishkin*. (Very rare)

Miller, Don, 175

Mitchell, William, 85

Moltke, Count Helmuth von, 81. *Loescher & Potsch, Berlin*

Monet, Claude, 128. *Muray*

Monroe, Marilyn, 209. "To Kayo / Warmest regards"

Montgomery, Bernard Law, 92

Mooney, Tom, 112. (Very rare)

Moore, Marianne, 67. *George Platt Lynes*

Morse, Samuel F. B., 34. Engraving

Moses, Grandma, 137

Moss, Stirling, 172. "Wishing you all happy & successful lives"

Mussolini, Benito, 90

Nabokov, Vladimir, 69. (Very rare)

Nagaoka, General, 97. (Very rare)

Nansen, Fridjof, 23. *The 'Van der Weyde' Light, London*

Napoleon III, 80. On verso, in another hand: "I sent this Carte to the Emperor Napoleon while captive at Wilhemshoe on Oct. 25 1870 and received it back (signed) Oct. 29 1870. J. M. Menson [?]". *Le Jeune, St. Cloud.* (Very rare)

Nation, Carry Amelia, 110. *Halls' Studio, N.Y.*

Nesbit, Evelyn, 190. *Sarony.* (Very rare)

Nijinsky, Waslaw, 142. "A Andre, Waslaw". (Very rare)

Norton, Charles Eliot, 42. *Pach Bro's, Cambridge*

Nungesser, Charles, 17

Nurmi, Paavo, 173

Oakley, Annie, 29. *Duryer, Newark, N.J.*

Olivier, Laurence, 202. "Dear Bill Thomer / Much Gratitude, Affection and Esteem"

O'Neill, Eugene, 61. *Muray*

O'Neill, James, 188. *Empire Studio*

Ouimet, Francis, 162–163; 164: *Geo. F. Pietzcker, St. Louis.* (Very rare)

Paderewski, Ignace, 146. "Yours Truly". *London Stereoscopic Co.*

Pahlavi, Mohammed Riza Shah, 99. "To Major General J. F. R. Seitz". *Imperial Photograph*

Paige, Leroy (Satchel), 169

Pankhurst, Emmeline, 108

Pankhurst, E. Sylvia, 109

Parker, Bonnie, 30

Parker, Charlie, 159. "To Kayo, Regards". *James J. Kriegsmann, N.Y.*

Parrish, Maxfield, 127. *Levesque Studio, Windsor, Vermont.* (Very rare)

Pasteur, Louis, 36. *A. Gerschel, Paris*

Patton, George, 92

Paul VI (pope), 119. *A. Felici, Rome*

Pavlov, Ivan, 40. (Very rare)

Pavlova, Anna, 142. *Alfred Ellis & Walery, London*

Peary, Robert E., 23

Pelé, 179

Penney, James Cash, 117. *Underwood & Underwood N.Y.*

Perón, Juan, 100. Inscribed to Cornelius Greenway

Picasso, Pablo, 130. "Pour Pierre Bertrand"

Pickford, Mary, 184. *Hartsook Photo*

Porter, Cole, 153

Post, Wylie, 21. (Very rare)

Presley, Elvis, 160. "To David / My Best to you"

Prokofiev, Sergei, 150. "To my friend E. F. Gottlieb, Chicago 1920"

Puccini, Giacomo, 146. "To Miss Violet Leverson". *Oest, Vienna*

Rankin, Jeannette, 84. "I want to stand by my country but I cannot vote for War / I vote *no* / Good Friday / April 6, 1917." Note that there is no signature. *Harris & Ewing*

Rathbone, Basil, 203

Ravel, Maurice, 151. *Henri Manuel*

Raymond, Alex, 134

Reinhardt, Max, 195. *Nicola Perscheld, Berlin*

Richthofen, Baron Manfred von, viii. *C. J. von Dühren, Berlin*

Rickenbacker, Eddie, 16

Rickey, Branch, 169

Ride, Sally, 24. *NASA*

Ripley, Robert, 135

Robeson, Paul, 153. *'Sasha,' London*

Robinson, Bill, 155. *Micholson, Kansas City*

Robinson, Jack Roosevelt, and his wife, 169

Rockefeller, John D., 114

Rodin, Auguste, 125. *H. Manuel, Paris*

Rogers, Ginger, 154

Rommel, Erwin, 91. (Very rare)

Roosevelt, Alice Lee, 78. *Frances B. Johnston*

Roosevelt, Eleanor, 89. *Bachrach*

Roosevelt, Franklin, 88. *Underwood & Underwood*

Roosevelt, Theodore, 72–73; 78: "To William Deacon Murphy, Columbia '08, with the good wishes of Theodore Roosevelt". *Geo. G. Rockwood*

Rossini, Gioacchino, 146. "Souvenir de Reconnaissance offert à mon jeune ami monsieur Le Baron Alfred de Rothschild". With drawing of chord. *Erwin Freier, Paris*

Rostand, Edmond, 54. *Paul Boyer, Paris*

Rouault, Georges, 131. *Yvonne Chevalier.* (Very rare)

Rubinstein, Helena, 117

Ruppert, Jacob, 166. *Cosmo*

Russell, Bertrand, 43

Russell, Lillian, 182

Ruth, George Herman, 166. The Babe is shown playing an exhibition game in Japan

St. Denis, Ruth, 143. *Toloff, Evanston, Ill.*

Saint-Gaudens, Augustus, 125. *G. C. Cox Photo.* (Very rare)

Sandburg, Carl, 53. *Ortho Print, N.Y.*

Schirra, Walter, 25. *NASA*

Schmeling, Max, 170. *Bryant, N.Y.*

Schumann, Clara, 147. *Franz Hanfstaengl, Munich.* (Very rare)

Schweitzer, Albert, 40. "A Richard Charles Nalven [?] avec mes bonnes pensées"

Scopes, John, 113

Scott, Blanche Stuart, 19. "First hop – Aug 8/1910 / First solo in the air Sept 2 1910". Modern print from old negative

Scott, Winfield, 77. *Brady photo; E. & H. T. Anthony print*

Seward, William, 77

Shaw, George Bernard, 56. *H. J. Whitlock and Sons, London*

Shearer, Norma, 192

Shepard, Alan, 25. *NASA*

Sherman, William Tecumseh, 76. *Brady*

Sibelius, Jean, 150. *Runeberg, Helsinki*

Silverheels, Jay, 205

Simenon, Georges, 59

Simpson, O. J., 177

Sinatra, Frank, 157. "For Rudy"

Sitwell, Edith, 63. "For Darling Evelyn with Edith's best love"

Slayton, Donald, 25. *NASA*

Soglow, Otto, 134

Stanley, Henry Morton, 22. *Platino Grapho, E. Passingham, Bradford, England*

Starr, Ringo, 160

Steichen, Edward, 139. *Joan Miller*

Stevenson, Robert Louis, 56. (Very rare)

Stewart, James, 199

Stewart, Potter, 121

Stowe, Harriet Beecher, 52. *Hastings, Boston*

Stravinsky, Igor, 151. "To Sybil Lawson / sincerely"

Strindberg, August, 54. *Norman Anderson, Stockholm.* (Very rare)

Stroheim, Erich von, 195. *Vandamm Studio, N.Y.*

Stuhldreher, Harry, 175

Sullivan, Arthur, 152. *J. C. Schaarwächter*

Sun Yat-sen, 102. *Burr, Shanghai.* (Very rare)

Supreme Court. *See* Warren, Earl

Swanson, Gloria, 193. "To Mr. Ralph D. Blumenfeld, Greetings". *Bachrach*

Taylor, Elizabeth, 208

Temple, Shirley, 204. Hand-tinted photo
Tennyson, Alfred Lord, 50. *Reynold's Photo Co., Chicago*
Terry, Ellen, 182. *Lafayette, Dublin*
Tetrazzini, Luisa, 144. *Varischi Artico Co., Milan*
Thomson, Robert, 169
Thorpe, Jim, 179. (Very rare)
Tilden, William, 165. *Wimbledon photo*
Tito, Marshal, 100
Titov, Gherman, 24
Tojo, Hideki, 90. (Very rare)
Tolstoy, Count Lev Nikolayevich. *R. Thiele*
Toscanini, Arturo, 140–141, 148. *Pieperhoff, Leipzig*
Tracy, Spencer, 199. "To George Welch with very best wishes / sincerely"
Twain, Mark, 52
Two Guns White Calf, 4. *Hileman, Kalispell, Montana.* (Very rare)

Undset, Sigrid, 55

Vance, Dazzy, 169
Vanderbilt, Cornelius, 114. *D'Utassy's National Porcelain Portrait Gallery, N.Y.* (Very rare)
Verdi, Giuseppe, 146. *Giulio Rossi, Milan*
Verne, Jules, 64
Victoria (queen of England), 74. *Mayall*
Villa, Pancho, 28. (Very rare)

Walker, Mary, 106. *C. M. Bell.* (Very rare)
Wallace, Edgar, 58. *Horace W. Nicholls, Goch Studio, Johannesburg*
Wallenda, Herman, Joe, Karl, and Helen, 26
Wallis, Duchess of Windsor, 94
Warren, Earl, and the Warren Court, 104–105, 121
Washington, Booker T., 118. *Rockwood, N.Y.*

Watson, Thomas A., 35. "Associated with Graham Bell in 1876 / Made the first telephone / Heard the first sound ever telephoned". (Very rare)
Wayne, John, 199. "Good luck, Tony"
Webster, Daniel, 7. "For Mrs. Brown; with the regards & good wishes of Dan¹ Webster". *Engraving by J. Cheney & R. W. Dodson from a painting by R. M. Staigg.* (Very rare)
Weismuller, Johnny, 204
Welch, Harry Foster, 134
Wells, H. G., 64. "To my long suffering collaborator Harold Wheeler [?] with much gratitude for endless help". *Harris & Ewing*
West, Mae, 216
Westover, Russ, 134
White, Byron R., 121
Whitman, Walt, 52. *G. F. E. Pearsall, Brooklyn*
Wilde, Oscar, 56. *W. & D. Downey, London*

Wilhelm II (emperor of Germany), 83. *Oscar Tellgmann*
Williams, Ted, 179
Willy, Colette. *See* Colette
Wilson, Woodrow, 84. *Underwood & Underwood, N.Y.*
Windsor, Duke of, 87, 94
Windsor, Duchess of, 94
Wright, Frank Lloyd, 133
Wright, Orville, 18
Wright, Wilbur, 18

Young, Brigham, 118. *Savage & Ottinger*

Zaharias, Mildred Didrikson, 165
Zaharoff, Basil, 9. *Numa Blanc fils, Monte Carlo.* (Very rare)
Zeppelin, Count Ferdinand von, 19
Ziegfeld, Florenz, 194. *Harold Stein, N.Y.*
Zola, Emile, 2. *Nadar.* (Very rare)

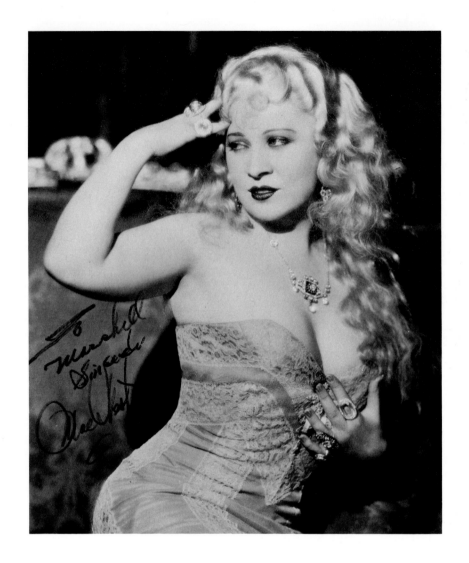

MAE WEST (1892–1980)

Circa 1930. The bawdy, buxom blonde wrote
those *double entendres* herself. She brought a new frank
sexuality to Hollywood from Broadway, and in 1935
was the highest paid woman in America.
"Goodness had nothing to do with it."

Designed by Susan Marsh

Captions by M. Wesley Marans, with Richard Maurer,
Geoffrey Mandel, and Lucy Lovrien

Composition in Monotype Bembo by The Stinehour Press
Printed on Michigan Matte
Printed and bound by The Murray Printing Co.

IV